Mine Eyes Have Seen

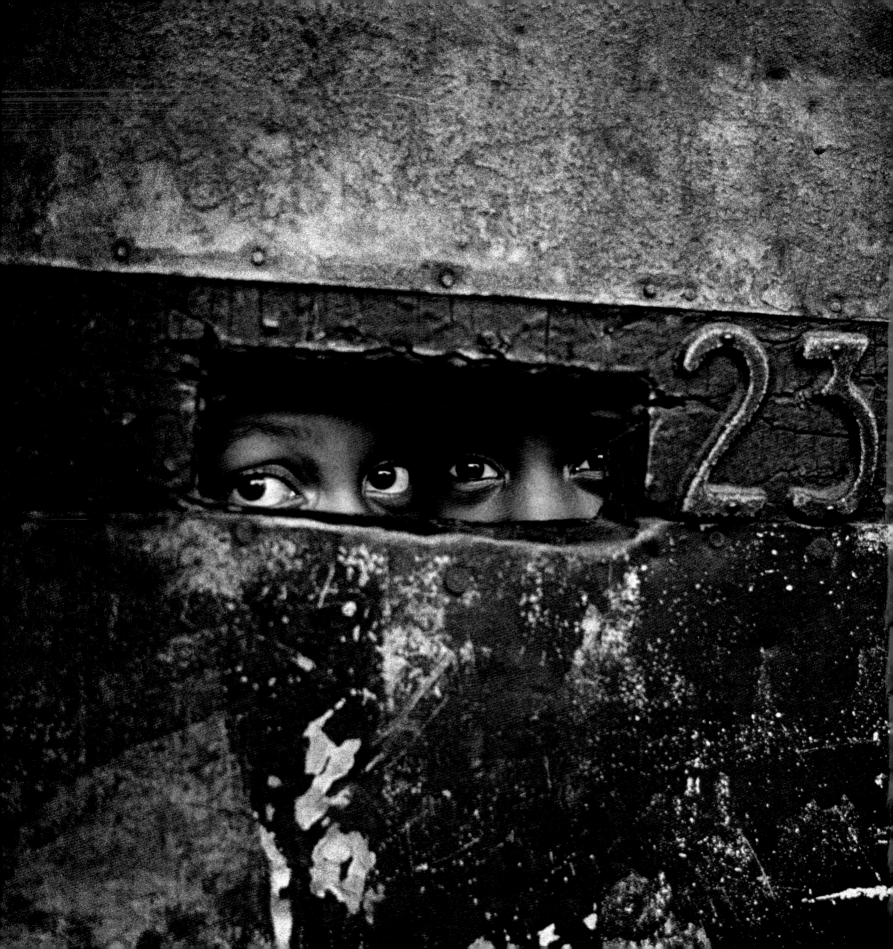

Mine Eyes Have Seen

Bearing Witness to the Struggle for Civil Rights

Bob Adelman Photographs

Charles Johnson Essays

A Bob Adelman Book

LIFE GREAT PHOTOGRAPHER BOOK

To the Movement's heroic women, men and children,
who helped redeem America's promise of liberty, lived the Dream
and, amidst their sacrifices, found the beloved community.

LIFE Books Editor **Robert Sullivan**

Bob Adelman Books Inc.
Art Director **Rick DeMonico**
Copy Editor **Mary A. Dempsey**
Digital Imaging **Stephen Watts**

Time Inc. Home Entertainment
Publisher **Richard Fraiman**
General Manager **Steven Sandonato**
Executive Director, Marketing Services **Carol Pittard**
Director, Retail & Special Sales **Tom Mifsud**
Director, New Product Development **Peter Harper**
Assistant Director, Brand Marketing **Laura Adam**
Assistant General Counsel **Dasha Smith Dwin**
Book Production Manager **Jonathan Polsky**
Design & Prepress Manager **Anne-Michelle Gallero**
Marketing Manager **Alexandra Bliss**

Special Thanks to:
Bozena Bannett
Glenn Buonocore
Suzanne Janso
Robert Marasco
Brooke Reger
Mary Sarro-Waite
Ilene Schreide
Adriana Tierno
Alex Voznesenskiy

Printed In China

Published by Time Inc. Home Entertainment Books
LIFE is a trademark of Time Inc.

ISBN 13: 978-1-60320-000-4
ISBN 10: 1-60320-000-2

Library of Congress #: 2007904502

Time Inc.
1271 Avenue of the Americas
New York, New York 10020

We welcome your comments and suggestions about TIHE
Books. Please write to us at:
TIHE Books
Attention: Book Editors
PO Box 11016
Des Moines, IA 50336-1016

If you would like to order any of our hardcover Collector's
Edition books, please call us at 1-800-327-6388.
(Monday through Friday, 7:00 a.m.— 8:00 p.m. or Saturday,
7:00 a.m.— 6:00 p.m. Central Time).

Acknowledgments
Forty years of photographing creates a mountain of debts. These pictures wouldn't be but for the help, patience and trust of all the people in this book. Knowing them has enlarged and enriched my life beyond measure. I hope there aren't too many unfair likenesses. And I hope that my many friends and fellow activists in the Movement find here a portion of our struggles and triumphs.

The help of my comrades without arms — who changed the world — was essential, and they gave it generously. They include Rudy Lombard, Jerome Smith, Dave Dennis, Marvin Rich, Bob Gore, Mary Hamilton, Julian Bond, Stokely Carmichael, Jim Foreman, Andy Young and so many more. Amidst all the bewildering turbulence, a number of writers and seers helped me grasp what was happening. How can you thank anyone enough for opening your eyes wider? Chief among them were Ralph Ellison — always Ralph — Jimmy Baldwin, Bayard Rustin, Michael Harrington, Lillian Smith, Malcolm X and Ira Glasser. We were blessed with great leaders. Jim Farmer gave so much, as did Floyd McKissick and John Lewis. And Martin Luther King Jr., our hero and a transcendent man for the ages, inspired us to go beyond what many of us thought possible. The great redeeming possibilities of creative non-violence that "Doc" embodied and preached, as we engage in yet another disastrous war, seem still elusive.

A book is the work of many hands, hearts and minds. Richard Fraiman intently looked at my pictures early on and, with steadfast conviction, has seen to their publication. A publisher extraordinaire and prodigious editor, Jamie Camplin, who has published some of the best books of our times, has always offered his encouragement and friendship — and that has meant the world to me. Charles Johnson, no doubt one of our greatest writers, who does indeed truly know, is the soul of kindness. He immediately understood my work and says so, eloquently. Bob Sullivan, the savviest of editors, spotted the rough spots and knew just how to fix them. Two great art directors, Michael Rand and Ian Denning, recognized what needed to be done with my photographs, but I was not ready to listen. Rick DeMonico took often-confusing materials and, with his great sense of style, mastery of graphics and good instincts, wove my photographs into a coherent whole. Stephen Watt's wizardry subtly improved innumerable photographs. Mary Dempsey always seemed to know just what needed to be said and where and how. In their different ways, Alex Bliss, Jane Sapp and Judy Twersky have lent a hand.

Having had the good fortune of receiving guidance and help from extraordinary and gifted colleagues and friends, I'd like to express my gratitude. This offering of photographs, I hope, serves as a form of redemption.

"Fondly do we hope — fervently do we pray — that this mighty scourge of war may speedily pass away. Yet, if God wills that it continue, until all the wealth piled by the bond-man's two hundred and fifty years of unrequited toil shall be sunk, and until every drop of blood drawn with the lash shall be paid by another drawn with the sword, as was said three thousand years ago, so still it must be said, "the judgments of the Lord are true and righteous altogether."

President Abraham Lincoln's second inaugural address

"Race is an illusion. Scientists tell us that there is more genetic variation within any one so-called racial group than between one group and another."

Charles Johnson

"There lived a race of people, of black people, of people who had the moral courage to stand up for their rights. And thereby they injected a new meaning into the veins of history and civilization."

Martin Luther King Jr.

"I don't know how white I am, and I don't know how black you are, Bob."

Ralph Ellison in conversation

Overture
Prologue
Charles Johnson

Street disturbance, New York City.

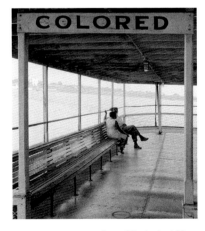

Ferry, Mississippi River.

When asked why he took so many photographs of black Americans, distinguished civil rights photographer Bob Adelman replies, with characteristic humility, that as a young man he was drawn to black people. In the 1950s, positive portraits of blacks in mainstream, white-controlled media were difficult to find. Mostly what we saw were pictures of Negroes in some form of civil disturbance, or being arrested by the police, or demeaning caricatures that relentlessly demonized people of color as inferior, dangerous or pathetically comic figures. But the artistic eyes of Adelman, who volunteered his services as a photographer to the Congress of Racial Equality (CORE) and the Student Nonviolent Coordinating Committee (SNCC), perceived for four decades (a period covering the early 1960s until the late '90s) something quite different. With compassion and courage — since taking photos in the Jim Crow South often put his own life at risk — he conjured the humanity, grace and dignity of his subjects.

That quotidian humanity is everywhere evident in *Mine Eyes Have Seen*. Looking at some of his pre-civil rights era images, we are transported back to what seems not just a different time but a different world, one of racial segregation — America's version of apartheid — which Adelman accurately describes as a madhouse. While a photograph can capture a moment, freezing it in time for eternity, it cannot reveal the conditions and causes that are the background for the image. We need to interpret and understand: A black man, his stringy muscles taut in his forearms, trucks cotton at a gin, pulling his load like a beast of burden. The eyes of children stare at us through the mail slot of a front

door, numbered "23," that at first glance resembles the peephole of a metallic cage or a prison cell for solitary confinement. As late as 1970, a smiling, white plantation owner in Yellow Bluff, Alabama, poses with his poor, dark-skinned tenants. And five years earlier, we see a party in progress at an elegant home in Dallas, Texas, where elderly white women chat as a black maid quietly stands in the background, awaiting their bidding.

Sadly, we realize these particular scenes, which reveal so much about the social world created for blacks by whites, could reflect any time during the 244-year history of American slavery, or the century bracketed by the Emancipation Proclamation of 1863 and the Civil Rights Act of 1964. These are a people from whom everything has been taken. Unseen, stretching behind them, are their predecessors who experienced the physical and psychological trauma and horrors of the Middle Passage then two-and-a-half centuries of chattel bondage. That oppression clings to each and every one of these photographs. Adjoa Aiyetoro, director of the National Conference of Black Lawyers, reminded us of its lingering effects in a *Seattle Post-Intelligencer* article (June 29, 1997) when she said, "One of the issues we deal with every day is the vestiges of our enslave-ment, and our post-enslavement treatment in this country has been such that it has beat us down as a people in so many ways."

Perhaps those "vestiges" might have disappeared if Congress had passed after the Civil War a famous bit of legislation known as Senate Bill No. 60, which not only would have provided emergency relief for black freemen, but also "three

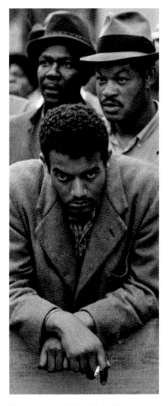

Man in crowd, New York City.

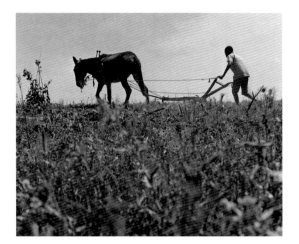

Spring plowing, rural Alabama.

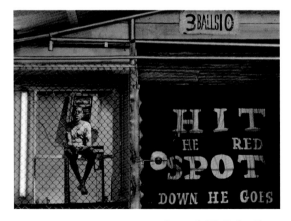

Game of skill, Dallas, Texas.

million acres of good land" in Florida, Mississippi and Arkansas for their settlement. In a January 18, 1866, edition of the *Congressional Globe*, Senator Lyman Trumbull, a Republican from Illinois, argued that "A homestead is worth more to these people than anything else… I think that if it were in our power to secure a homestead to every family that has been made free by the constitutional amendment, we would do more for the colored race than by any other act we could do." This "forty acres and a mule" bill put America's racial future, one might say, squarely at a crossroads. If approved, it might have done much to heal the devastating wounds of slavery and assist an impoverished, landless people in their transition from bondage to a fuller participation in American life, particularly in the area of economic development. But the bill was vetoed by President Andrew Johnson, who argued, "It was never intended that they [ex-slaves] should thenceforth be fed, clothed, educated and sheltered by the United States. The idea on which the slaves were assisted to freedom was that, on becoming free, they would be a self-sustaining population. Any legislation that shall imply that they are not expected to attain a self-sustaining condition must have a tendency injurious alike to their character and their prospects."

In short, after slavery, black people were left on their own. But no. That hardly says enough. They were segregated, systematically disenfranchised from their rights as citizens, and relentlessly portrayed as subhuman in a maddeningly complex, even Kafkaesque, social world.

But such a system of oppression, built on a lie, was fragile. Everyone knew this, black and white. Everyone saw it. The Founders, who were slaveholders, time

and again framed their outrage at England by comparing themselves to slaves. From the beginning of the Republic to the Civil War and for a hundred years after that, the American soul was schizophrenically divided between desiring the profits that came from the exploitation of black people and its deepest and dearest belief that "We hold these truths to be self-evident, that all men are created equal, that they are endowed by their Creator with certain unalienable Rights, that among these are Life, Liberty and the Pursuit of Happiness."

Believing in the soaring idealism expressed in the Declaration of Independence and the preamble to the U.S. Constitution, equipped with their indefatigable capacity for labor, their faith in God, their imagination and their love for one another, the people whose lives you see portrayed on these pages literally "made a way out of no way," as the old saying goes, and by virtue of doing so came to represent all that was good and great and noble about the American spirit.

This spirit, I believe, is what ensorcelled photographer Bob Adelman, leading him to record his remarkable subjects in settings that ranged from the Apollo Theater in Harlem to Beale Street in Memphis, from Alabama to Bedford Stuyvesant, entering into their homes, social events, religious experiences, professional and personal lives. And in this galaxy of images, one dominant impression surfaces again and again that defines these people so often written off and dismissed by others: namely, their irrepressible creativity and genius, which since the colonial era have enriched every dimension of American culture and politics.

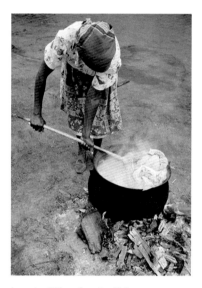

Laundry, Wilcox County, Alabama.

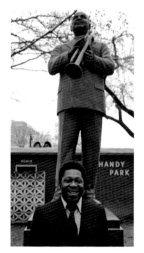

B.B. King at a statue of W.C. Handy, Memphis, Tennessee.

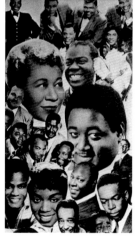

Montage of stars in lobby of Apollo Theater, Harlem, New York City.

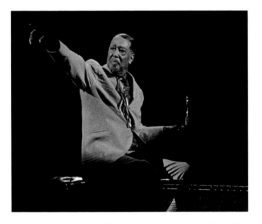

Duke Ellington in concert, New York City.

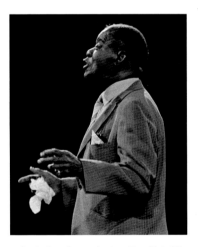

Louis Armstrong singing, New York City.

In the most humble, materially impoverished black lives we see what William Blake once called "evidence of the divine": the imagination given flesh as art, first in such everyday items as quilts and baskets, then in the artistry and skill required for horse training, and at last in a musical gift that, on its simplest level, calls forth pleasing sounds from a jug or a bone and emerges full-blown in breathtaking performances that forever changed the possibilities for music on planet Earth. Indeed, these images of Duke Ellington and Miles Davis remind us that black people, blessed with class and style, created the only indigenous, truly American music on these shores. But the transformative achievements do not end there. In the boxing ring, on the baseball field, the black presence is dominant. It is equally groundbreaking in film, represented here by a shot of a young, tuxedo-wearing Sidney Poitier looking for all the world like a god descended from the heavens in *For Love of Ivy*.

Literary artists provide us with yet another perspective on the world-class significance black Americans have long maintained as creators and innovators. There are photos of the iconic James Baldwin, a writer and civil rights activist who — like his friend Martin Luther King Jr. — served as a moral conscience for America, forever forcing it to face and acknowledge its crimes against humanity. We see the brilliant poet, playwright and essayist Amiri Baraka, a principal theoretician of the Black Arts Movement, who in the 1960s inspired a generation of young blacks to stop "conking" their hair, imitating white lives. He taught them to appreciate the wisdom and cultures of their African ancestors and, as I heard him say at a lecture to college

students in 1969, to "bring your talent back home to the black community." Yet he is placed, ironically, on the same page as the always impeccably dressed, literary perfectionist Ralph Waldo Ellison, the first black American to win, in 1953, a National Book Award for his magisterial novel *Invisible Man*, one of the most acclaimed works of fiction in American literature. When Ellison died in 1994, Baraka, in an interview, confessed that politically in the 1960s, "We were on opposite sides of the fence." While Baraka at one point in his life embraced the Nation of Islam and black cultural nationalism (then in the 1970s switched to what he called Scientific Socialism), Ellison was always a staunch integrationist. Ellison and his wife Fanny were at the ceremony in 1990 when my novel *Middle Passage* received the National Book Award, and during a joint interview we did, he said, "You don't write out of your *skin*, for God's sake. You write out of your imagination." Over and over, Ellison expressed in the one novel and two books of essays published during his lifetime that, "By a trick of fate (and our racial problems notwithstanding), the human imaginative is integrative — and the same is true of the centrifugal force that inspirits the democratic process." Both of these extraordinary artists embody two often conflicting tendencies in what W.E.B. Du Bois called "the souls of black folk," the tug of war between integrationist and separatist ideals.

For being a person of color living in a predominantly white, very Eurocentric society means being caught between the Scylla of *do we separate from the racial Other to be independent and self-sufficient?* and the Charybdis of *do we integrate and embrace our interconnectedness?* Each thesis creates a profoundly

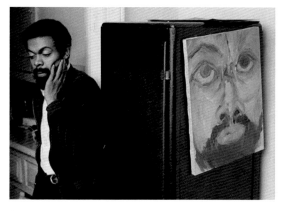

Amiri Baraka, Harlem, New York City.

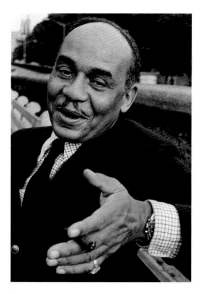

Ralph Ellison, Harlem, New York City.

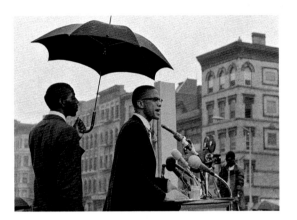

Malcolm X, Harlem, New York City.

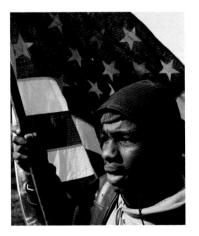

Marcher on Selma Highway, Alabama.

difficult problem, one both personal and political, that must be negotiated each and every day. Neither alternative can be viewed as absolute. Their respective virtues were hotly debated during the era of slavery, especially after the creation of the American Colonization Society in 1816, with many whites, Harriet Beecher Stowe and Abraham Lincoln (both white supremacists) among them, opposing the institution of slavery for its obvious evils but believing the solution could be found by sending former slaves back to Africa, specifically to the American colony of Liberia.

While some black Americans — James Forten, Paul Cuffee, Booker T. Washington, Marcus Garvey, Elijah Muhammad, Malcolm X — also passionately debated the value of separation, the majority of African-Americans realized that this country was their creation as much as it was that of whites. Without them, its economy, politics and culture were simply inconceivable. They knew they were as American as anyone else, and arguably more so when compared to European immigrants who did not arrive until the nineteenth and twentieth centuries. The Ellisonian position was, historically, the one most blacks preferred.

The issue, then, after World War II, when America entered its greatest period of prosperity, was not whether the Negro should leave. It was how, once and for all, blacks could force a nation to honor the principles enshrined in its most cherished political documents. By the mid-1950s, black Americans understood, as did Thomas Jefferson a century earlier, that "The tree of liberty must be refreshed from time to time with the blood of patriots and tyrants."

Overture

Photographs and Comments

Bob Adelman

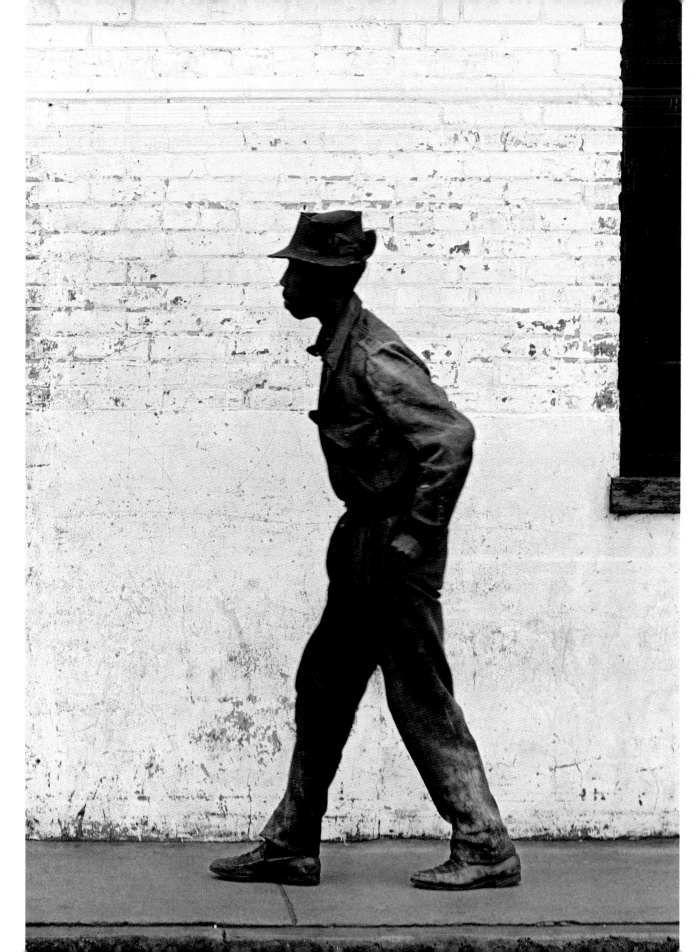

Scuffling, Sumter,
South Carolina.

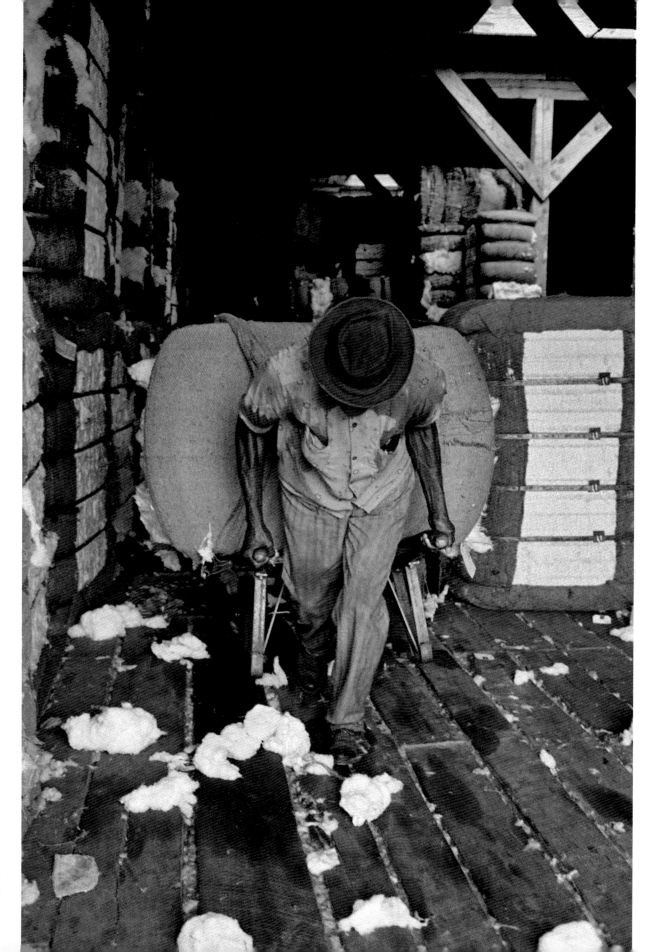

Trucking cotton,
Wilcox County, Alabama.

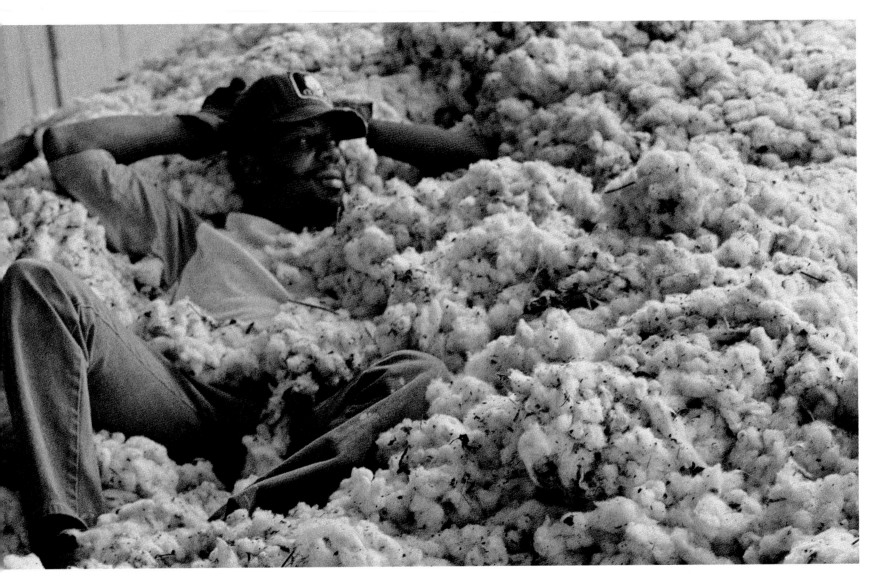

In high cotton, Tchula, Mississippi.

"He's got a minute's rest, waiting for his cart to fill and the cotton gin to restart. King Cotton had long been the bane of blacks' existence. The labor-intensive crop spurred the need for large numbers of slaves. Later, as tenant farmers, no matter how hard they worked, African Americans just scraped by. These days in the South, most cotton fields are on giant mechanized farms, requiring few workers."

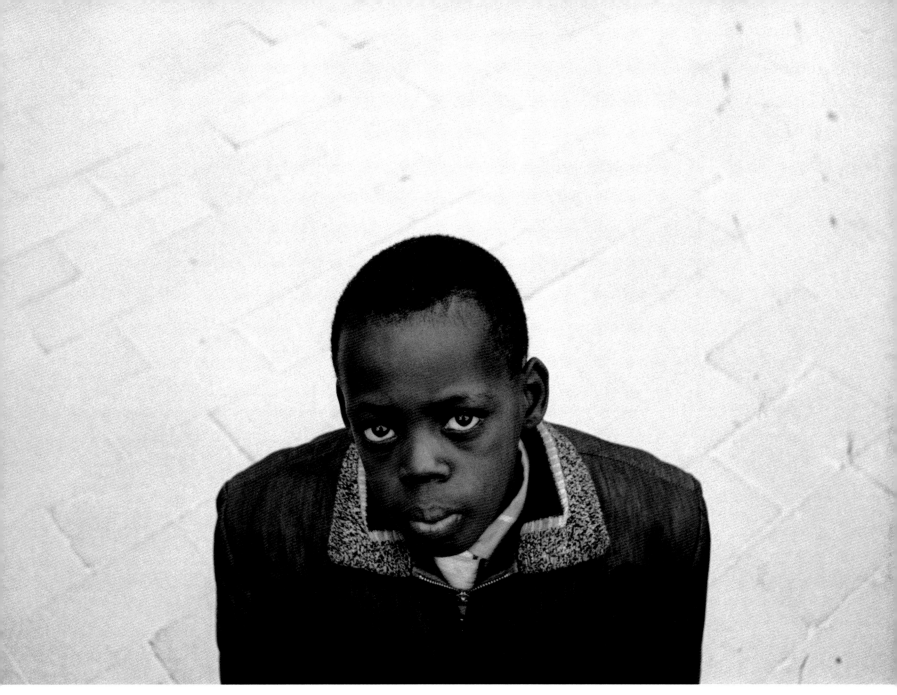

Chilly scene in winter, Brooklyn, New York City.

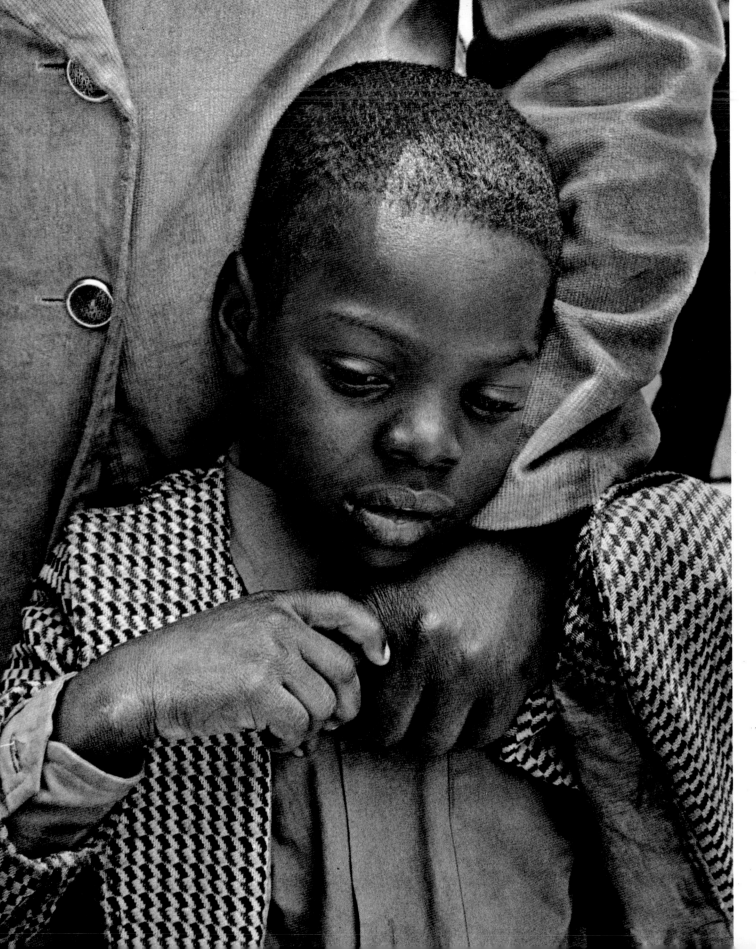

Comforted by a
day-care worker,
Harlem, New York City.

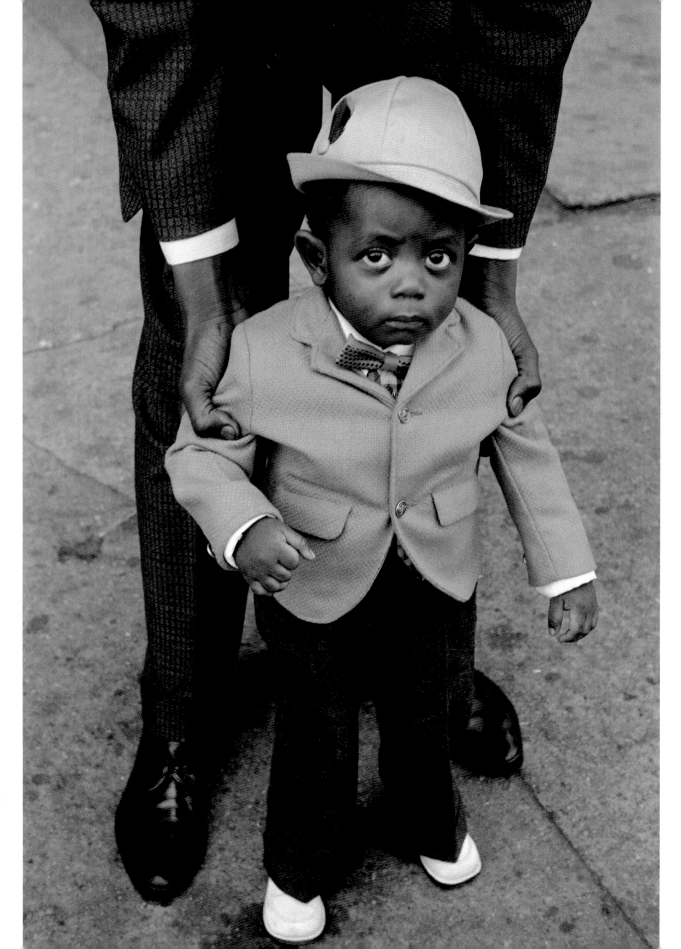

Daddy's little
man, Harlem,
New York City.

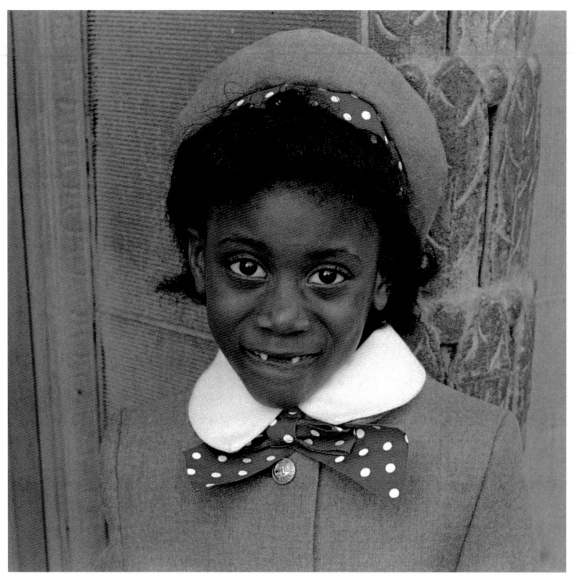

Sunday best, Harlem, New York City.

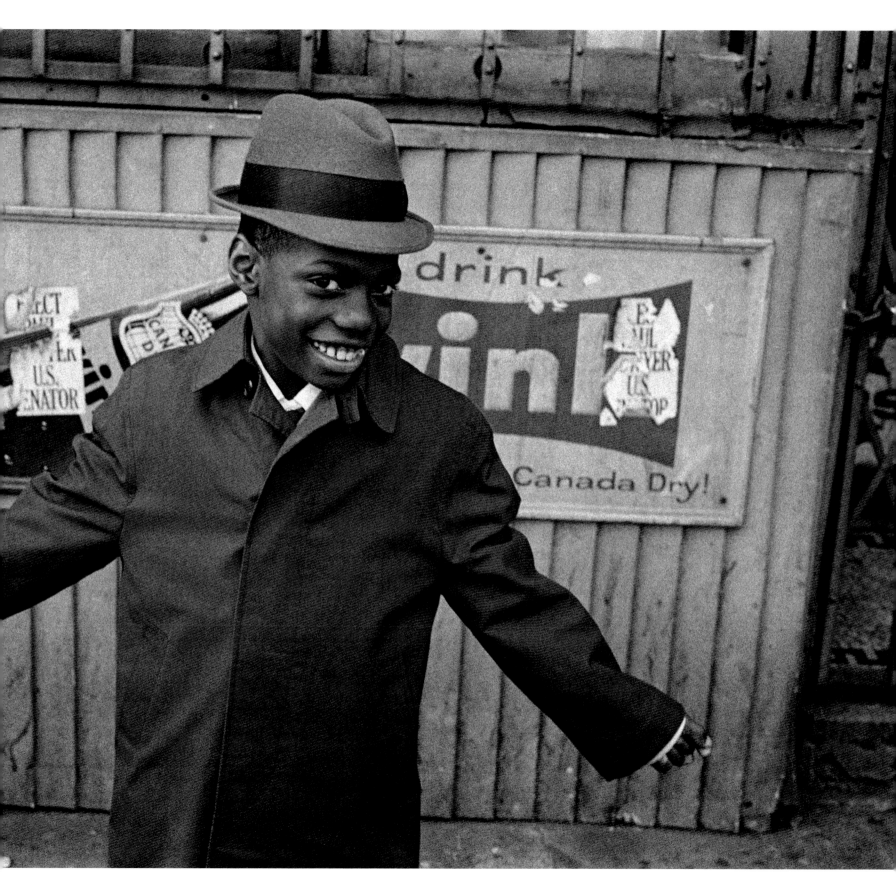

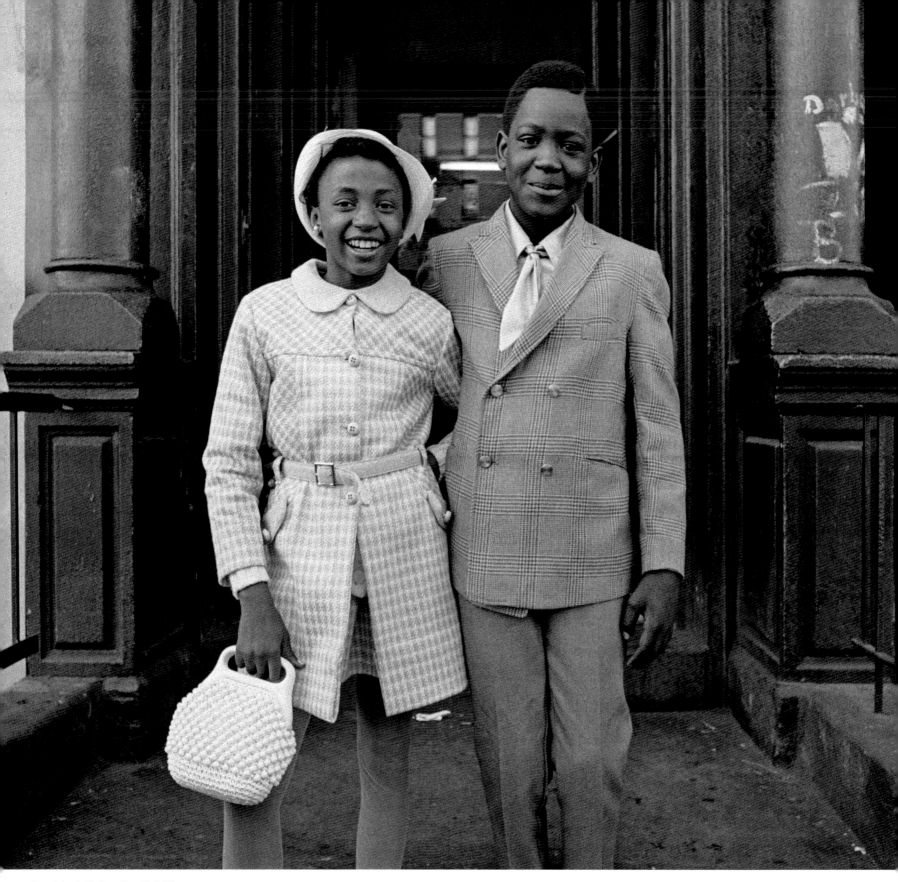

Steppin' out, Harlem, New York City.

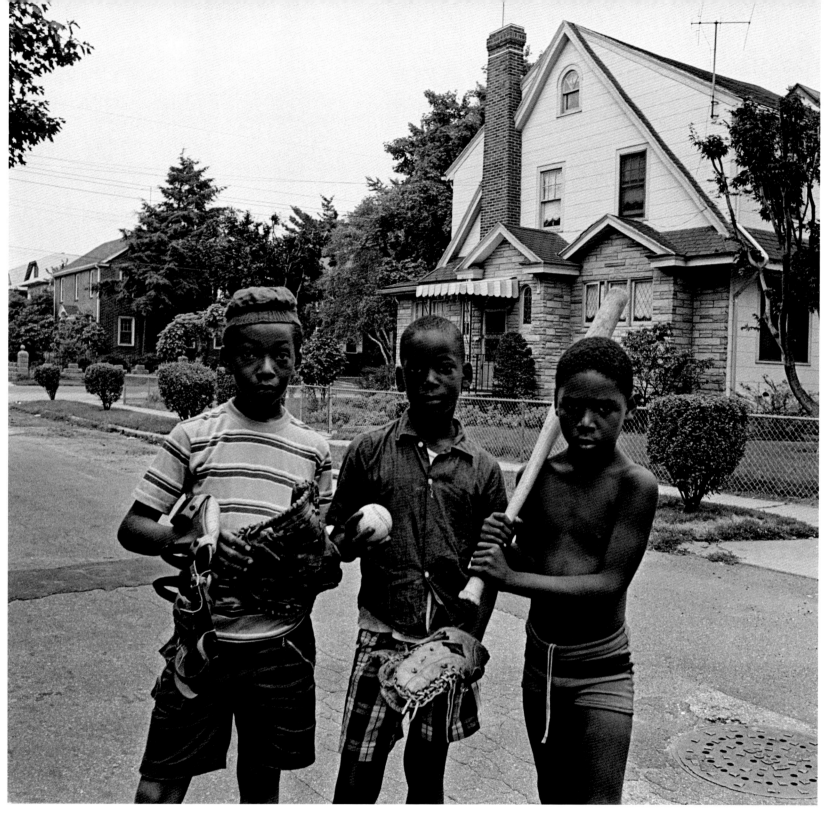

Play ball, St. Albans neighborhood, Queens, New York City.

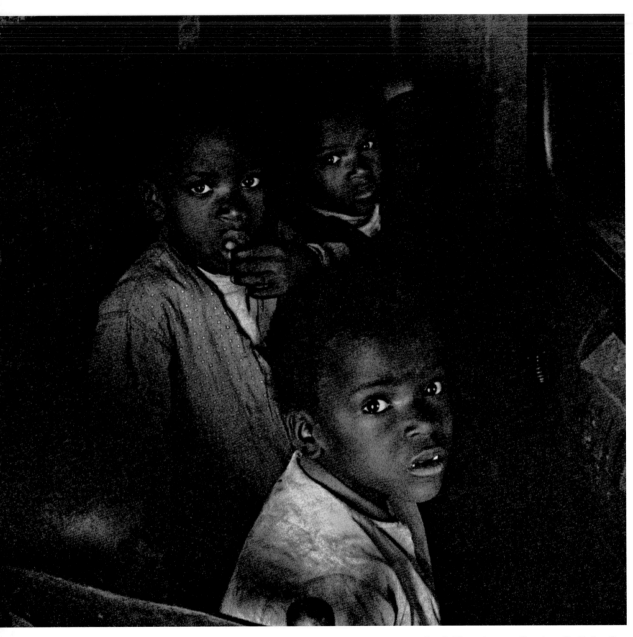

Startled by a stranger, Kingstree, South Carolina.

Peering through a mail slot, Brooklyn, New York City.

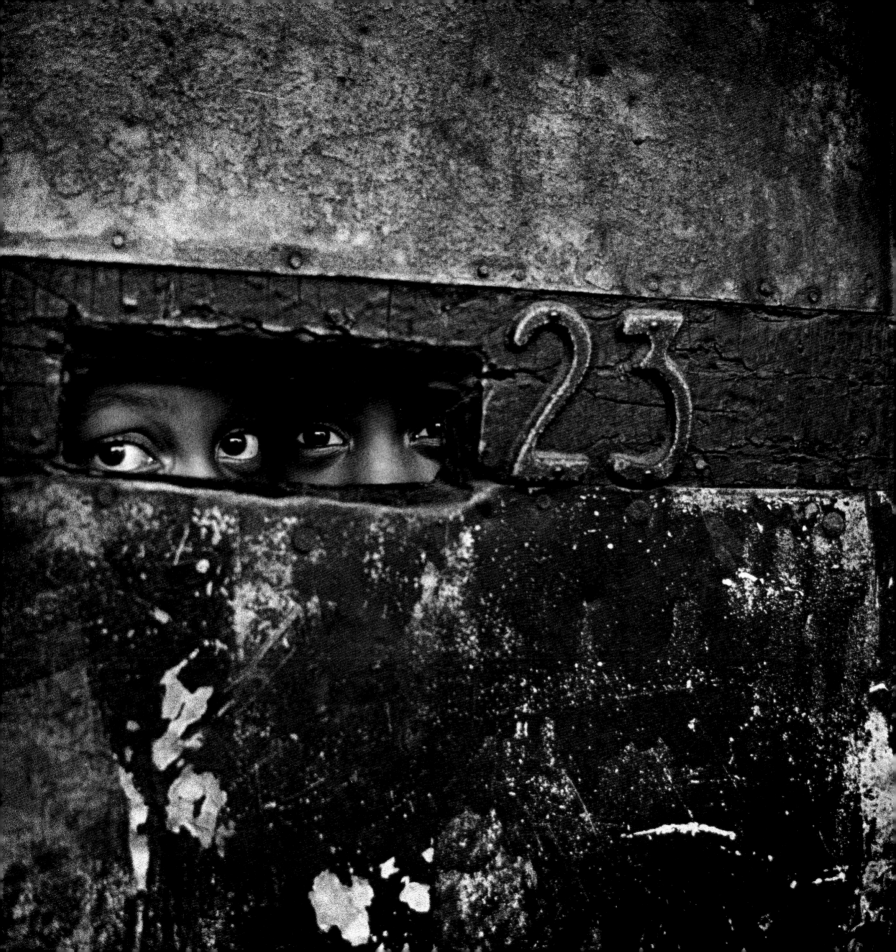

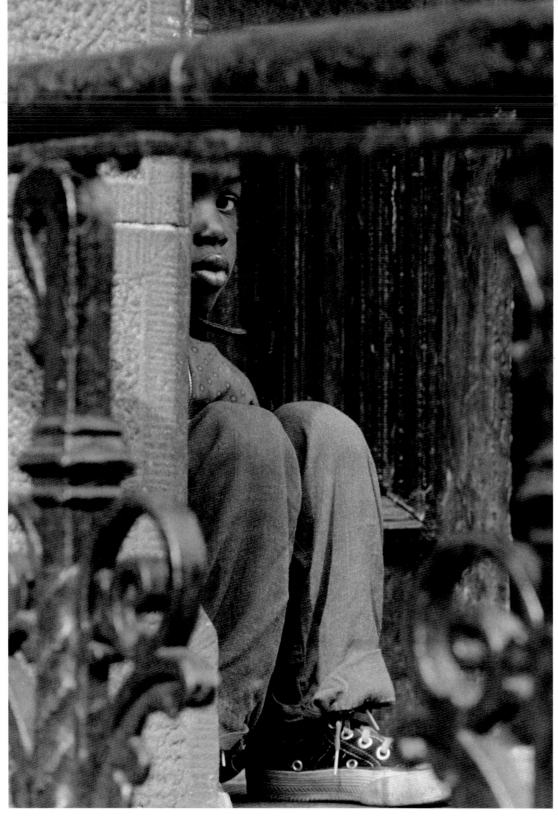

Boy in the Box, Brooklyn, New York City.

"The Box was the nickname for the Bed Stuy ghetto back in those days. I remember thinking when I made this picture that the elaborate filigree metalwork had been left over from much better times."

Returning from a sit-in,
New York City.

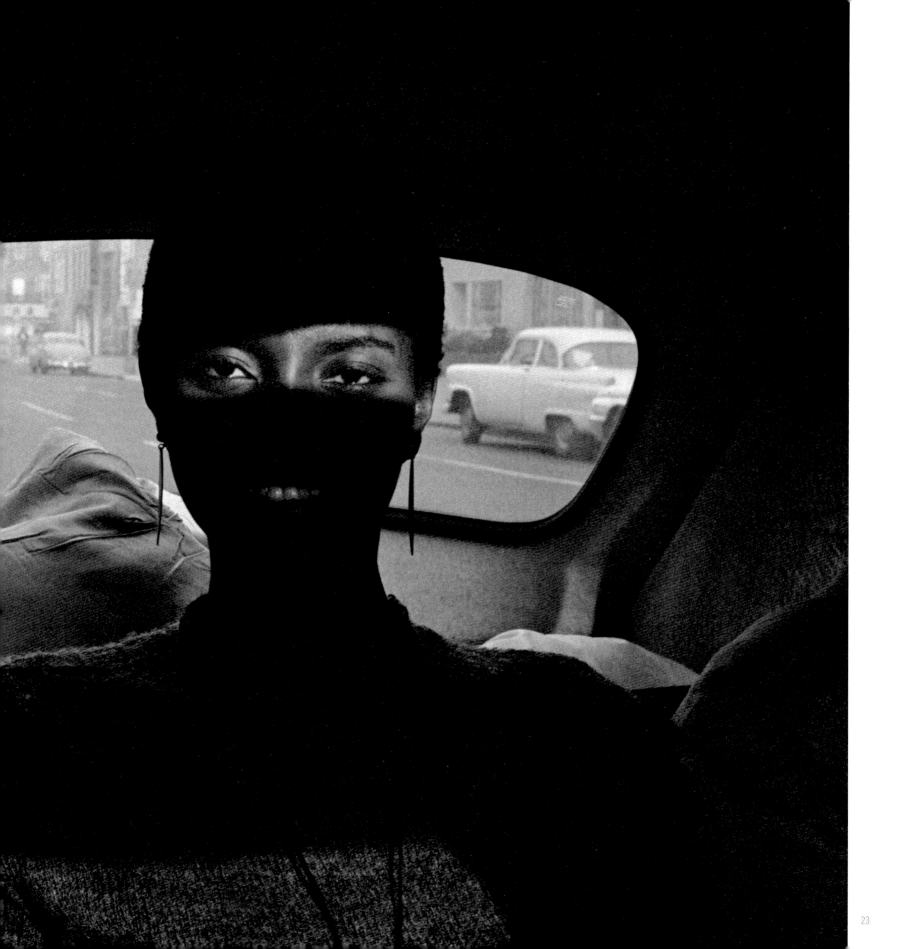

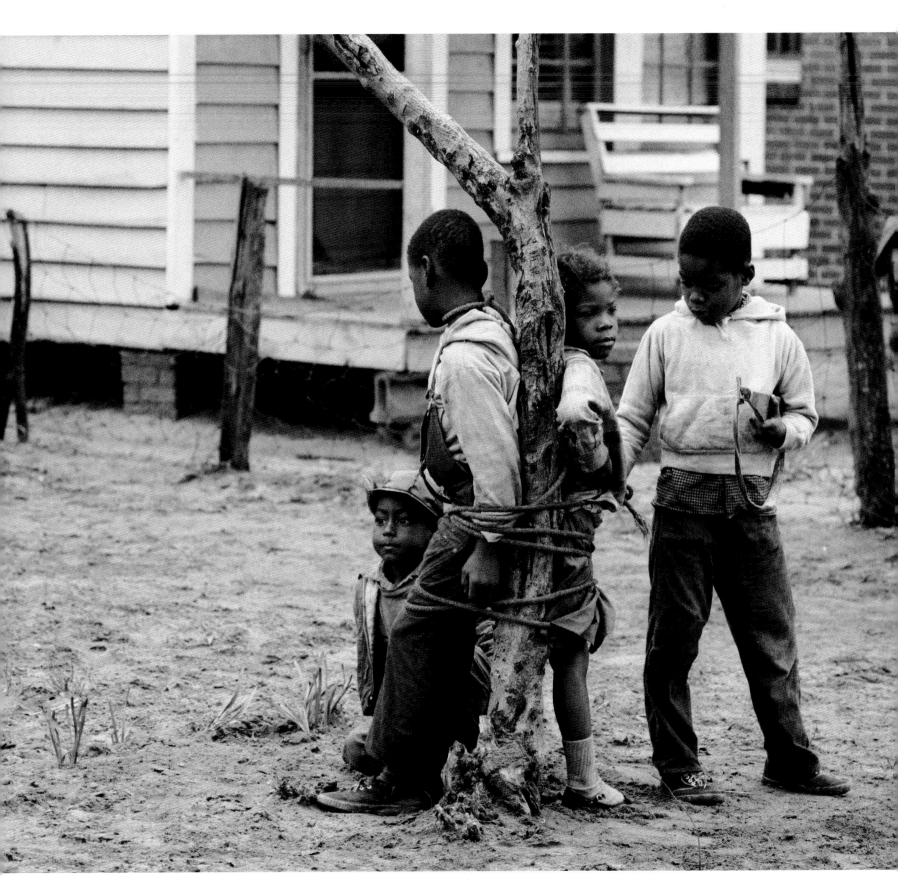

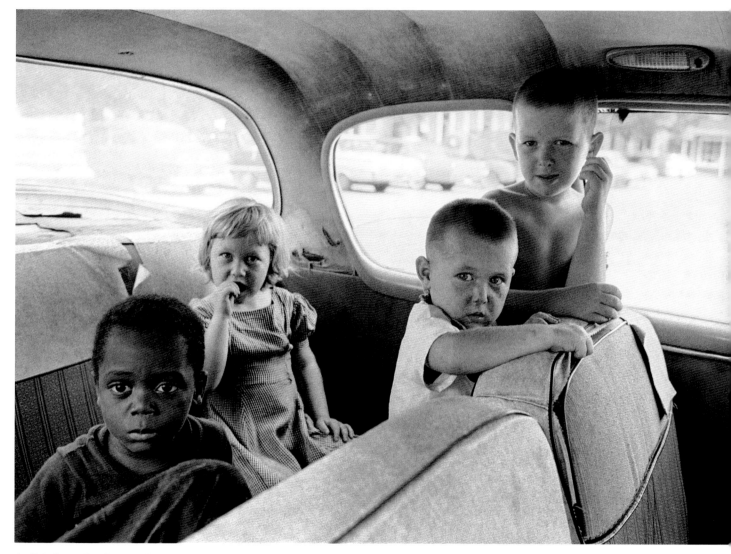

On Main Street, East Feliciana Parish, Louisiana.

"I ran across these children in a car near the Voter Registrar's Office during the Freedom Summer of 1964. They weren't waiting for someone who was registering but for a black domestic to finish the family's shopping."

Strange fruit, Sumter, South Carolina.

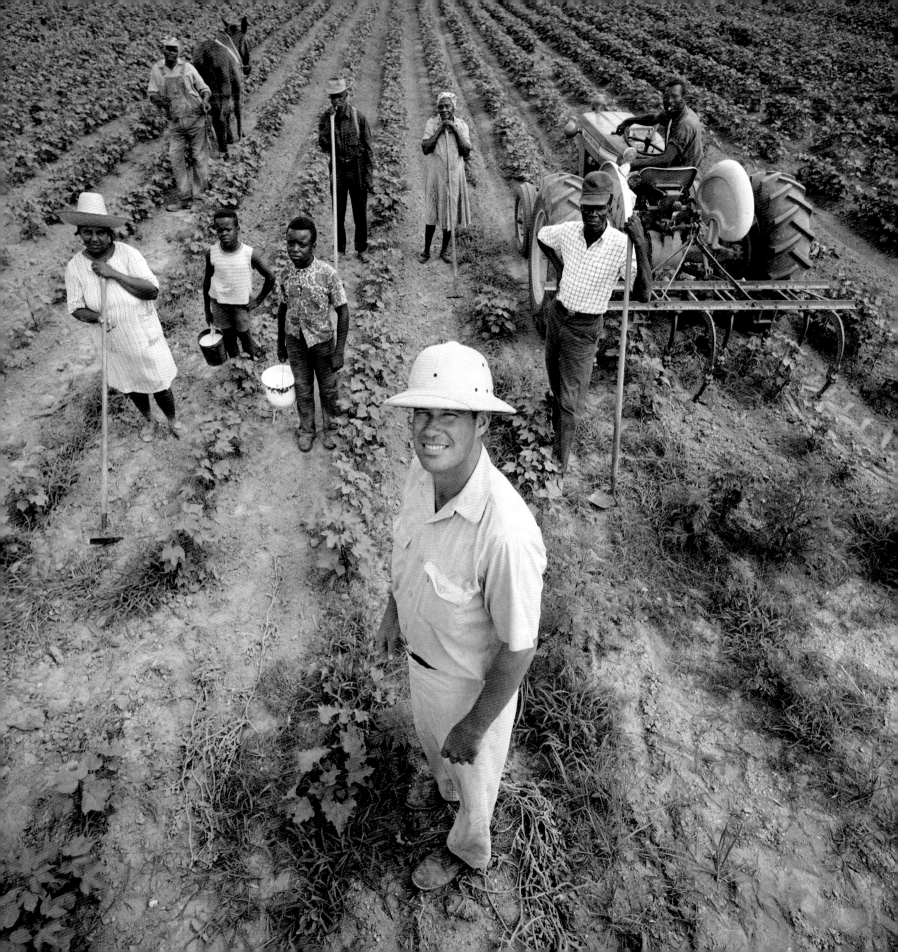

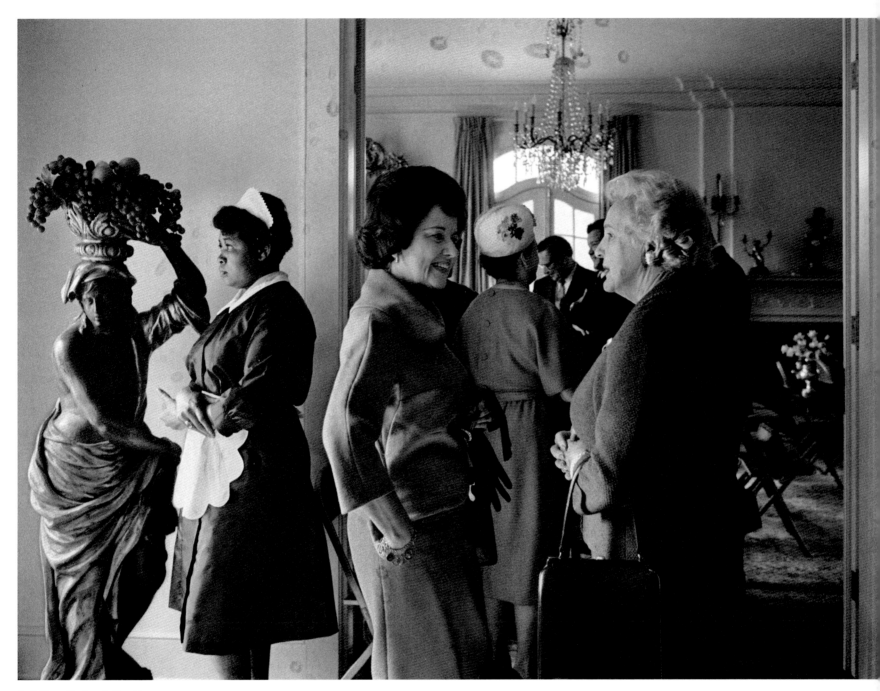

Socialite gathering, Dallas, Texas.

"This picture was taken back when cotton was farmed on Buford's land in Yellow Bluff. Today the land is a cow pasture and the workers—and their jobs—have vanished."

Peyton Buford Jr. and his tenant farmers, Yellow Bluff, Alabama.

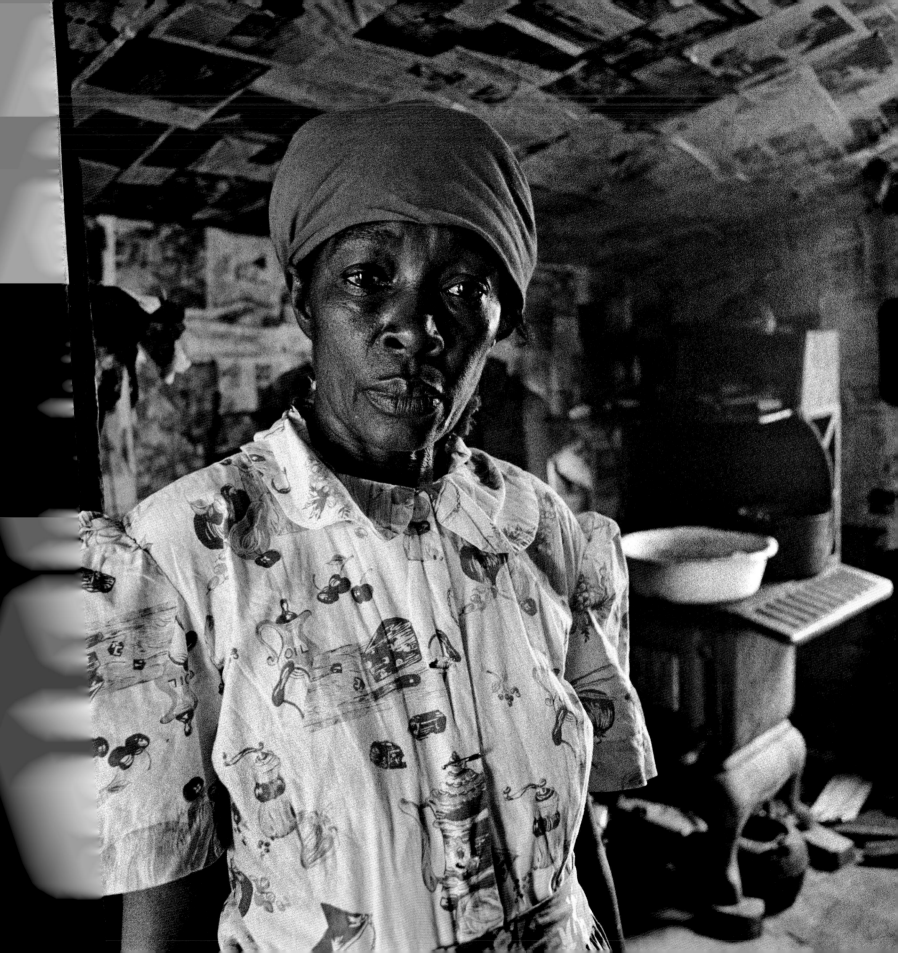

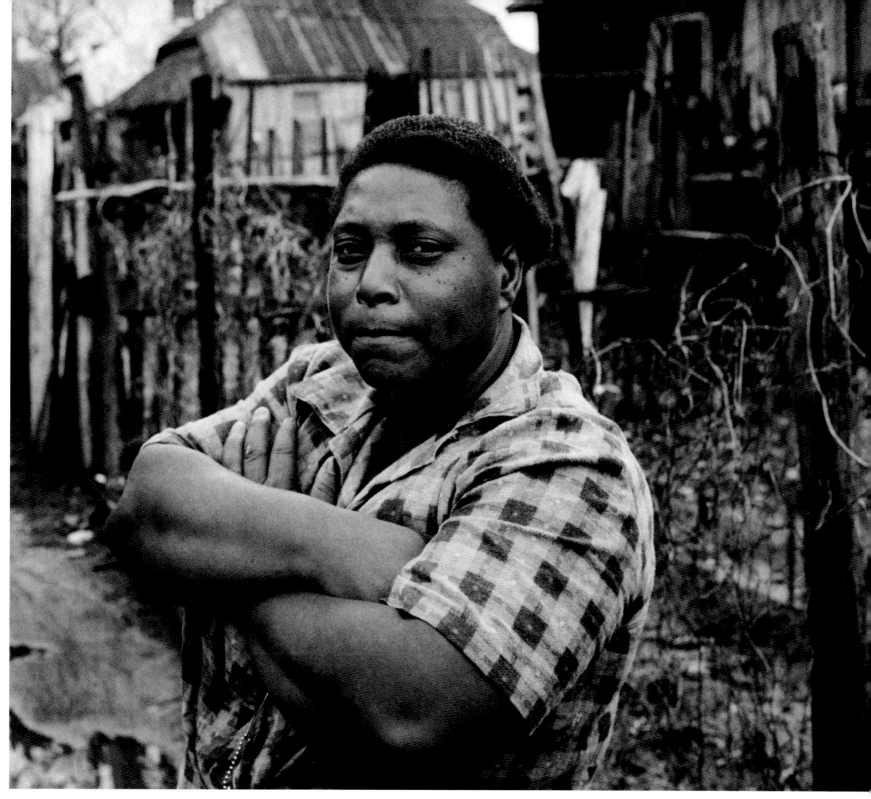

Backyard, Sumter, South Carolina.

"Mrs. Pettway was a proud woman, proud of the meals from her wood-burning stove, proud of her wallpaper and proud of Martin Luther King Jr. King, who 'got us to the place where we wasn't afraid. He told us to be together. We needed someone to stand for us who wasn't afraid.'"

Mrs. Pettway, Canton Bend, Alabama.

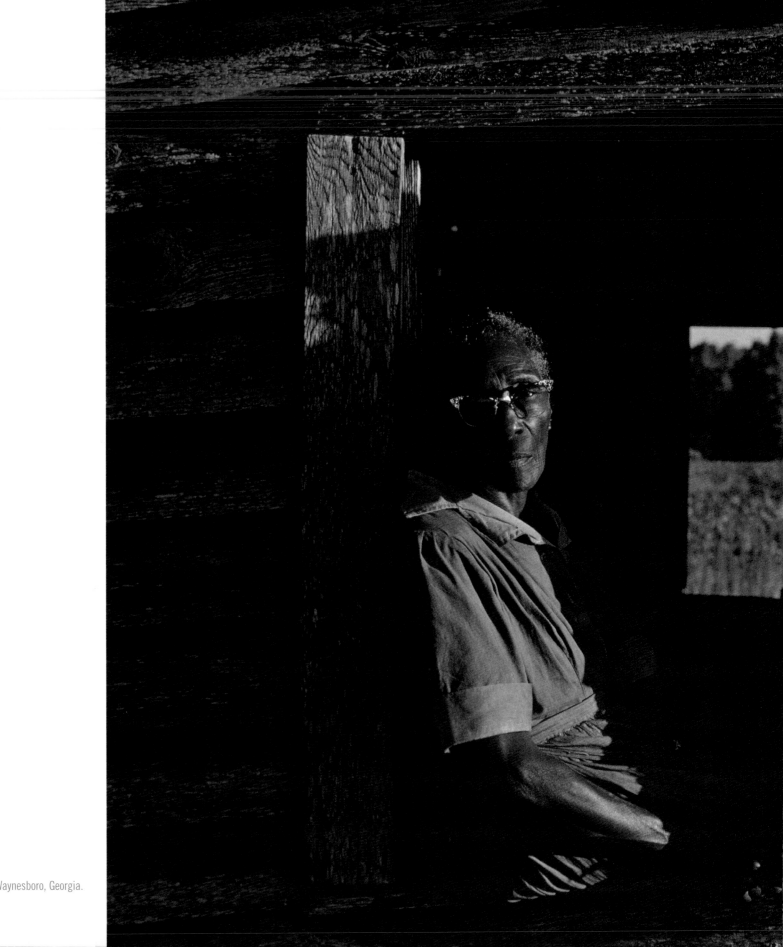

Just settin', Waynesboro, Georgia.

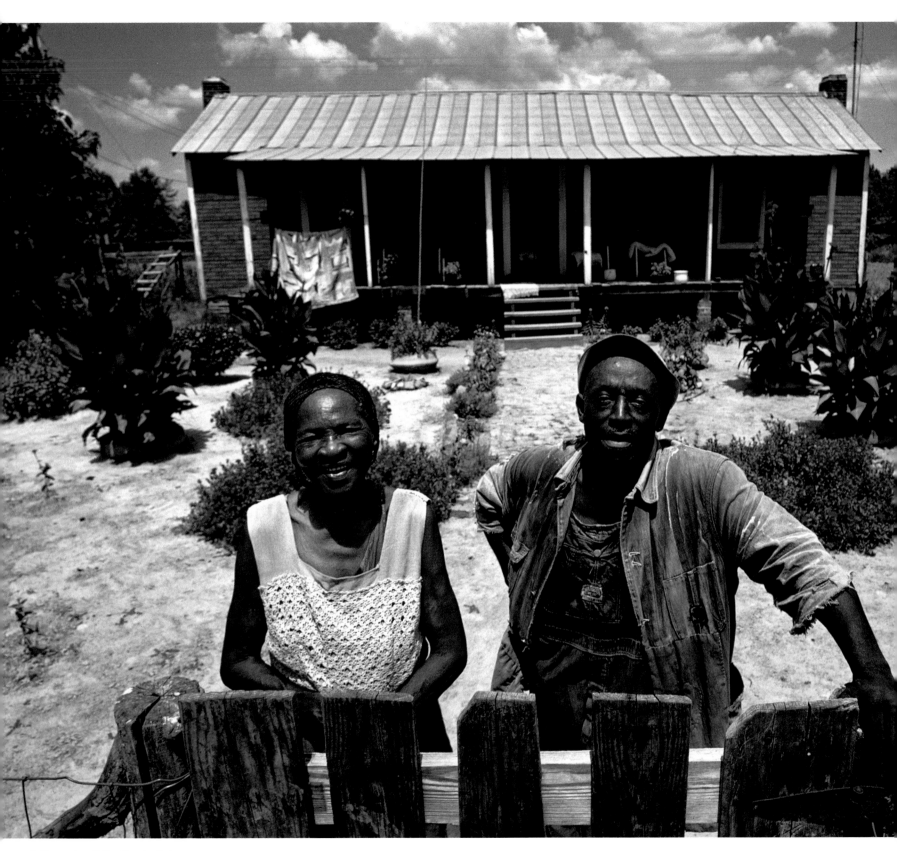

In the garden, Dallas County, Alabama.

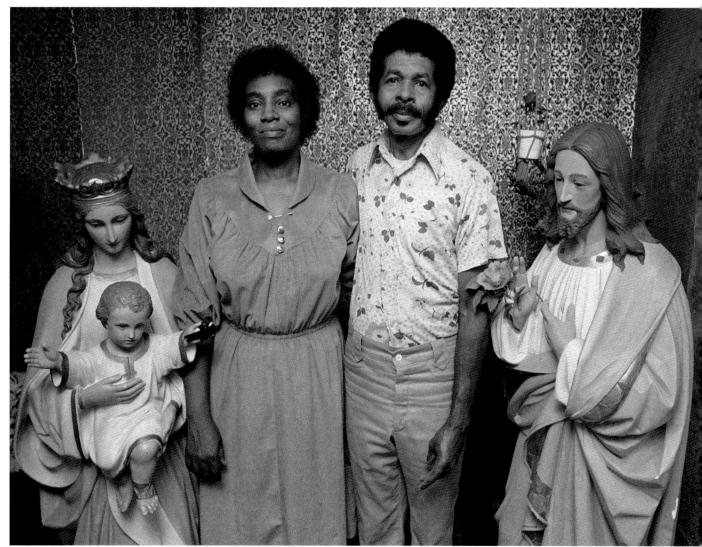

True believers, the Mississippi Delta, Mississippi.

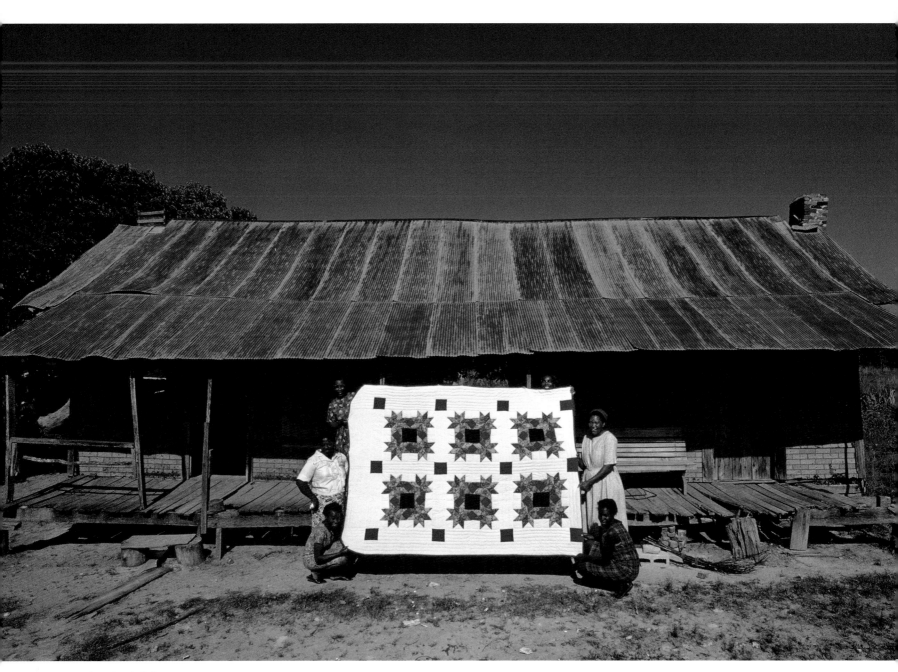

Quilting bee, Gee's Bend, Alabama.

"Touring exhibitions of their extraordinary folk art have made the Gee's Bend quilters world famous and have made their quilts objects of great value to collectors. In 2006, their designs graced a set of U.S. postage stamps. That art of such modernity and sophistication emerged here indicates the immense creative resources in the rural black South."

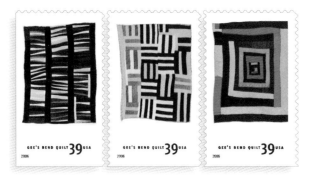

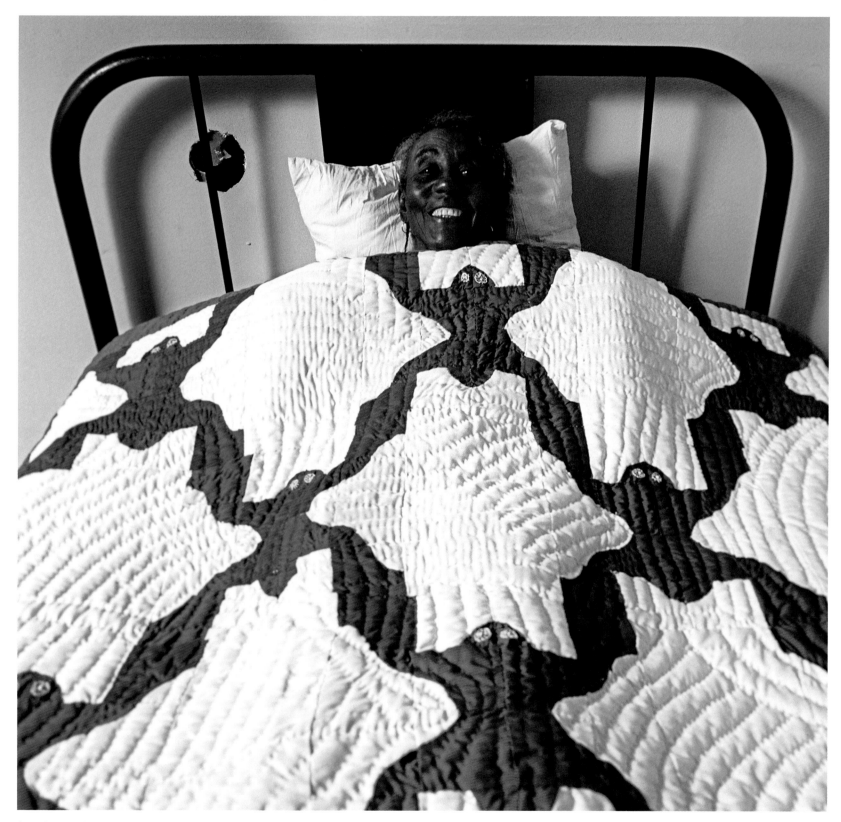

Second-generation quilter Betty Rogers finds "quilting keeps my mind steady." She is amused — and embarrassed — to be photographed in her bed under her leaping-frog quilt, Clinton, Alabama.

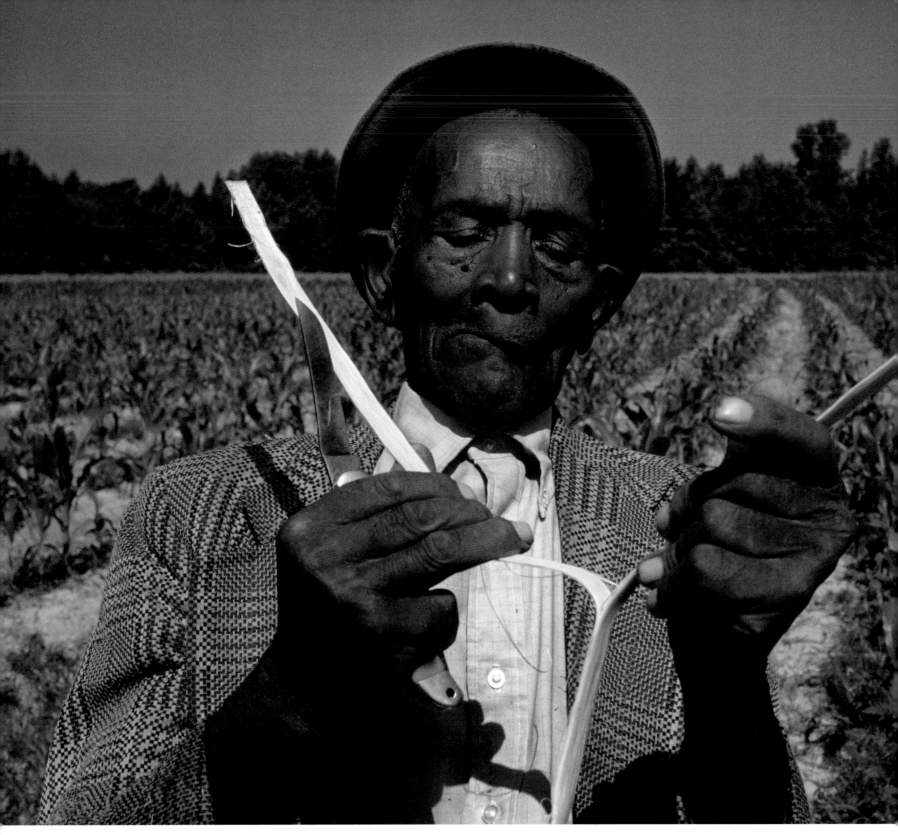

Ben Jones splits a tree limb into strips, then weaves a basket, Demopolis, Alabama.

"Ben Jones took almost 10 years to learn basket weaving. When his father taught him, he insisted,
'I done give you a trade. Don't you throw it down. Stick to it, and you'll meet a great day.'"

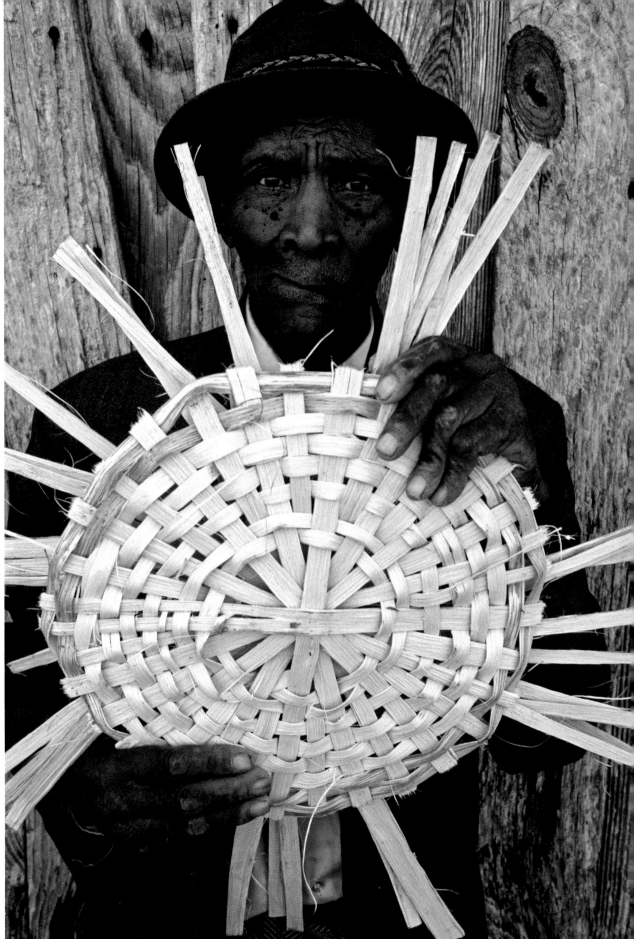

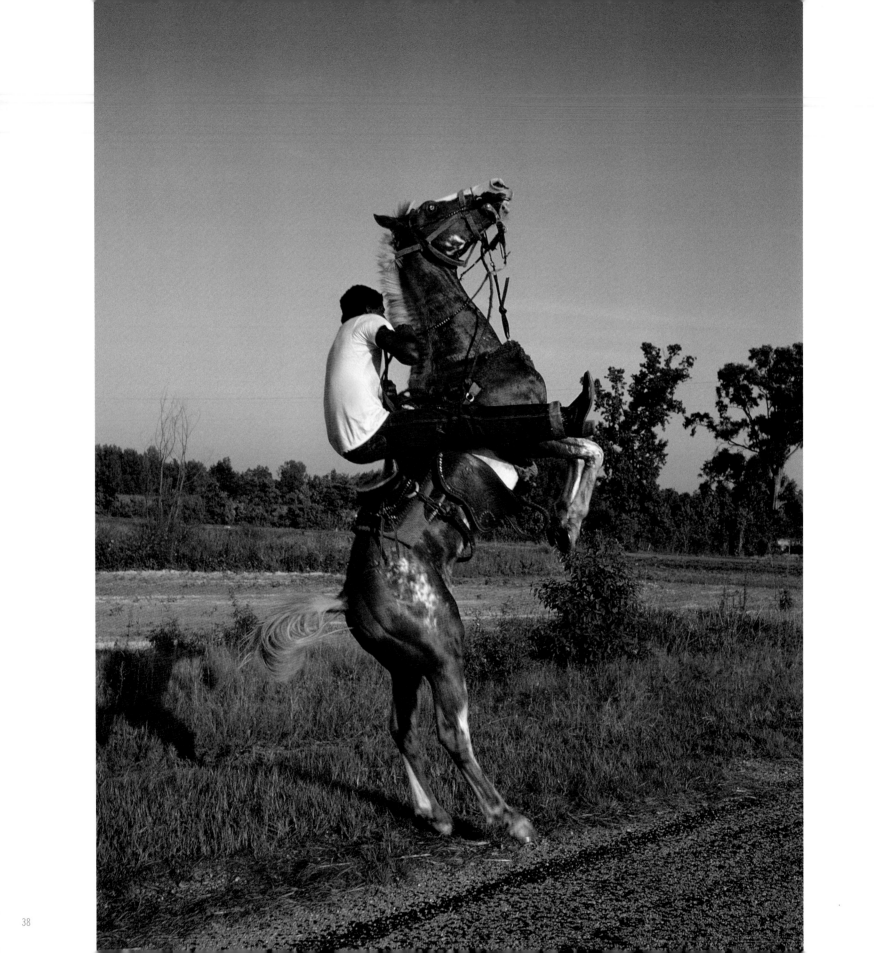

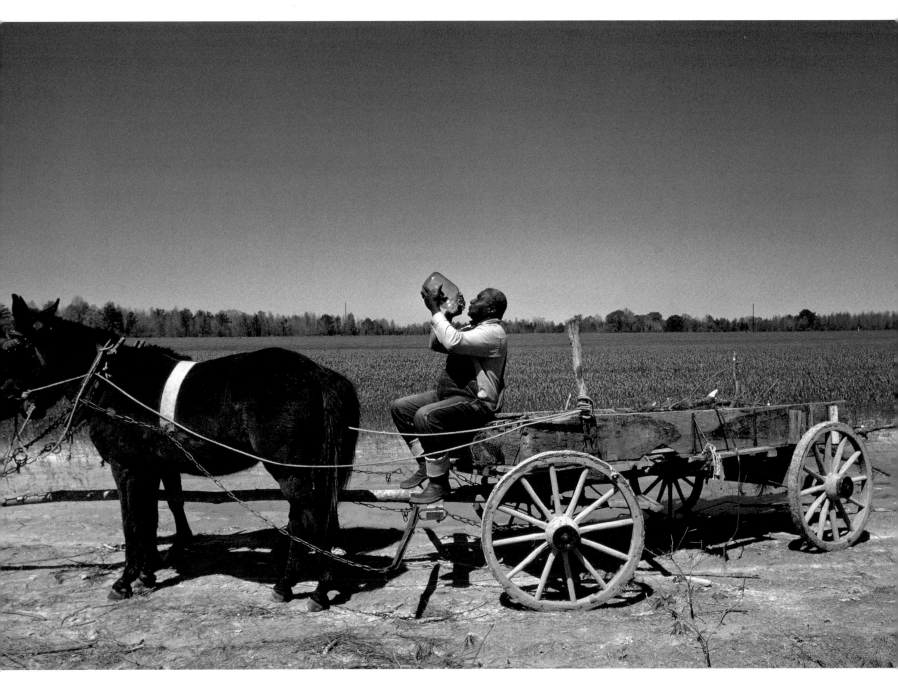

Jug blower Will Henley, Tishabee, Alabama.

"At parties in the old days, Will Henley recalled, 'You'd hear them blowing every which way, half the night. We'd be blowin' the jug and folks was dancing. It was like they would tear the house down.'"

Champion show horse shows off, Epes, Alabama.

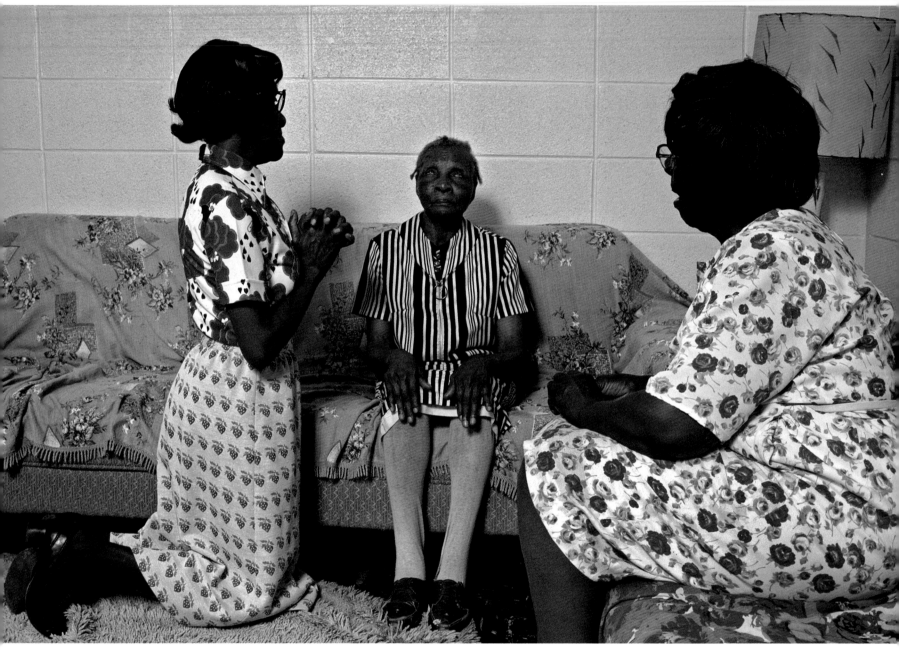

Love thy neighbor: A visiting prayer band prays with a blind parishioner, Mantua, Alabama.

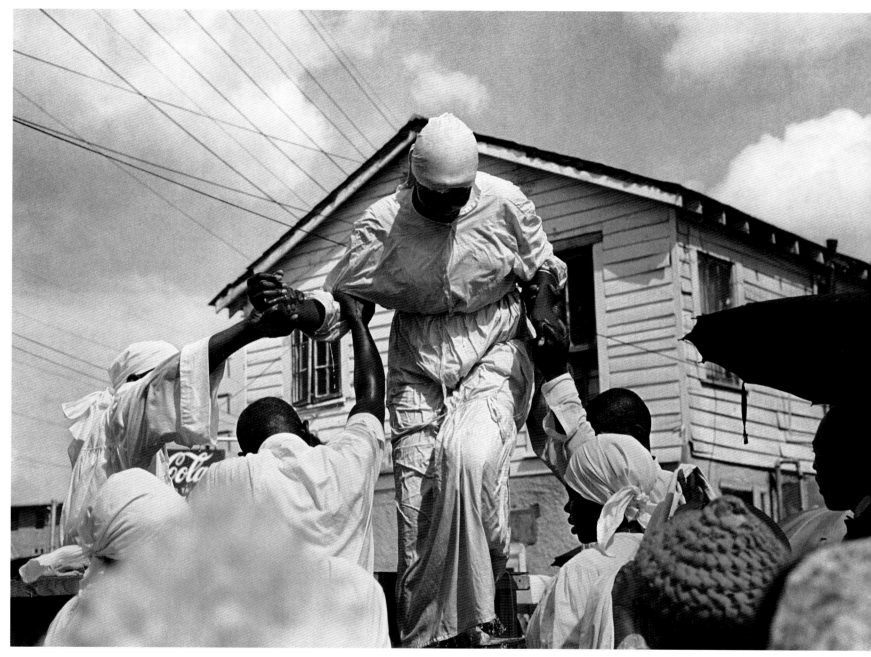

On-the-street baptism, New Orleans, Louisiana.

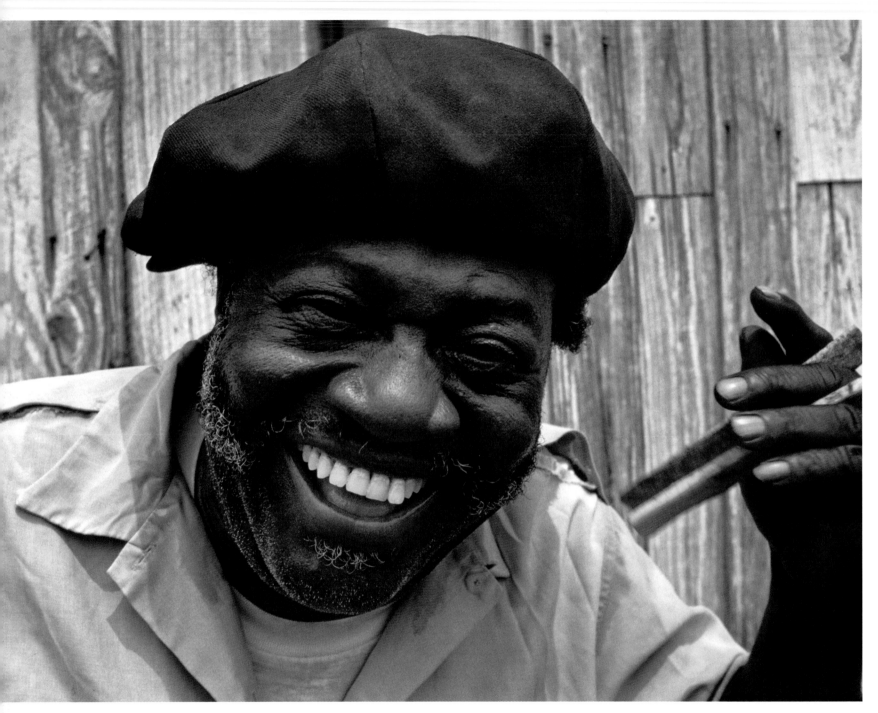

Bone knocker Arthur Tucker, Starkville, Mississippi.

"'Folks would dance on the naked ground,' Arthur Tucker
said, when he knocked his cow bones."

"At the Apollo, I remember, the great Al Green tossed
dozens of roses to the ladies in the front rows."

Al Green, live at the Apollo Theater, Harlem, New York City.

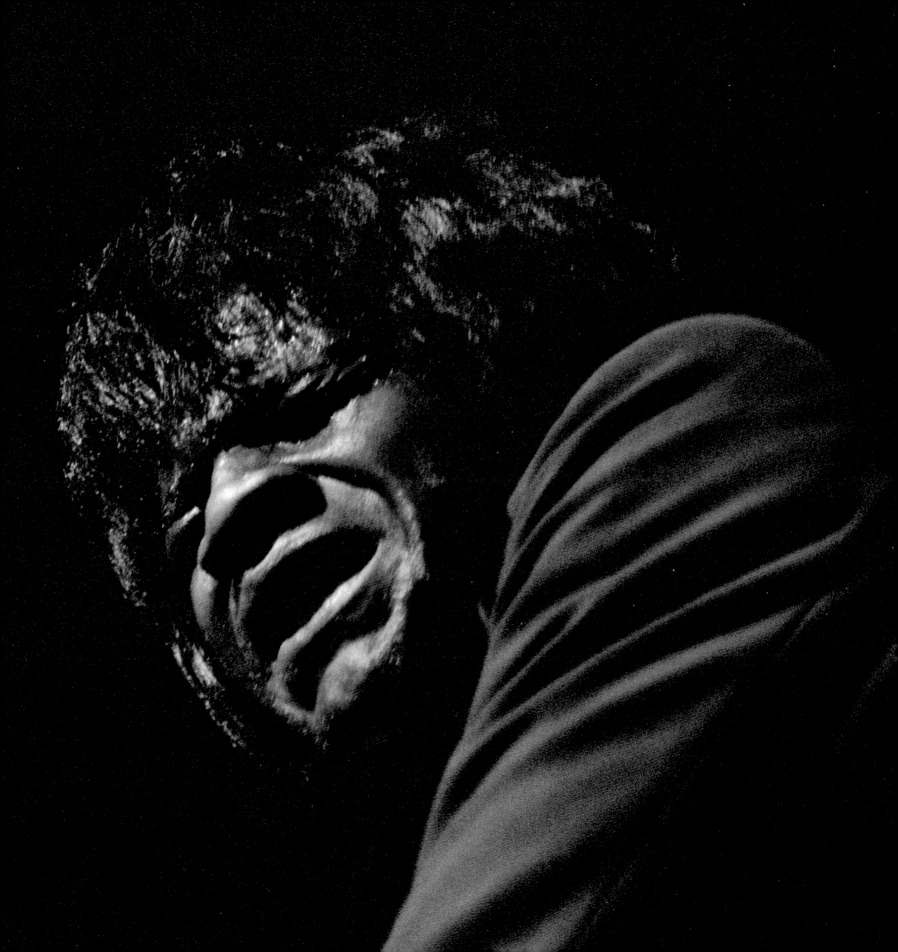

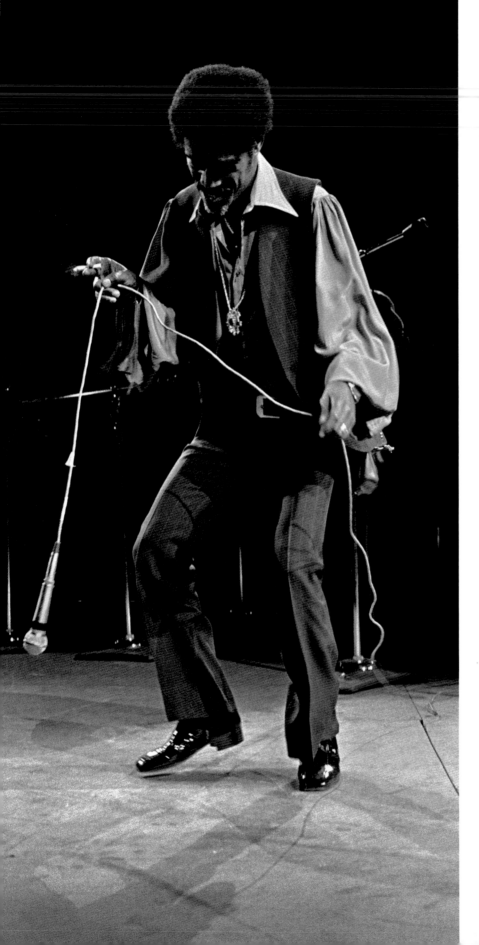
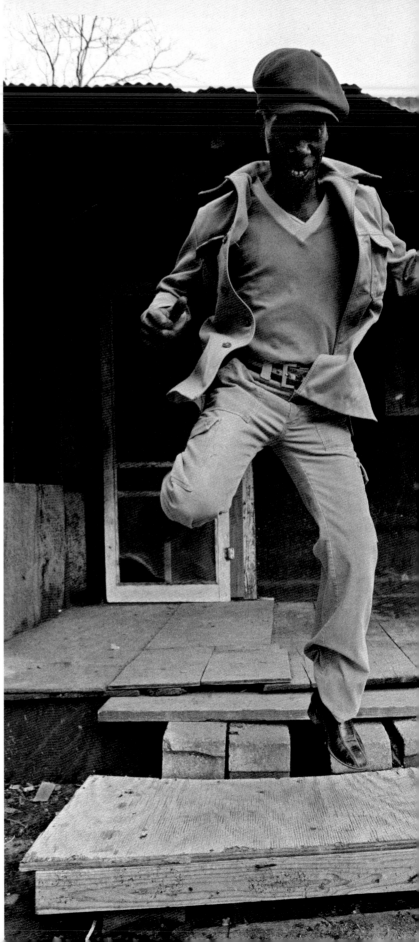

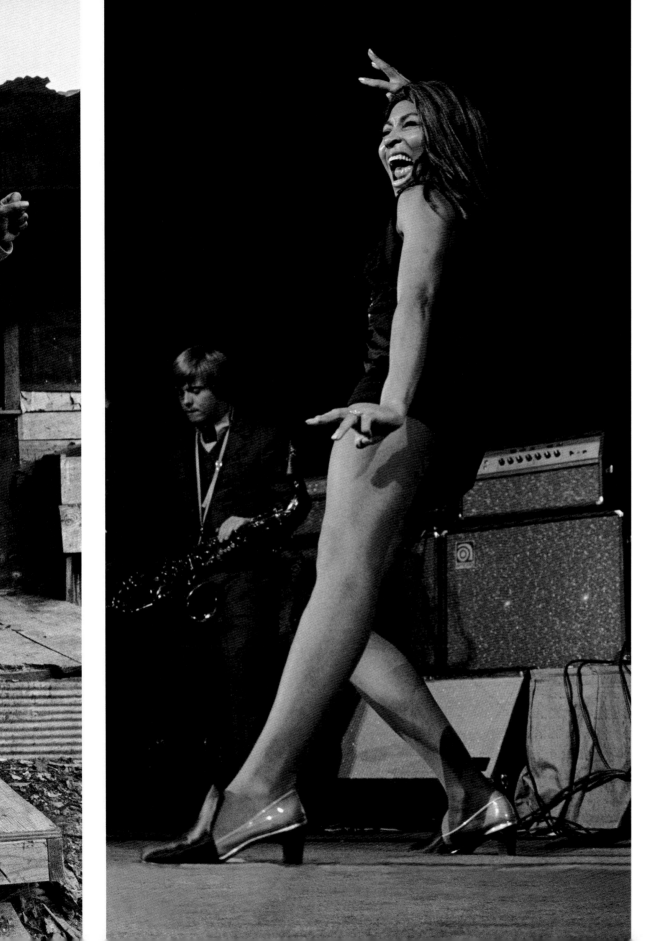

Left to right:

Making himself heard: Sammy Davis Jr. at Madison Square Garden, New York City.

Buck-and-wing dancer Lemon Harper, Gainesville, Alabama.

Tina Turner struts at the Apollo Theater, Harlem, New York City.

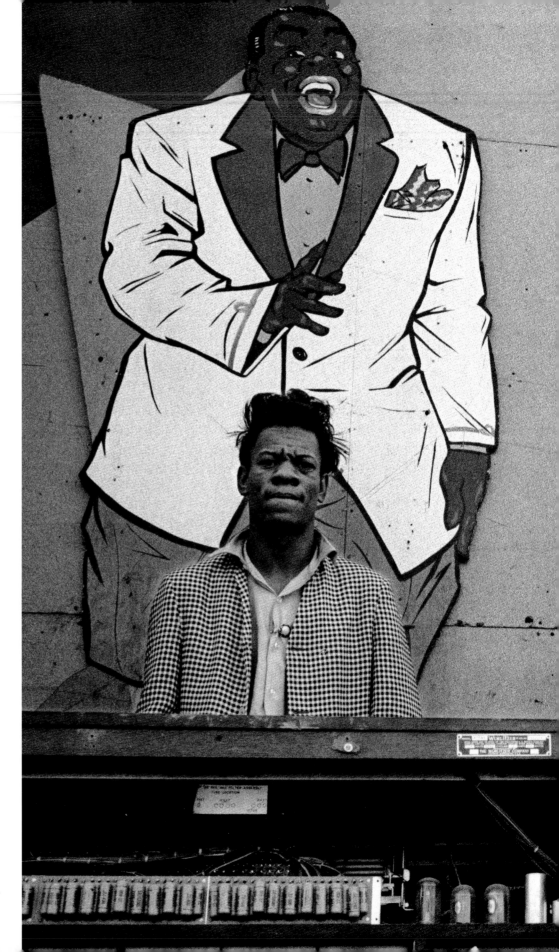

Image and reality: a blues band
at the state fair, Dallas, Texas.

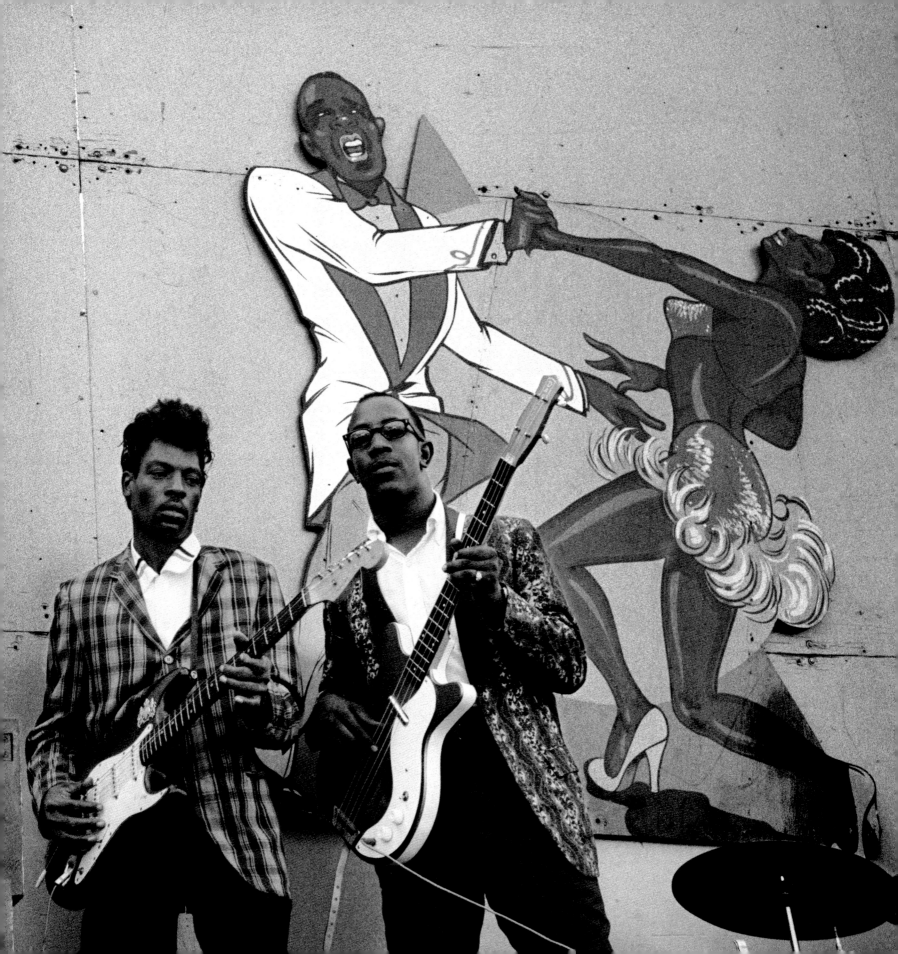

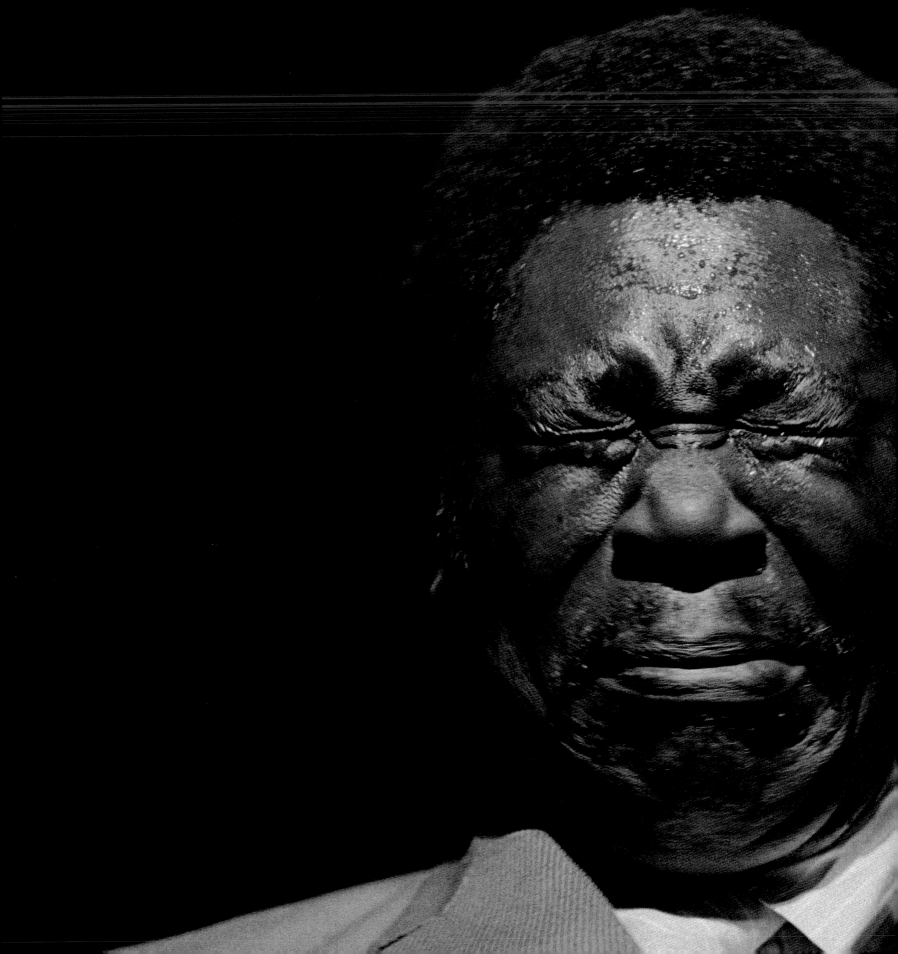

"B.B. King's face mirrors every chord he plays. The man known as the Beale Street Blues Boy is the foremost living practitioner of the form. The blues is, I think, a great American literature that sees the world through the prism of the man-woman thing. It's music that mysteriously dips into the darkest registers yet ultimately sounds triumphant."

As blue as he can be, Sunbeam's Club Paradise, Memphis, Tennessee.

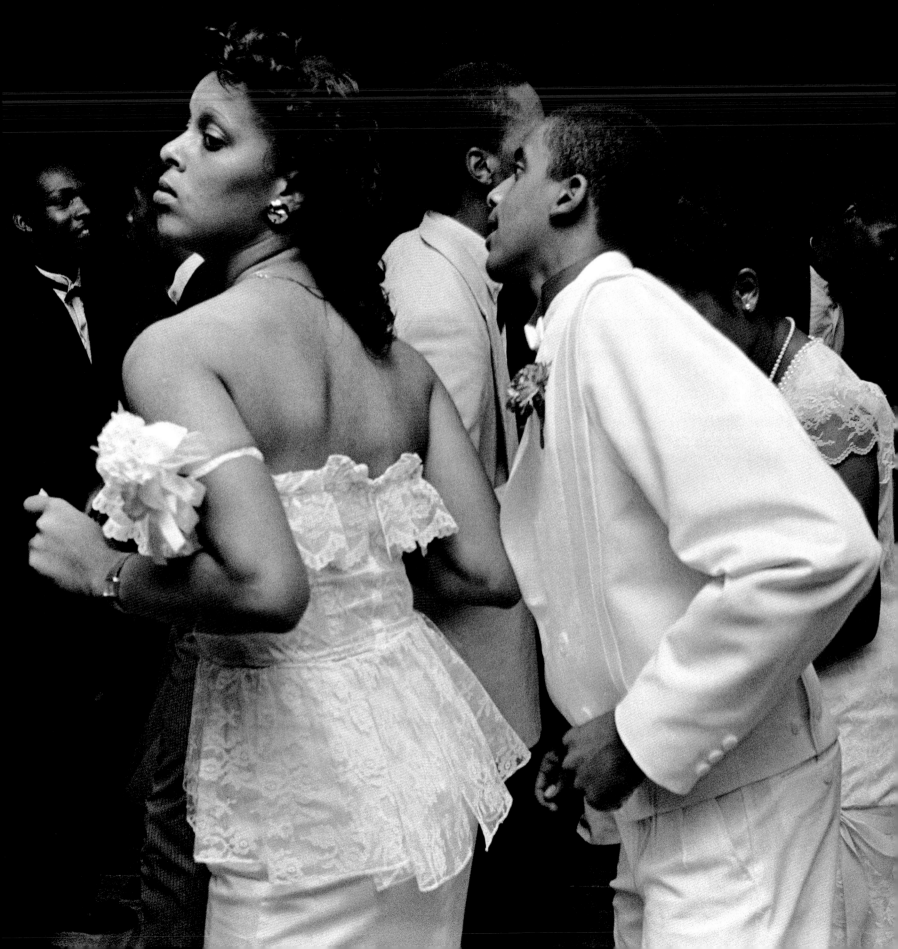

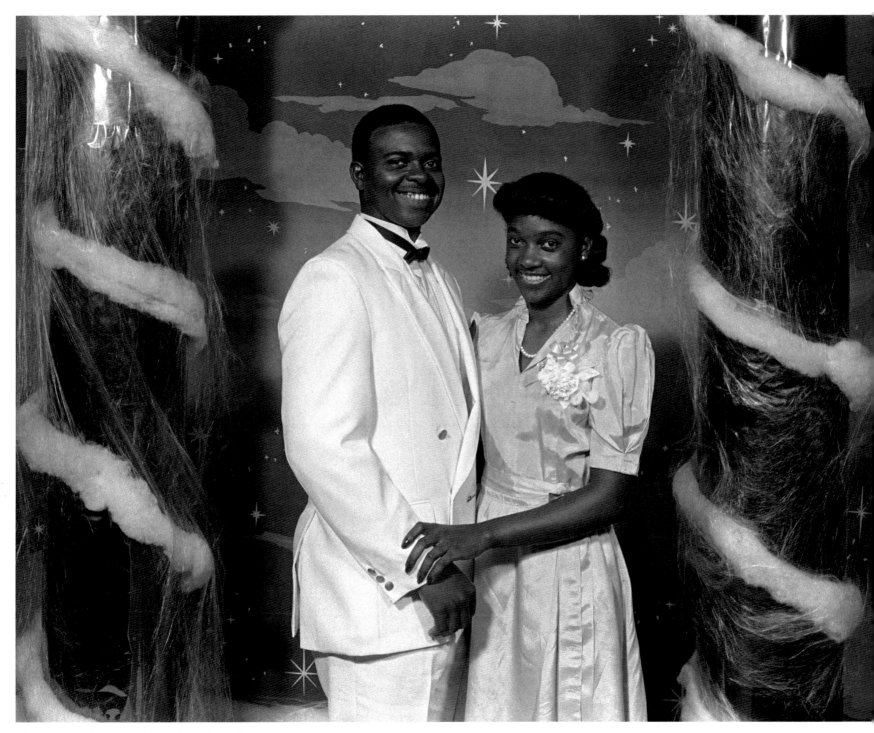

Mighty fine threads on prom night, Blair, South Carolina.

"As elegant and stylish as these graduates look, the real sight to see was the beaming faces of their pleased parents as these kids set off, all dolled up, for the festivities."

Senior prom at McCorey Liston High School, Blair, South Carolina.

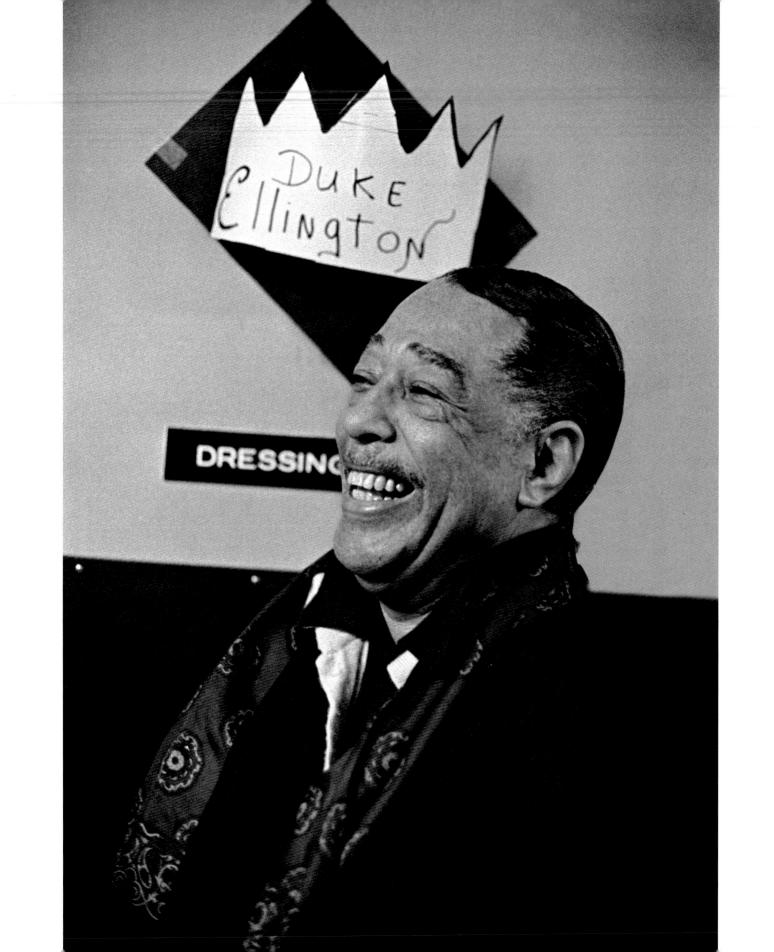

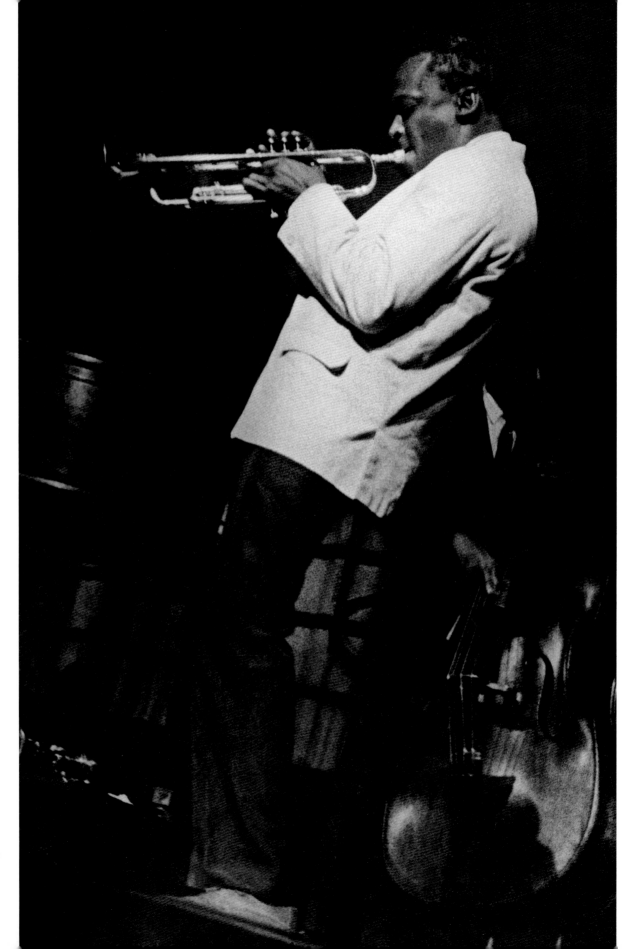

Nonchalantly, the jazz great Miles Davis turns away from the audience at the Village Vanguard, New York City.

Opposite: "I love you madly," Duke Ellington at Madison Square Garden, New York City.

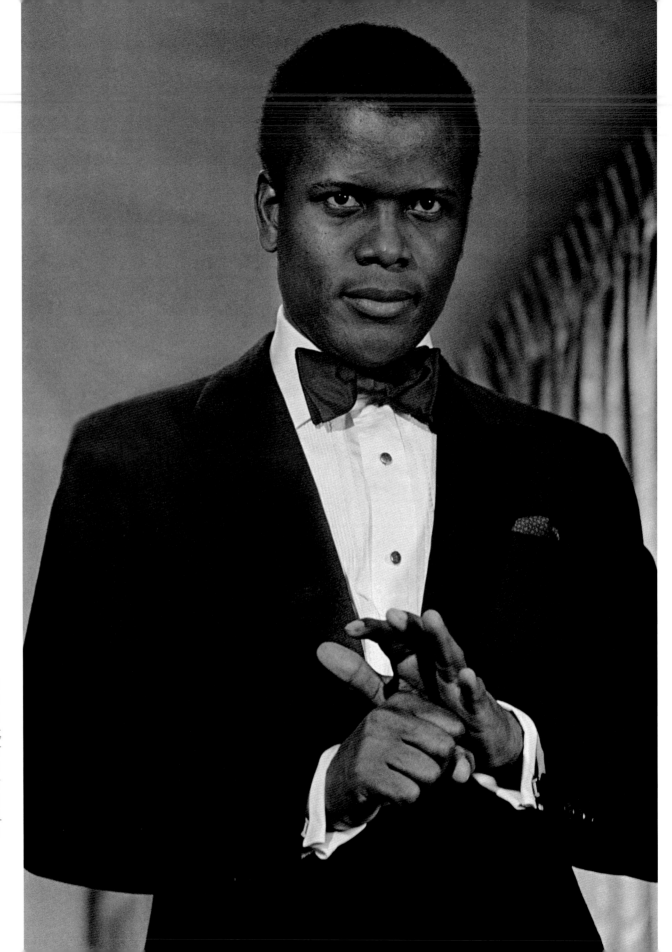

"I photographed Sidney performing in *Ivy*, a movie he also wrote. This same year, he starred in three box office hits: *Guess Who's Coming to Dinner*, *In the Heat of the Night* and *To Sir With Love*. Sidney Poitier did for the movies what Jackie Robinson did for baseball. Not only could they play with the best, they were the best. And they made sure that the doors they opened stayed open."

At the top of his game: Sidney Poitier on the set of *For Love of Ivy*, New York City.

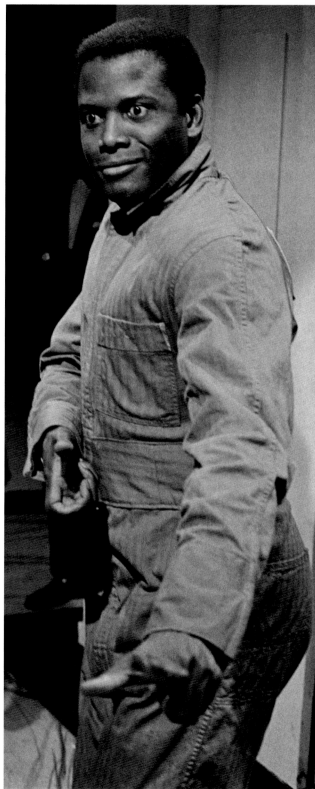

Poitier joins Abbey Lincoln in a love scene in *Ivy*, then clowns around on the set, New York City.

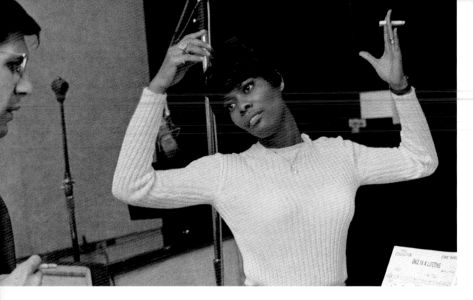

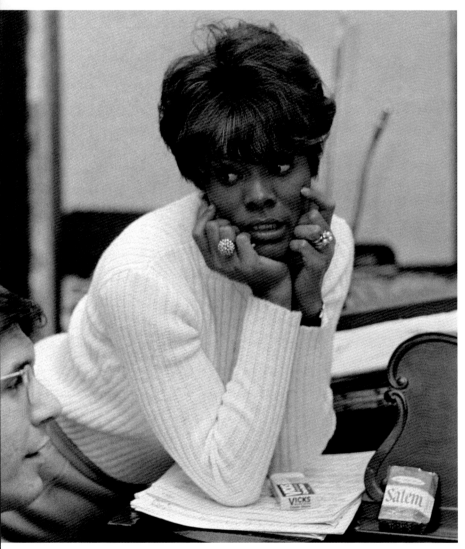

Dionne Warwick rehearsing with musicians, New York City.

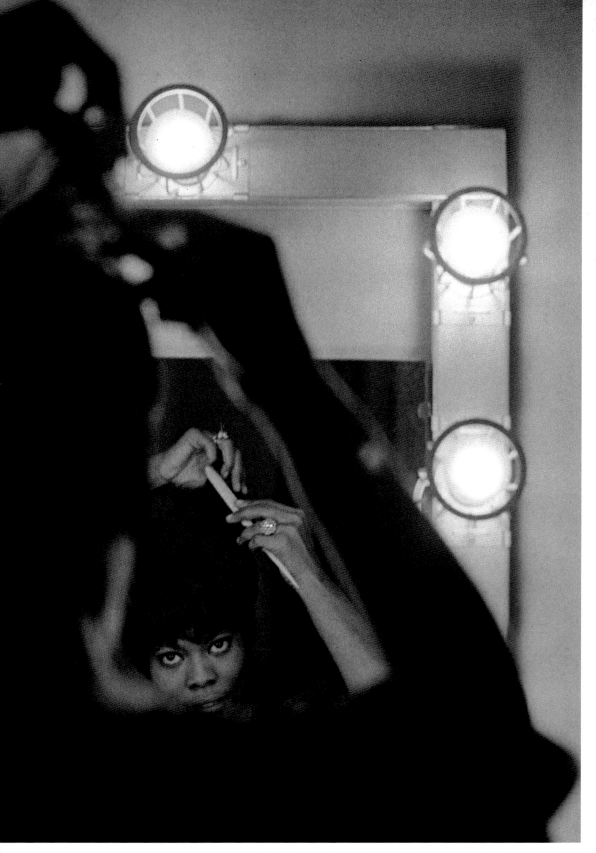
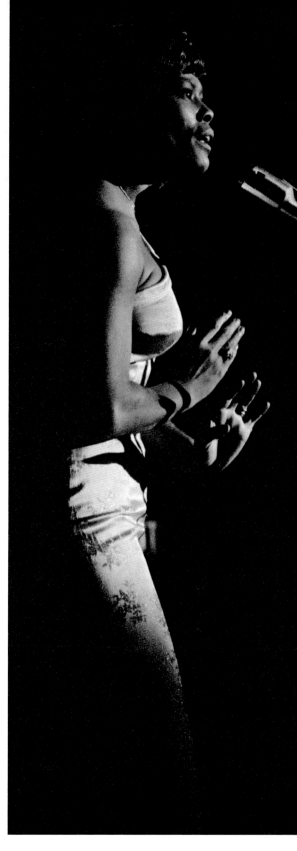

But beautiful: Warwick primps and then wows an audience, Washington, D.C.

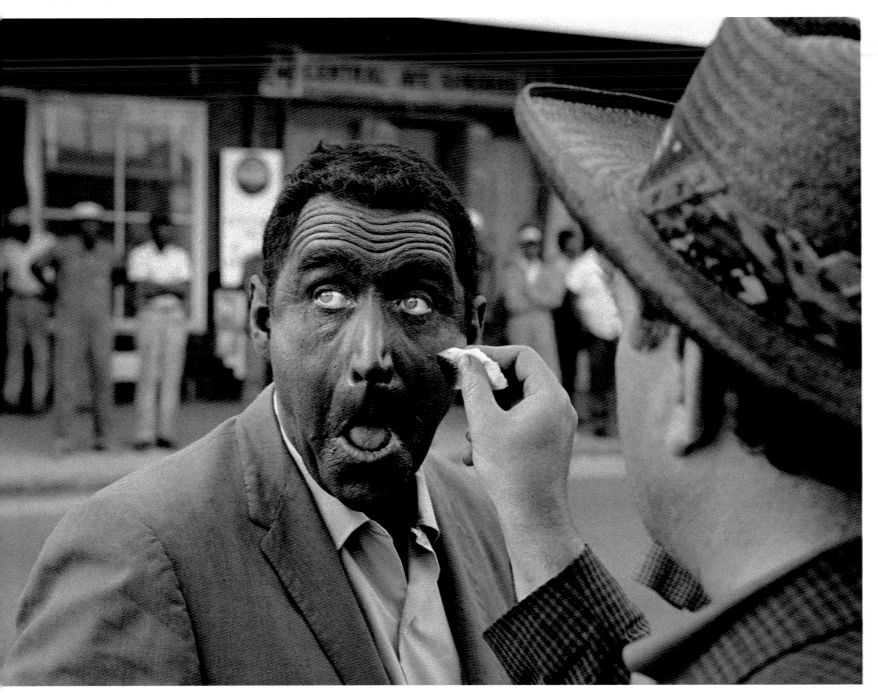

James Whitmore filming *Black Like Me*, Tampa, Florida.

"For many people in America, the book and then the film *Black Like Me*, in which a white journalist traveled the South in blackface, learning what it was like to be black in a segregated land, was a revelation. Many whites had no idea of the daily indignities and the constant strain visited by racism. Today blackface is rightly taboo. But Fred Astaire's homage to the great Bojangles and *Black Like Me*—those are the exceptions to that rule."

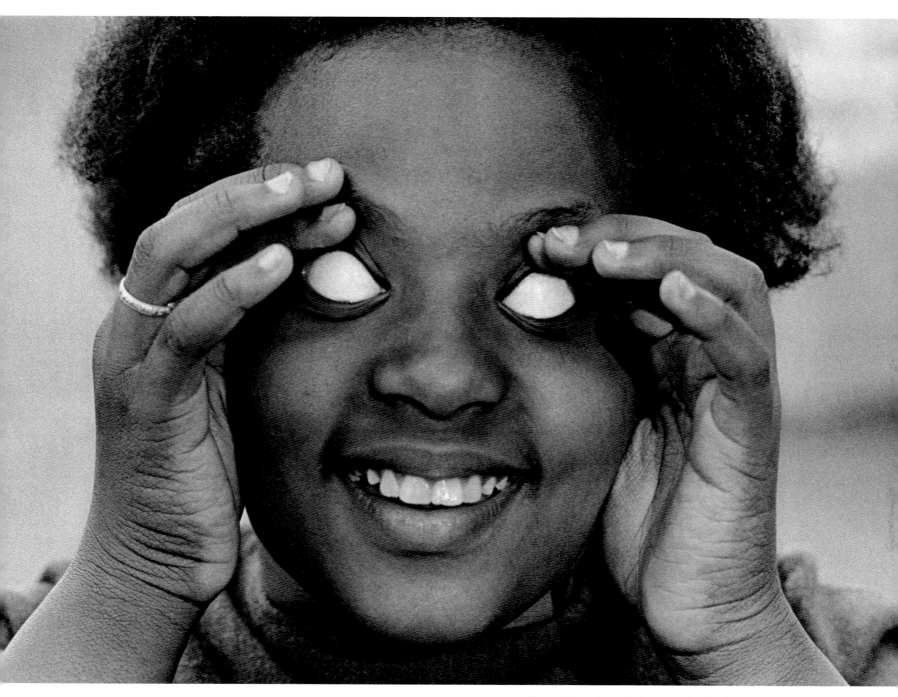

Playing "Statue," a girl makes a face that breaks up her playmate, New York City.

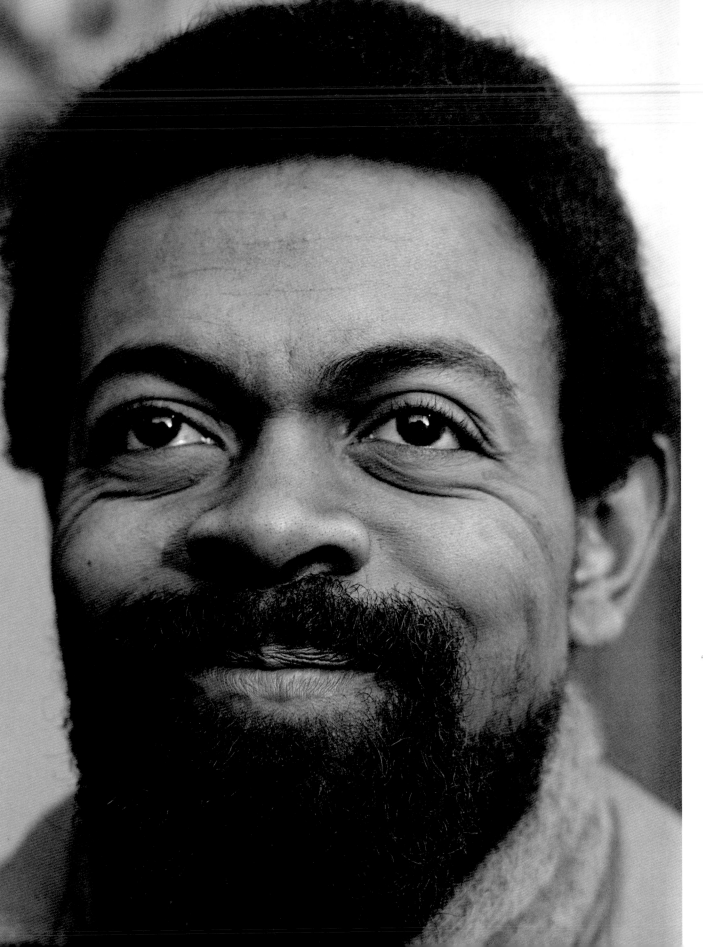

"Gifted poet, brilliant essay-ist, startling playwright Amiri Baraka, who I knew as Leroi Jones in his youth, has spent his life searching for the answers to the problems of African Americans—a search for systematic answers to bedeviling questions. His quest led him to Black Nationalism and, later, Scientific Socialism."

Soul on fire: Amiri Baraka, Harlem, New York City.

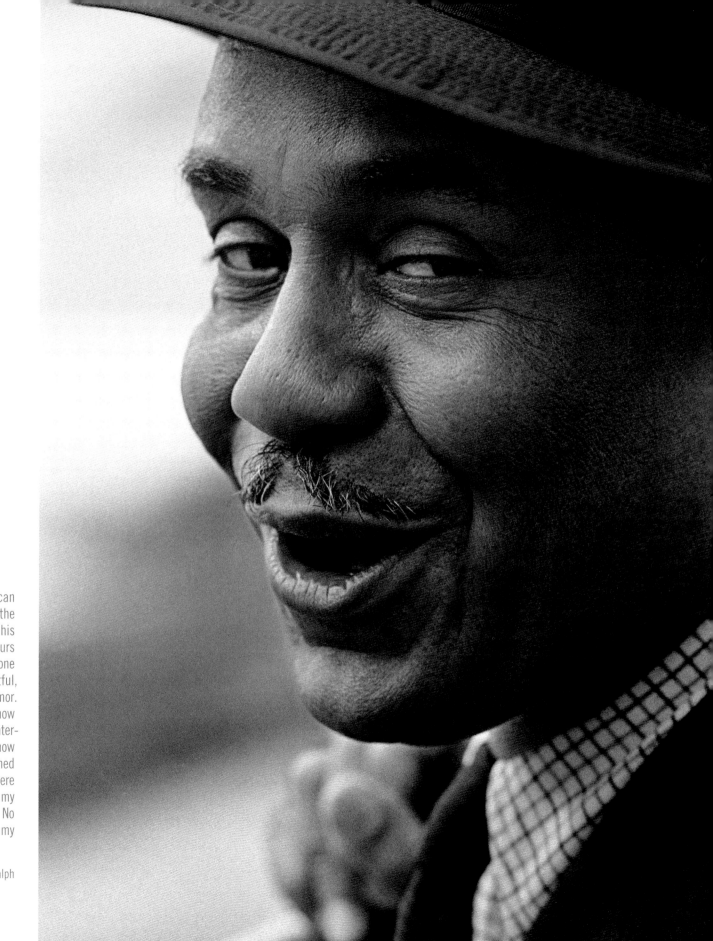

"Ralph wrote the great American novel, *Invisible Man*, and I had the good fortune to benefit from his wisdom through many, many hours of great talk. I never met anyone more intelligent and insightful, or with a better sense of humor. Ralph understood brilliantly how black and white cultural life intertwined, and he recognized how much that interaction enriched American life. His insights were so powerful, they transformed my vision and my photographs. No one in my adult life influenced my thinking more."

Master of them that know: writer Ralph Ellison, Harlem, New York City.

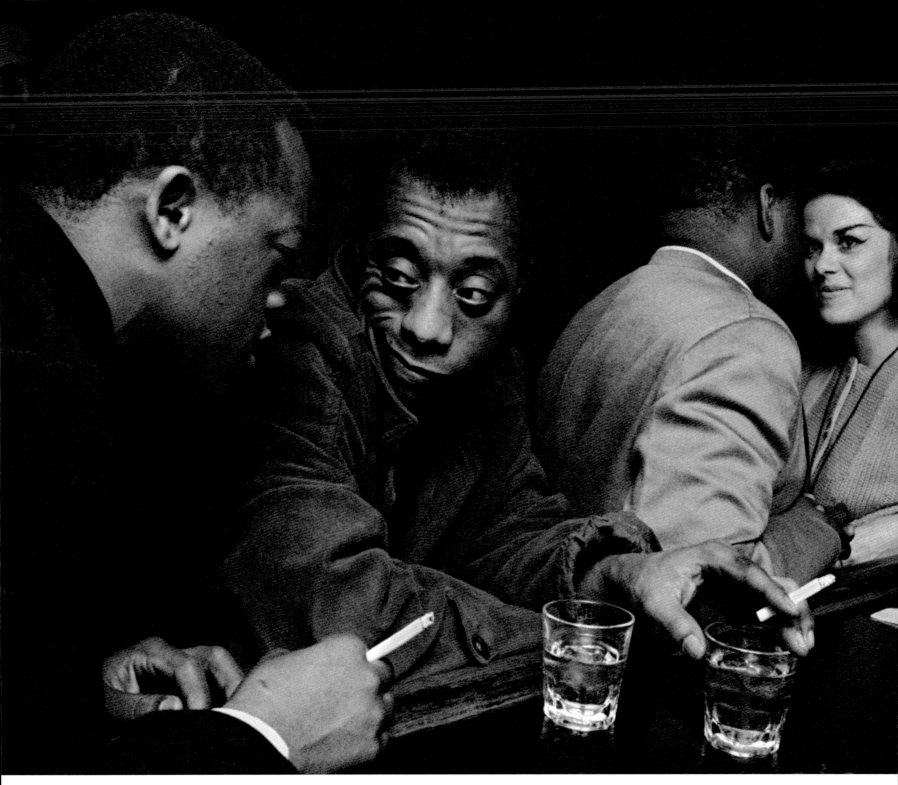

James Baldwin having a drink with his brother at a Broadway bar, New York City.

"Many who saw Jimmy on television remember him as a scold. But if you knew him, he was the most tender, affectionate friend. He warned America that we were on the brink of racial chaos and we must find our way back to each other—hopefully through love. He could preach. And could he ever write. In a not-totally-sober moment, he confided that he became a writer because he thought he was ugly: The only way he could communicate with people was if they didn't see him. Paradoxically, he became one of the most visible writers in the world, and nobody appreciated the irony of that more than Jimmy."

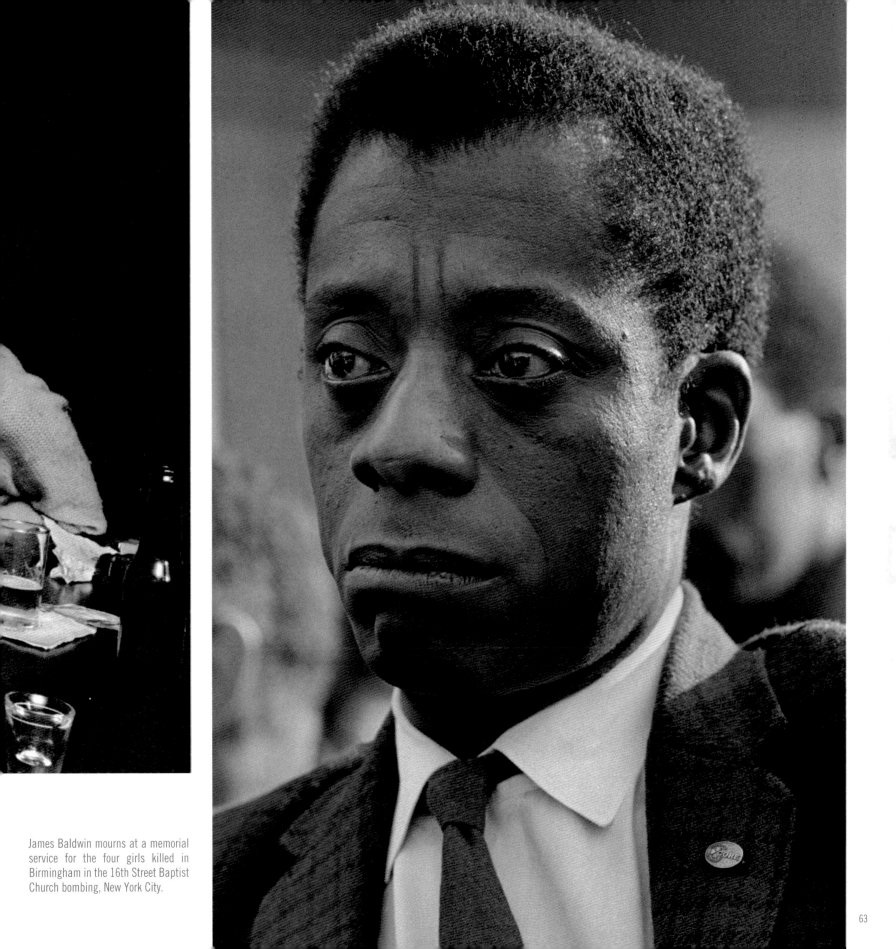

James Baldwin mourns at a memorial service for the four girls killed in Birmingham in the 16th Street Baptist Church bombing, New York City.

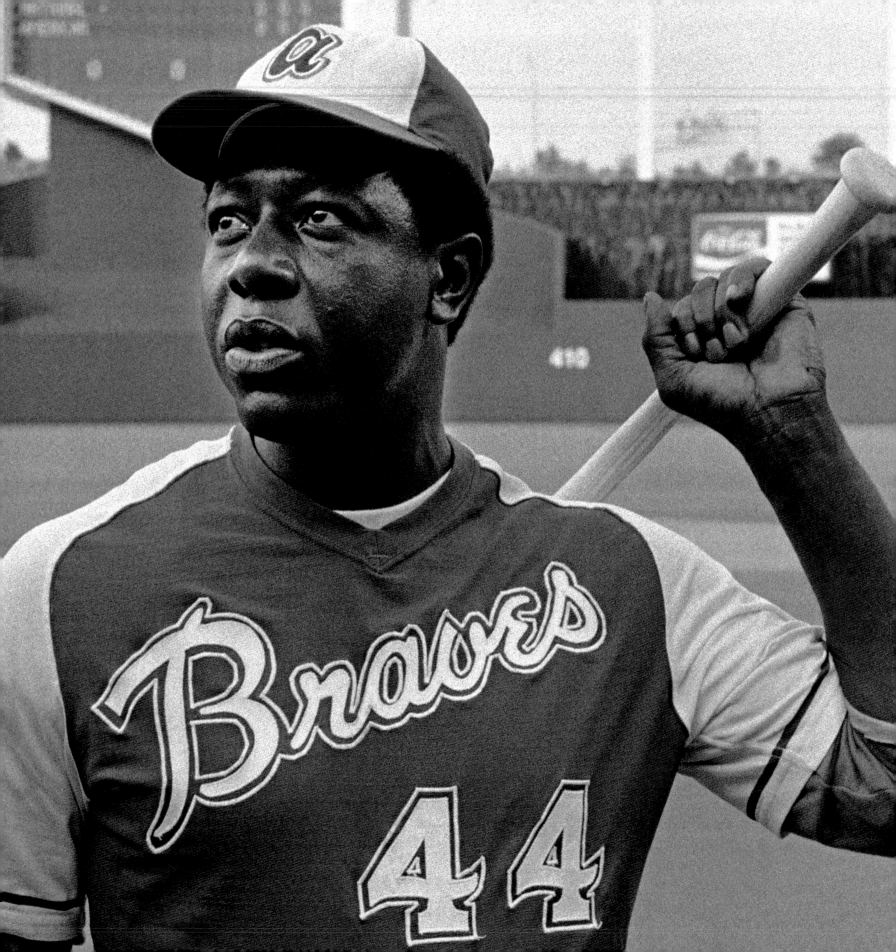

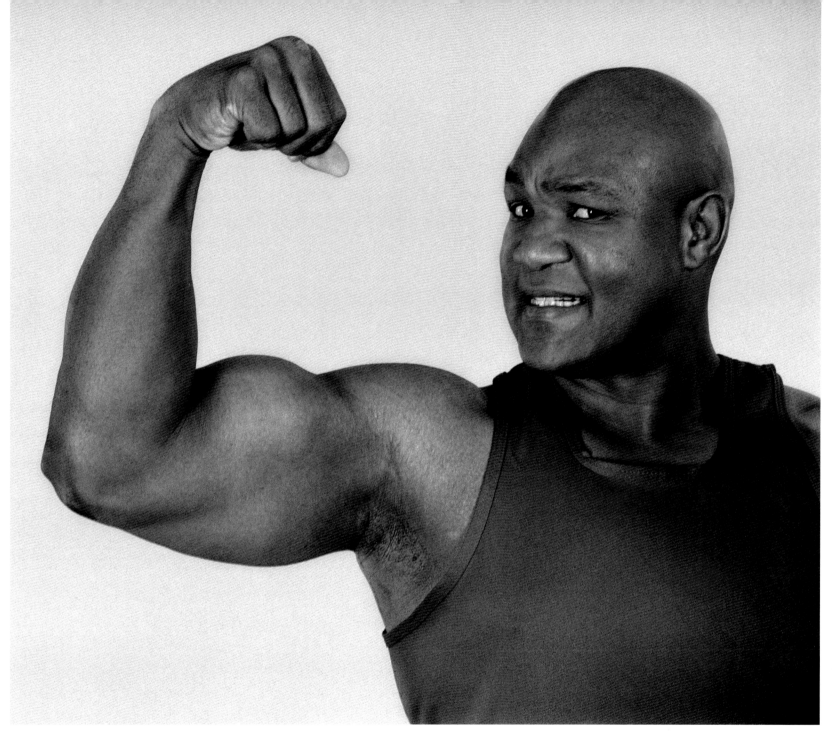

The Champ: heavyweight boxing champion George Foreman, New York City.

"During a break, Foreman told me that he was saved by a 'benevolent society.' He had been doing poorly in school and was getting into trouble. Fearing police were looking for him, he hid under his family's home and covered himself in sand, breathing through a straw. There had to be a better way. His salvation was a government-sponsored anti-poverty boxing program that led to his Olympic gold medal."

The Slugger: baseball great Hank Aaron at the All-Star Game, Kansas City, Missouri.

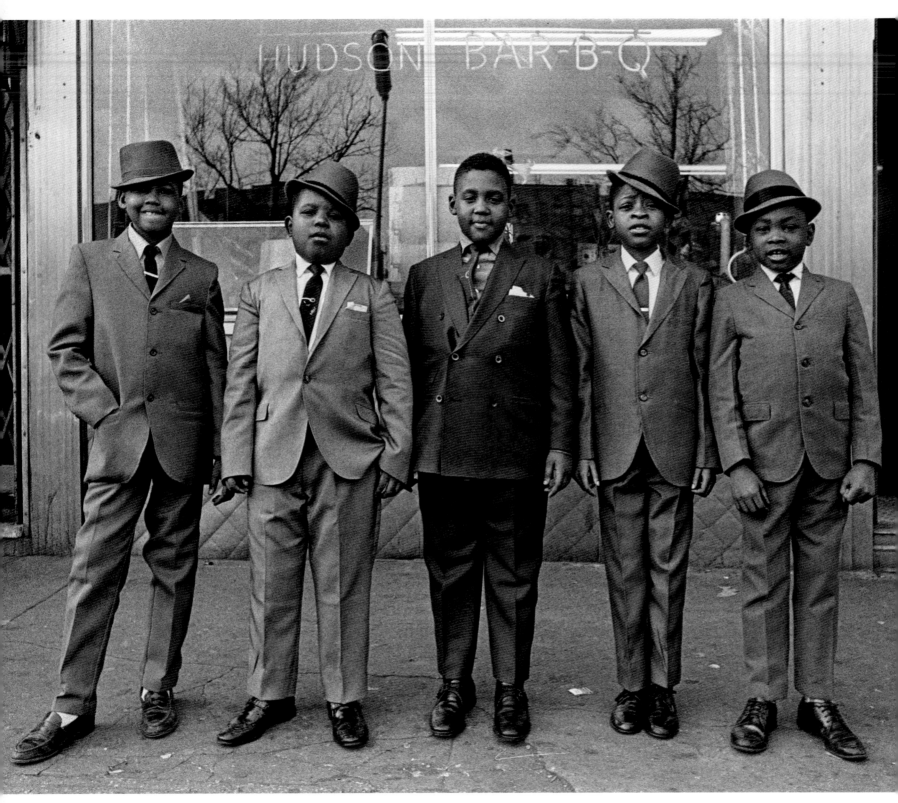

Boys to men, Easter Sunday, Harlem, New York City.

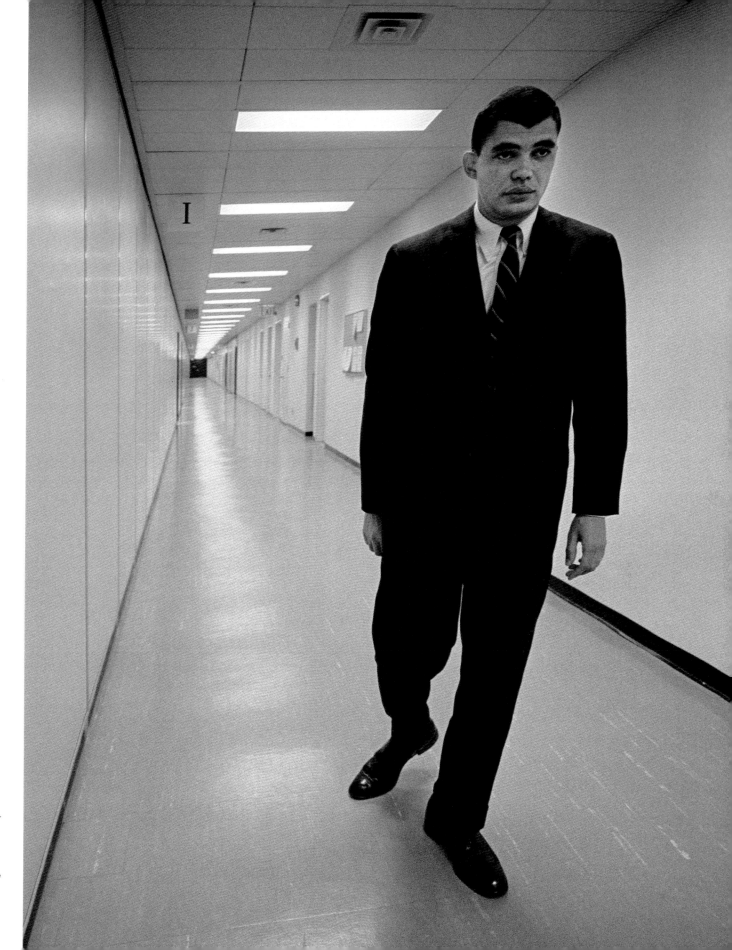

Corridors of power: Lionel M. Stevens joins a growing cadre of savvy young black executives at a Wall Street firm in the wake of the Civil Rights Movement, New York City.

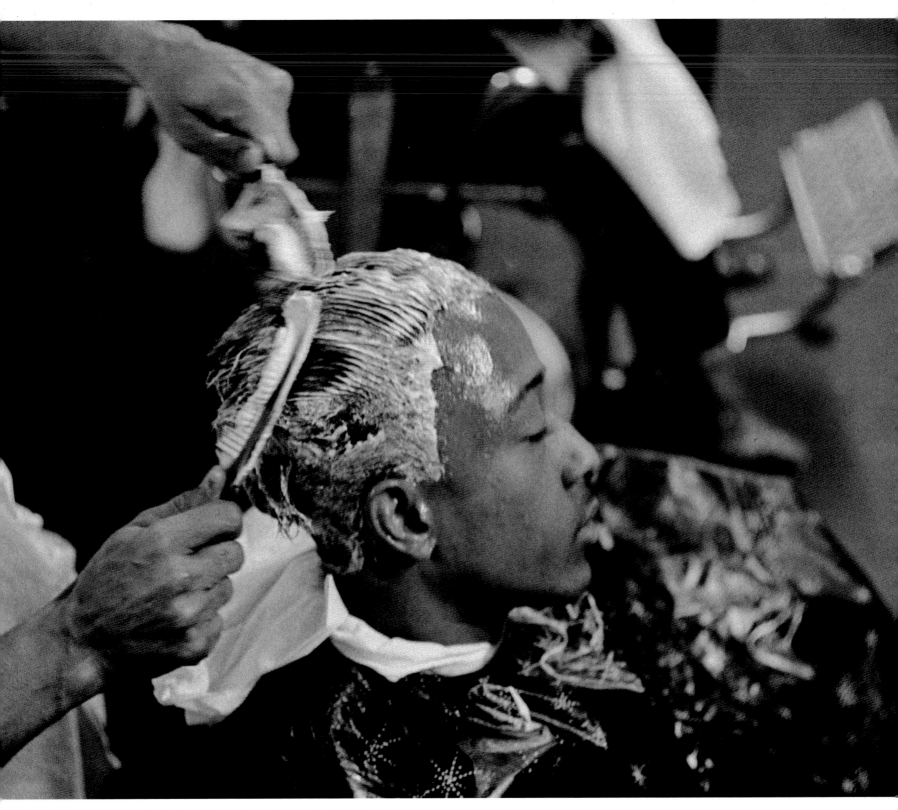

Styling: A barber conks, or chemically straightens, his client's hair, New York City.

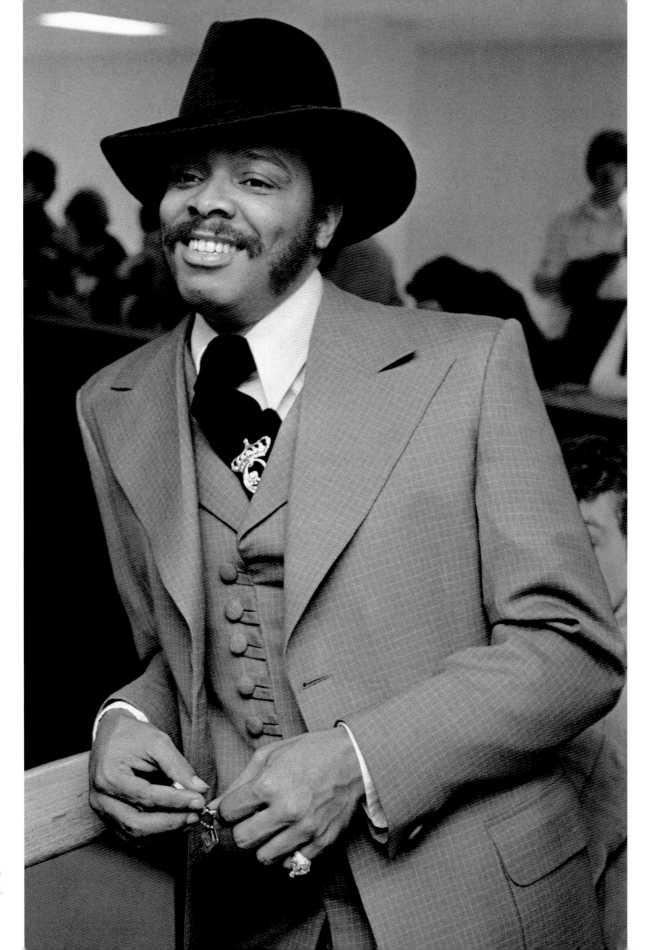

Fly, at Kennedy
Airport, New York City.

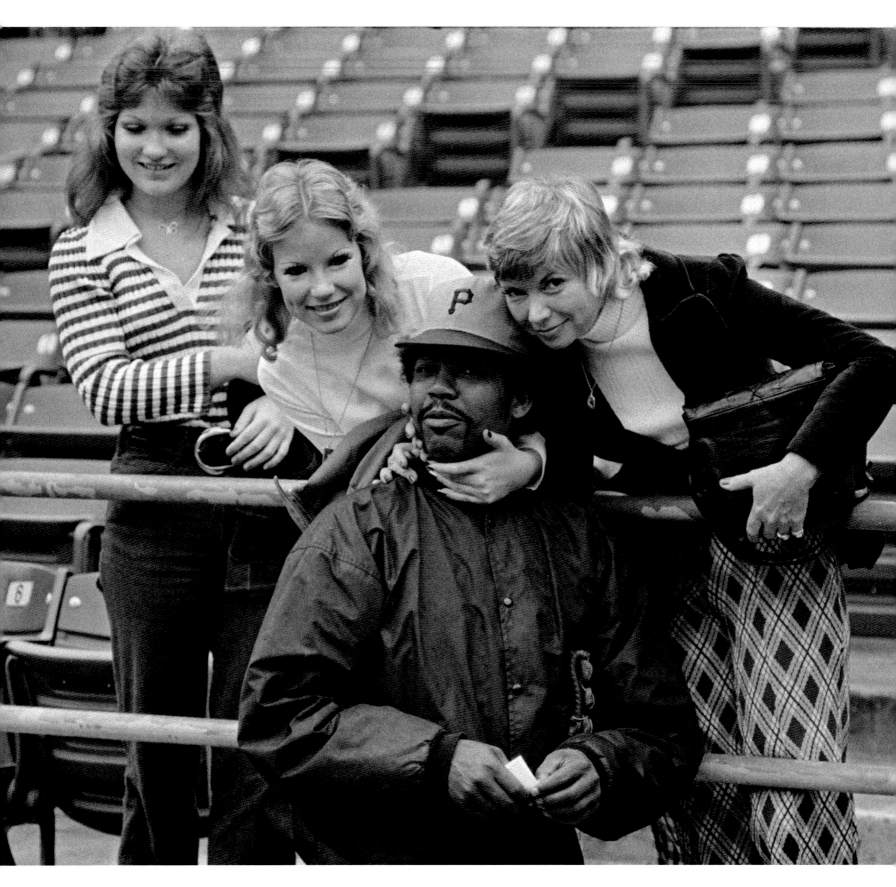

"Silky," a pimp, with his "stars," New York City.

"Why would a pimp who leeches off women end up as a popular culture hero? The illusion persists that there is some effortless way to make it to Easy Street. And in a world of one-parent families, a man who is getting it over on women may appear enviable. Outlaws can look like heroes to the young and rebellious. Maybe that's why a good deal of the pimp's lingo and myth and style permeates hip-hop. This isn't brand new: Americans have been for generations listening to music, dancing, dressing and talking with expressions that started on the street. Jazz was first played in bordellos, jitterbugging and zoot suits came up from the underground. Chump change, a Wall Street expression, originally referred to the kind of money an unsuccessful pimp made."

Celeb: Fans pose for a photo with Pittsburgh Pirates pitcher Dock Ellis before a game at Three Rivers Stadium, Pittsburgh, Pennsylvania.

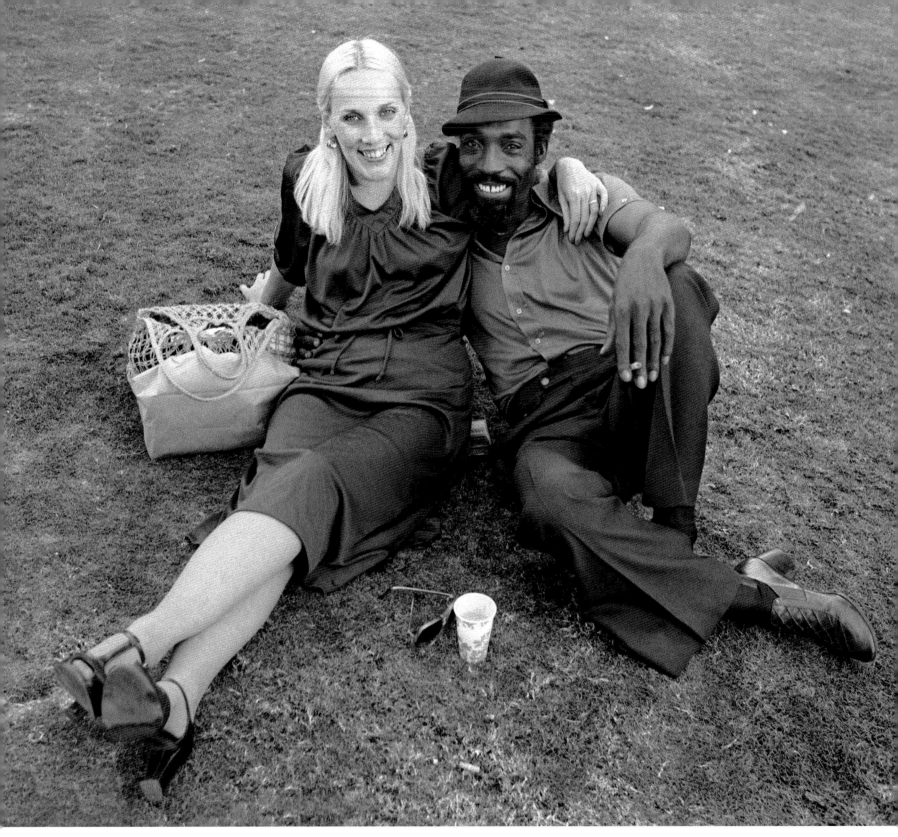

Married couple, Atlanta, Georgia.

"This happy pair met and married when he was in the U.S. Army stationed in Germany. The husband told me, 'Had we been married and living here in Georgia 25 years ago, I would've been hanging from a lamppost.'"

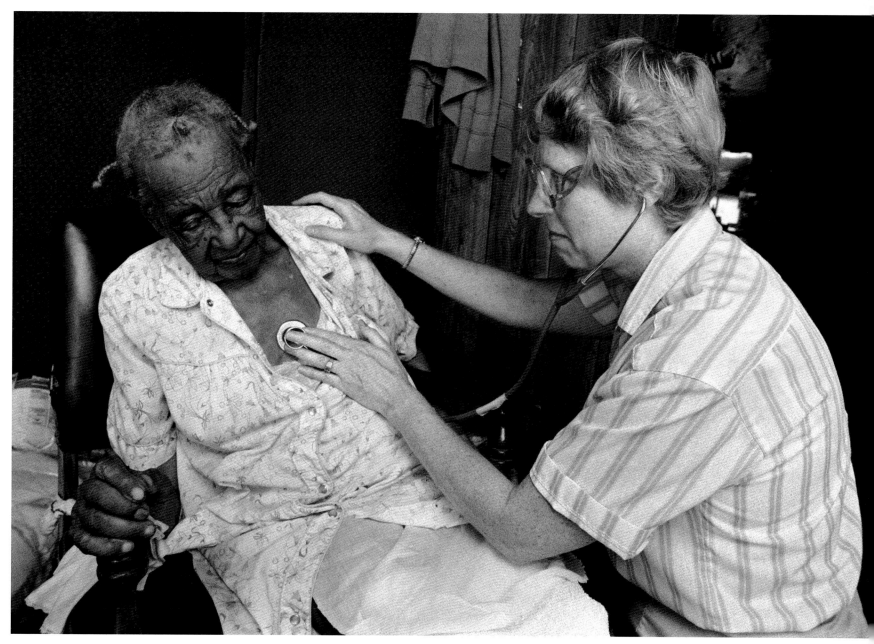

Alabama's Mother Teresa, Pine Apple, Alabama.

"This Mother Teresa is, in fact, Dr. Roseanne Cook, who is also a nun. She sees 30 patients a day at a free clinic then goes to the homes of those with no transport. She offers great care, free medicine, kindness, cheer and sympathy to those who have the least."

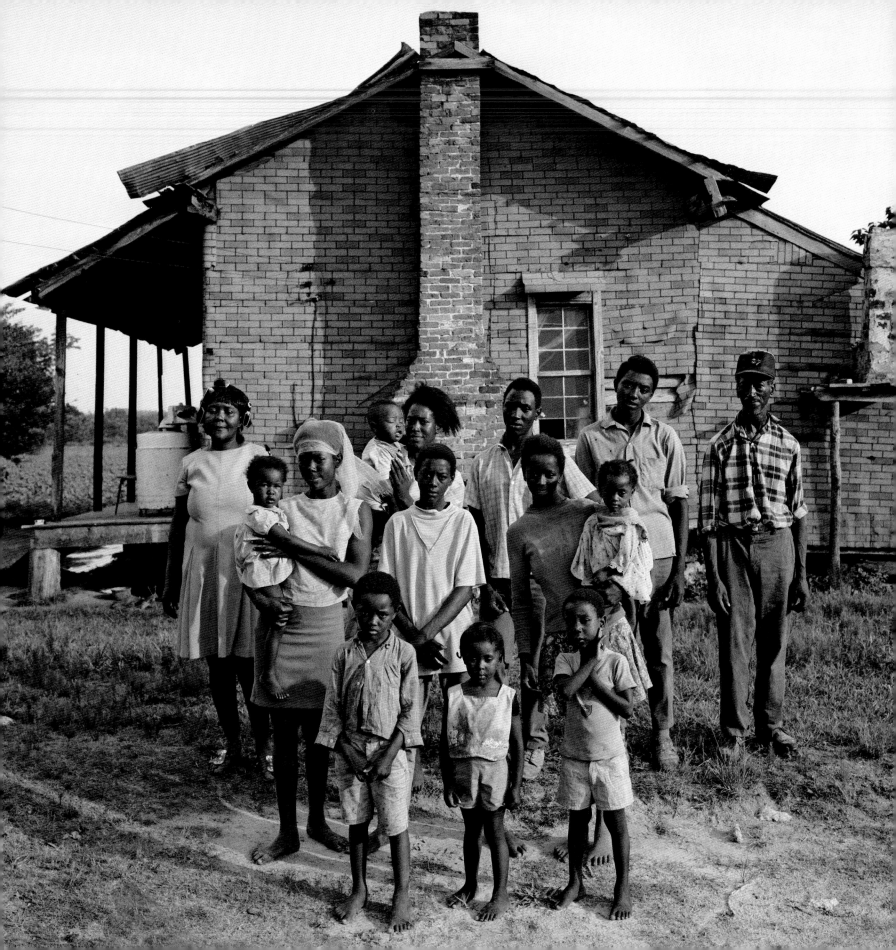

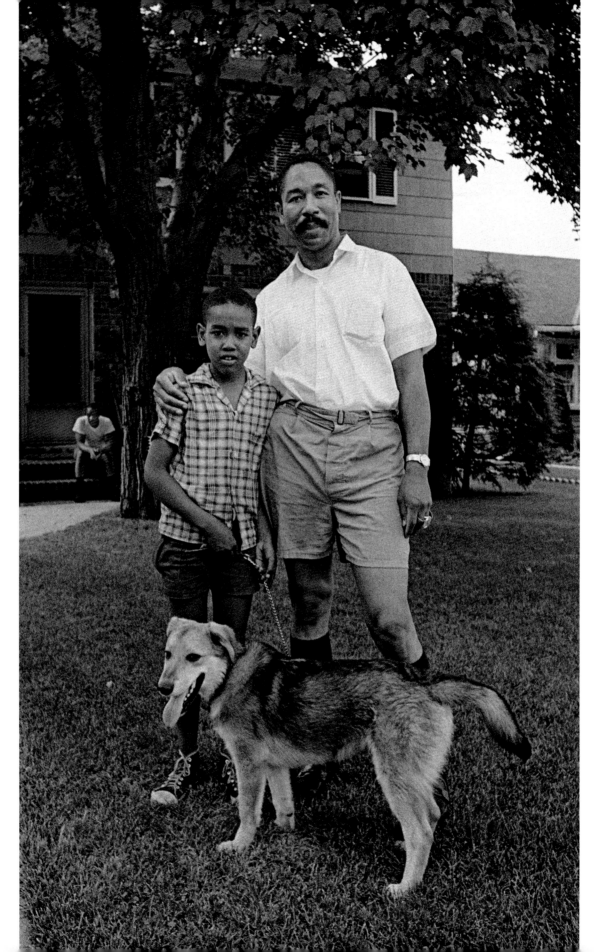

Father and son, Queens, New York City.

Opposite: Three generations of tenant farmers, Millers Ferry, Alabama.

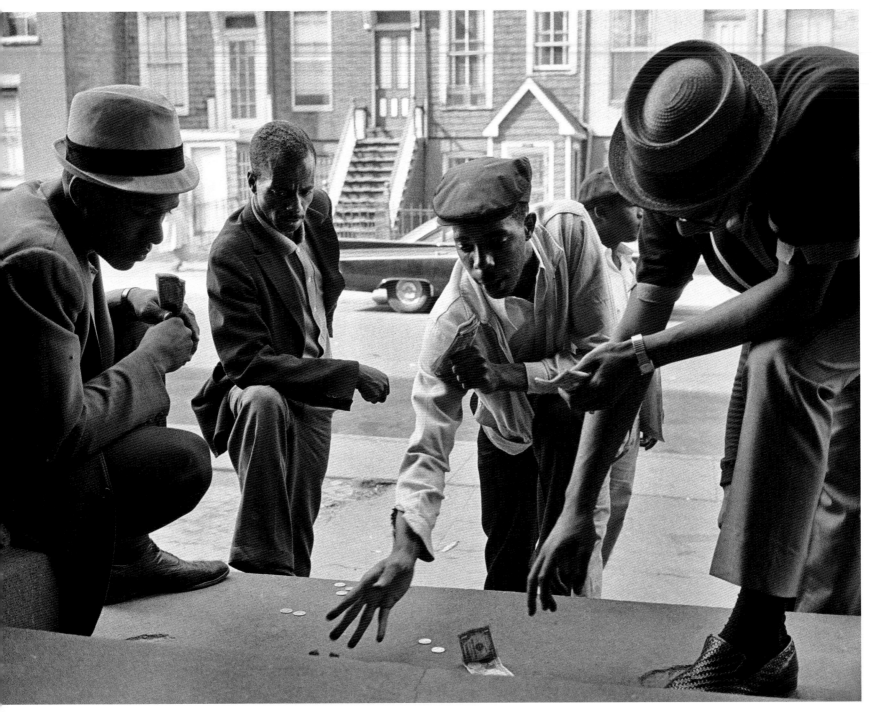

Shooting craps, Brooklyn, New York City.

"In central Harlem at this time, an unemployment rate of one out of every four men was not uncommon. Limited skills, poor schooling, racism, a downturn in the economy and the employers' preference for immigrants over blacks were some of the reasons these men were out of work. Often they squatted in abandoned buildings and scavenged for survival. Neighbors might give them errands and little jobs to do in exchange for a meal. Grinding poverty forced many men like these into despair, substance abuse, crime, apathy and rage."

Out of work, out of luck, Harlem, New York City.

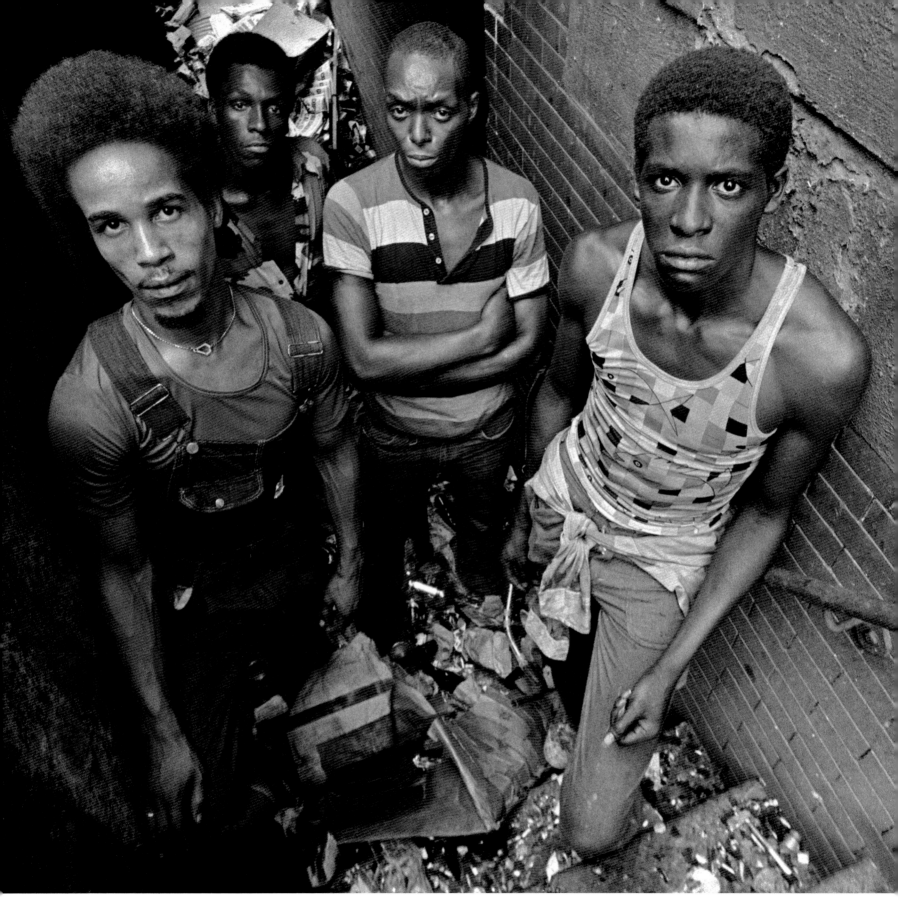

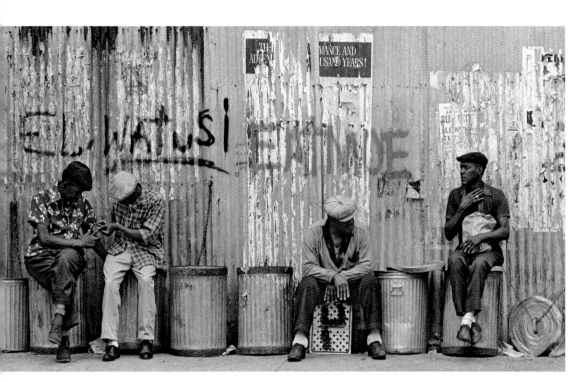

Chewing the fat, Brooklyn, New York City.

"A good deal of socializing is done on the street. Though the image above may look like a scene out of a Beckett play, these cans provide a convenient place to sit and catch up."

"As difficult as the Bed Stuy street might look, it was teeming with life. Twenty years later, I went back and the neighborhood had fallen apart. All the buildings were boarded up and deserted."

The Bedford Stuyvesant ghetto, Brooklyn, New York City.

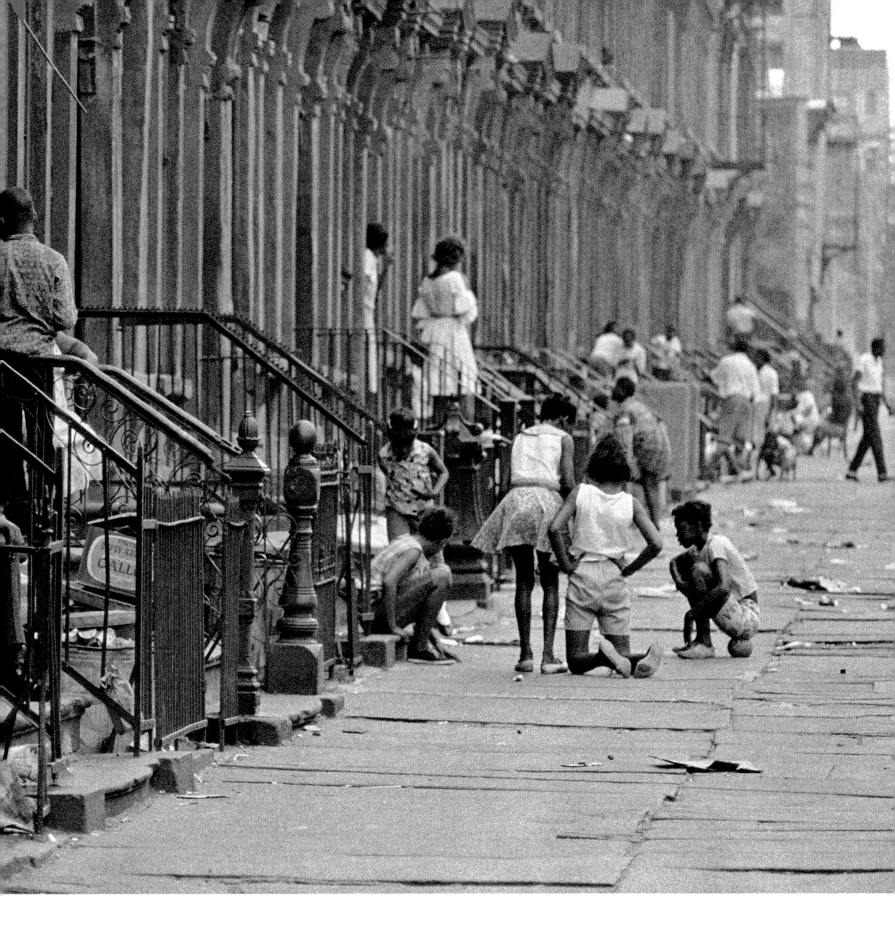

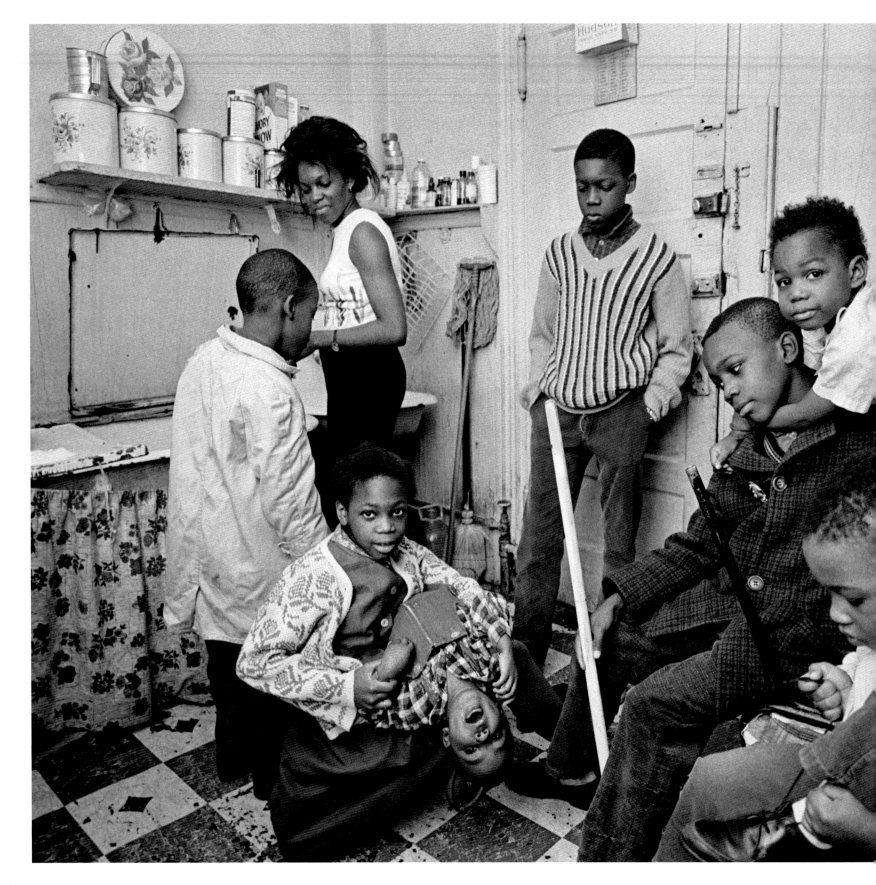

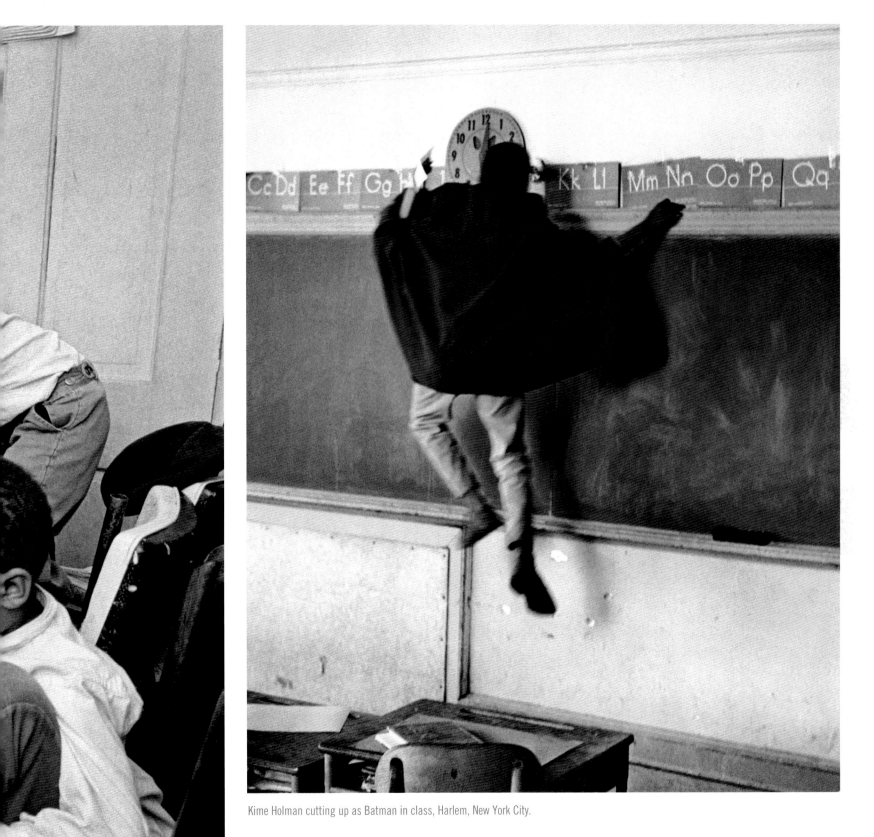

Kime Holman cutting up as Batman in class, Harlem, New York City.

Eartha Holman, a single mother on welfare, lived with her eight children
in a three-room, fifth-floor walk-up, Harlem, New York City.

"I met Kime when I was working on a story called 'Life Without Father.' He was nine, and in school he was a problem. What he craved was attention. With so many children, his mother favored the quiet ones.

"On his own when he was finishing grade school, he wrote to many prep schools that he was poor and black and afraid he might not make it because of all the drugs and violence in Harlem. Several schools offered him basketball scholarships and he chose Maine Central Institute because it was the farthest from Harlem. Graduating MCI, he went on scholarship to Boston College.

"Today he's a men's fashion designer with his own company in New York. For many years now, he has been living in a very different Harlem, on Strivers' Row, four short blocks from where he grew up. With Kime as a model, almost all of his brothers and sisters made it to college, but two were swallowed up by those mean streets."

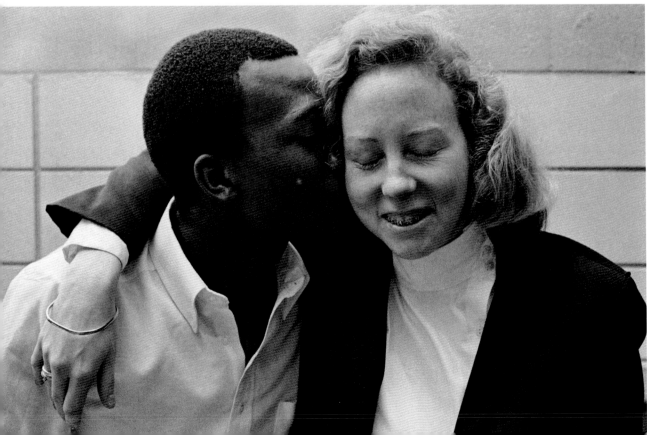

Top: Kime clowns around in the gym at Maine Central Institute, Pittsfield, Maine.

Left: Kime playfully snuggles with an old school chum at a basketball game, New York City

Opposite: Kime graduates from Boston College, Boston, Massachusetts.

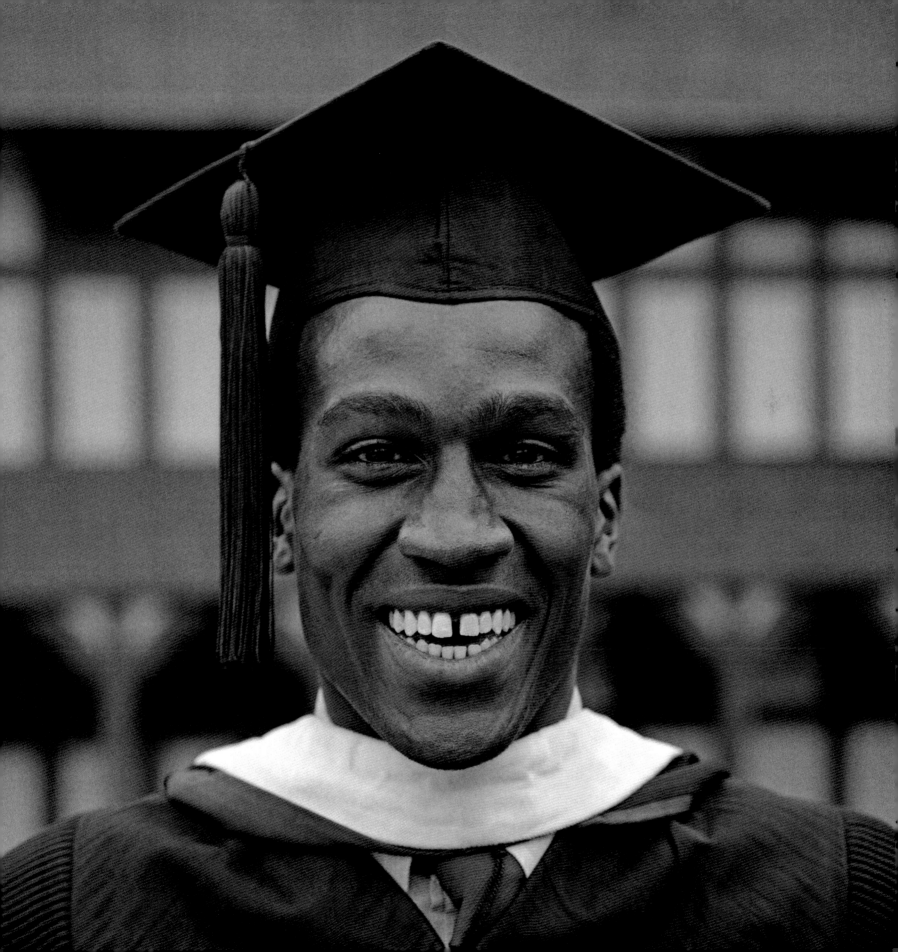

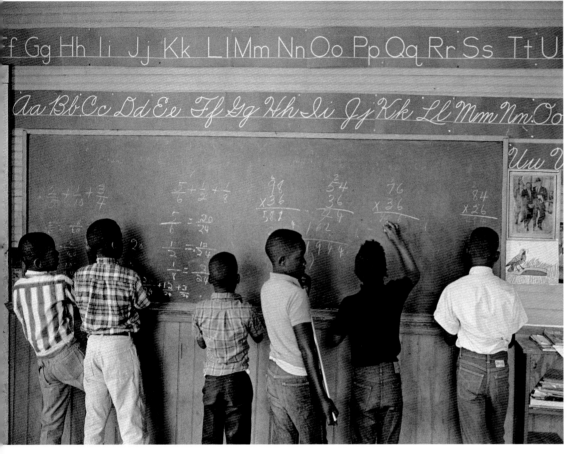

Segregated classroom, Prairie Mission, Alabama.

"Although attempts have long been made to desegregate our schools, neighborhoods largely determine the racial make-up of the classroom, and neighborhoods, especially in large cities, are often not diverse. The rate of integration nationally today is just about the same as it was in the 1960s when school integration was a battleground."

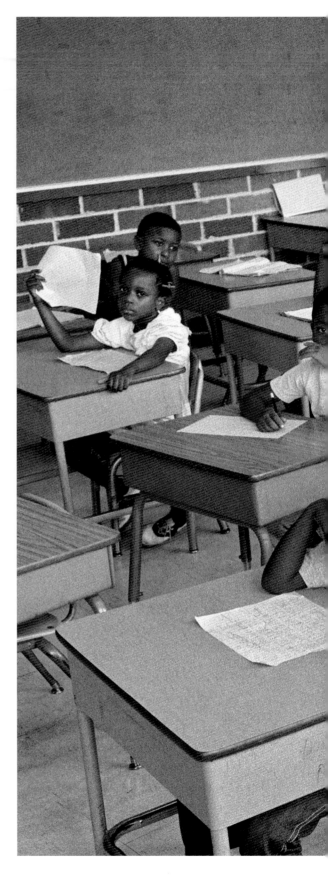

Integrated classroom, Camden, Alabama.

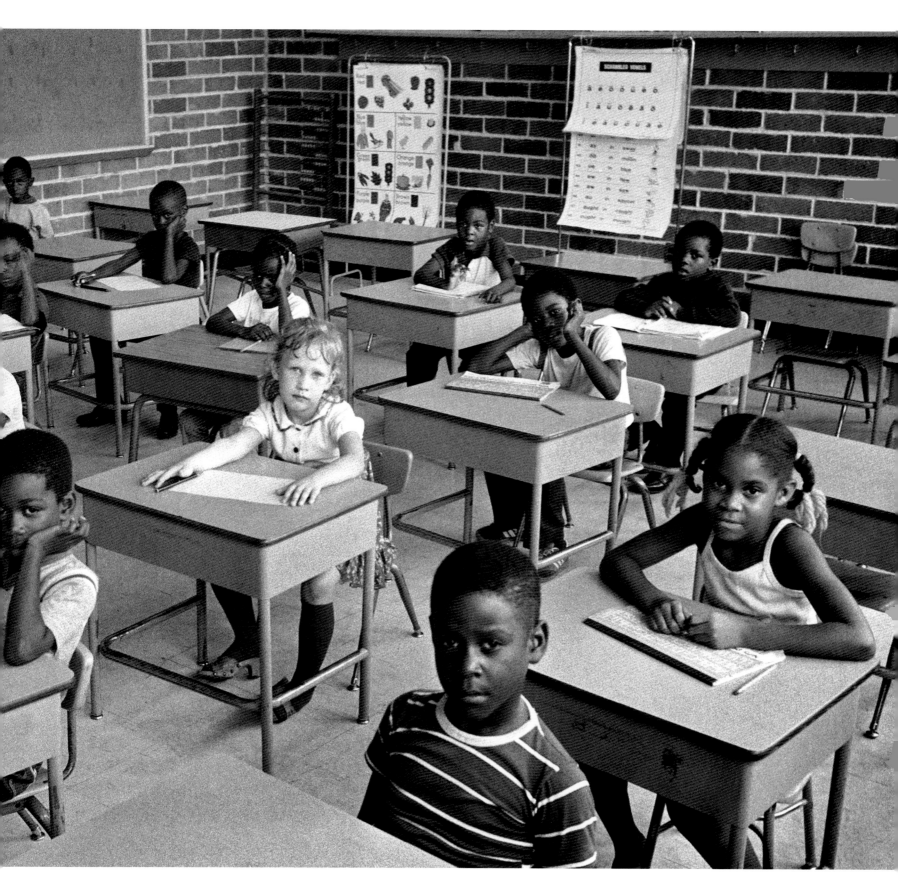

On the National Mall, Washington, D.C.

Classroom, New York City.

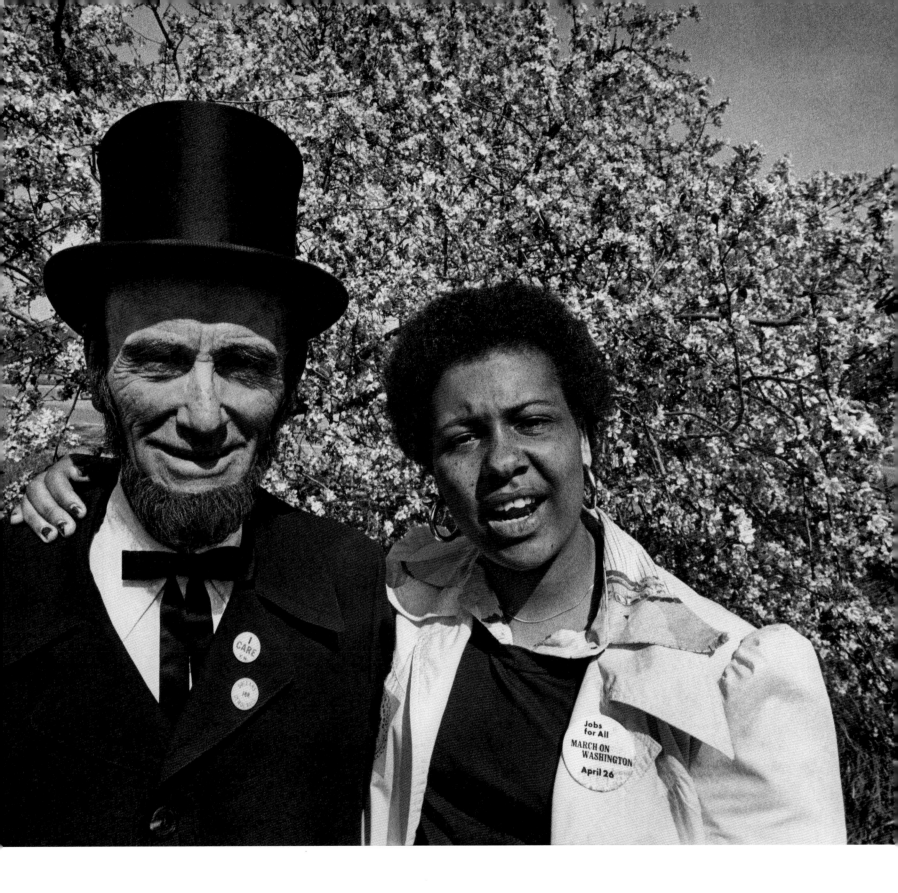

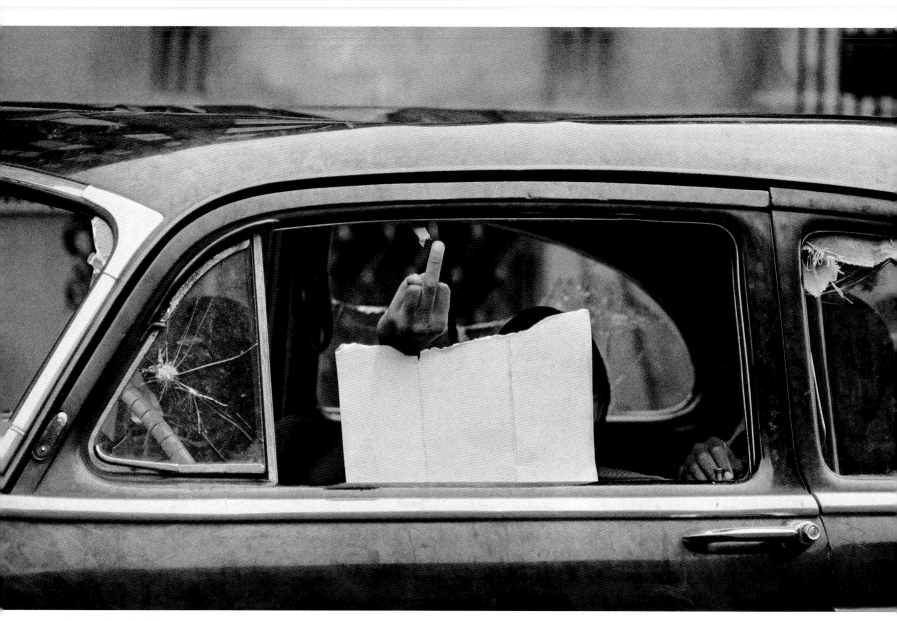

A salute, Brooklyn, New York City.

"When these pictures were taken in the '60s, racial tensions were mounting, and the Civil Rights Movement was front page news on a daily basis. The boy in the car was up to some mischief he didn't want me seeing, and this was his response. My street sense told me he was saying, 'White man, bad enough you put me down. Don't stare.'"

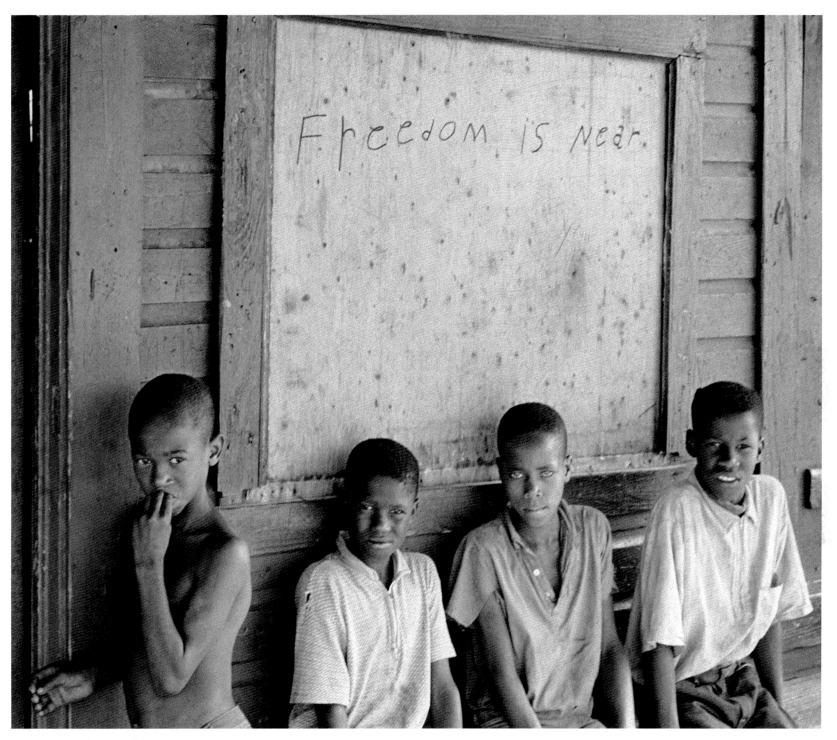

Writing on the wall, Alberta, Alabama.

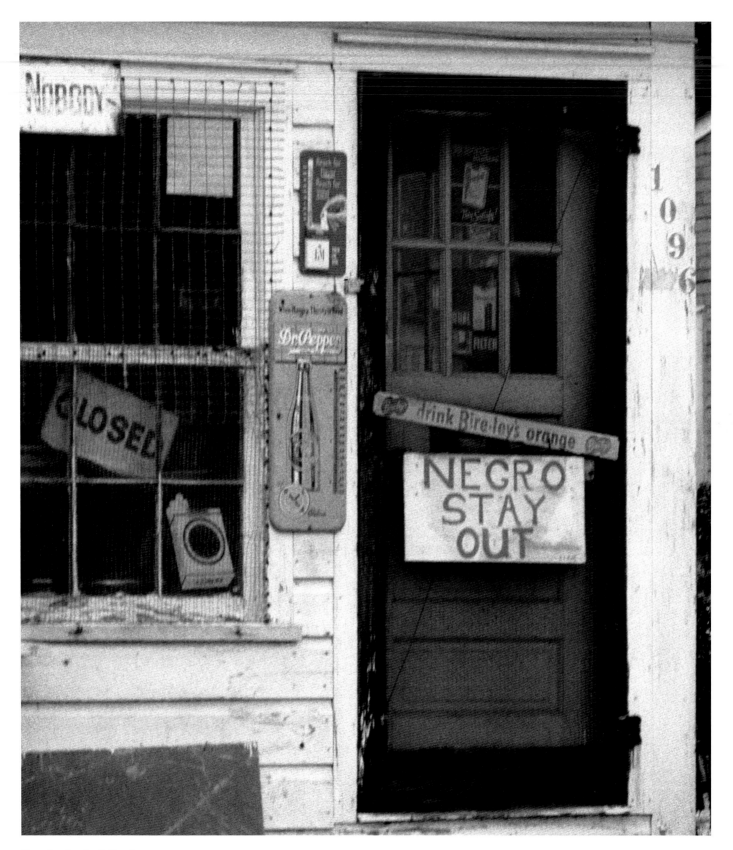

Store, Sumter, South Carolina.

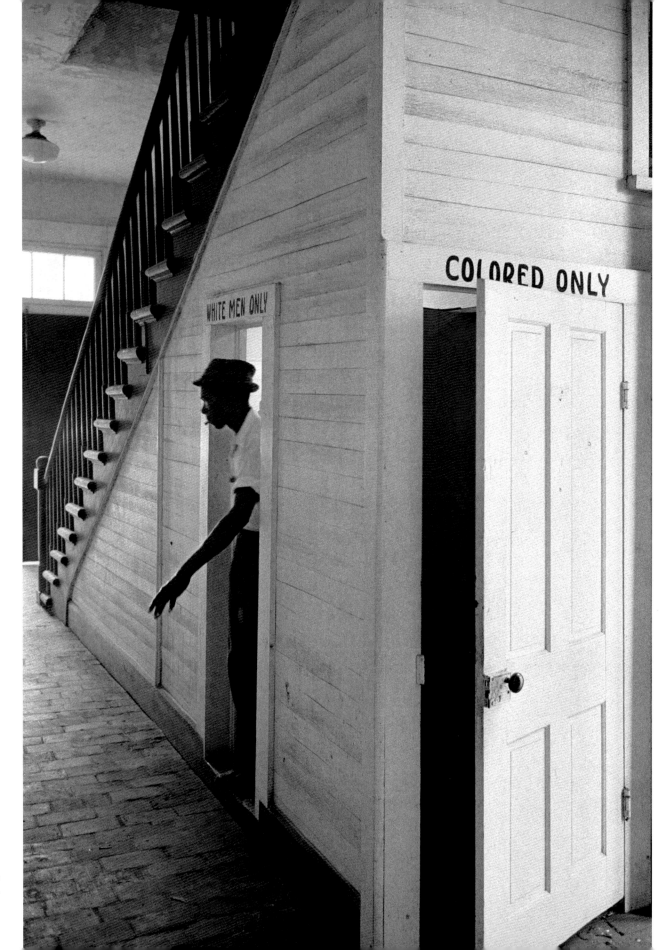

Courthouse,
Clinton, Louisiana.

The Movement

Prologue

Charles Johnson

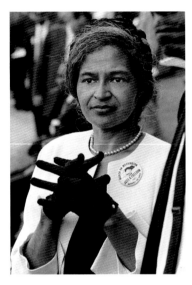

Rosa Parks, Washington, D.C.

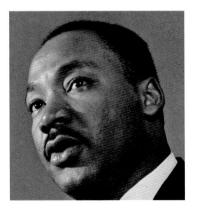

Martin Luther King Jr.,
Montgomery, Alabama.

On December 1, 1955, a year after the U.S. Supreme Court ruled in *Brown v. Board of Education of Topeka* that racial segregation in public schools was unconstitutional, a forty-two-year-old seamstress and secretary of the Montgomery, Alabama, branch of the National Association for the Advancement of Colored People named Rosa Parks refused to relinquish her seat to a white man in the black section of a crowded bus. The brave, pivotal action of this grand woman, her non-cooperation with the ancient and universal evil of racism, unified the fifty thousand black men and women in that city around an epic 382-day bus boycott. Donations and support poured in from across America, as well as from Tokyo and Switzerland.

The boycott also thrust before the world's cameras a twenty-six-year-old Baptist minister named Martin Luther King Jr. who, on January 30, 1956, made good on his promise to those boycotting Montgomery's segregated buses that, "If you will protest courageously, and yet with dignity and Christian love, when the history books are written in future generations, historians will have to pause and say, 'There lived a great people — a black people — who injected new meaning and dignity into the veins of civilization.'"

While King was at a meeting of the Montgomery Improvement Association, for which he served as president, his home was bombed. Rushing back he found his wife Coretta and their baby, Yolanda, unharmed. Outside, an angry, armed black crowd was spoiling for a showdown with white policemen at the scene. The situation was edging toward violence, a repeat perhaps of all the race riots and slave revolts that had occurred for two centuries. Blacks could not ulti-mately win such an uneven contest, for they were but ten percent of the nation's population, and all the advanced weaponry, the sophisticated resources, were

on the side of their antagonists. Knowing this, King raised one hand to quiet the crowd. He said, "I want you to go home and put down your weapons. We cannot resolve this problem through retaliatory violence. We must meet violence with non-violence… We must meet hate with love."

King's Gandhi-esque stance, his agapic vision, resonated 'round the world as something uniquely redemptive in the bloody struggle for black liberation in America. Moreover, one must marvel at the creativity, the stroke of brilliance and balance, that King brought to this situation, for not only did the police confess that he saved their lives that night, but his insistence on non-violence and love made the Civil Rights Movement morally superior to those who opposed it, thereby trumping their greater numbers, wealth and political power. In other words, this social revolution (which as easily could be called evolution) was not simply about desegregating city buses. On the contrary, it was about realizing the loftiest ideals of the human species, ideals that would free black Americans from being second-class citizens, yes, but also free whites from those self-created illusions that led them to violate again and again principles they claimed to have cherished since the Enlightenment (to say nothing of two thousand years of Christian belief in brotherly love). Such idealism made each and every Movement worker, from their eloquent leaders to the anonymous men and women behind the scenes and from all walks of life, like photographer Bob Adelman ("PhDs and no Ds," as King once put it), a patriot in the truest sense of that word. Unable to "wait" for freedom, as whites had been telling them to do for a hundred years, they understood on the deepest level that their great sacrifices would realize the Founders' unfulfilled promises from that first Revolution of 1776 and complete the long unfinished business of Reconstruction. For King, it promised to usher in an era of the "beloved community."

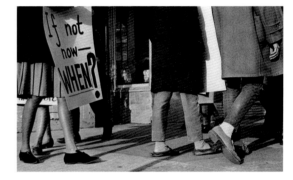

Picketers, Long Island, New York.

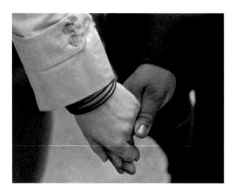

Martin Luther King Jr.'s funeral, Atlanta, Georgia.

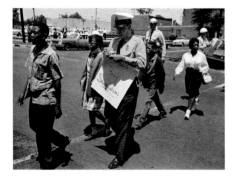

An arrest, Birmingham, Alabama.

One can see this historically conscious conviction, the certainty of the righteousness of their humanist crusade, in the photographs of students in Congress of Racial Equality workshops developing the skills necessary for non-violent resistance. In a way, they are as much artists as the rural basket weaver and famous black musicians at the Apollo, for they have imagined the truly *un*imaginable, what a new social world might *be*, and through their genius developed the flexible, spiritual and imaginative strategies necessary for its realization. They also had tremendous faith, for who could say with certainty where their actions would lead?

So the idealists picketed and marched. Risking their lives, they dared to register to vote, claiming their constitutional right to the franchise. They lay down in front of trucks operated by concerns that refused to hire people of color. They endured severe beatings from mobs, insults, and in massive numbers willingly allowed themselves to be arrested—the Children's Crusade that filled to overflowing Birmingham's jails is particularly notable and controversial, for King and the Southern Christian Leadership Conference were criticized for placing black children in harm's way, in the path of police dogs and fire hoses. For its critics, the SCLC had an answer: These children were ready and eager to fight for their own future.

Yet, however much they were prepared for passive resistance by men like CORE's James Farmer, it is difficult to imagine how these attractive, well-dressed young men and women maintained their discipline, walking a razor's edge, when a Maryland coffee shop owner refused them service, a burly policeman at his side preparing to arrest them. How could Bayard Rustin maintain his composure in a Baltimore restaurant when a white woman glanced

at him as if he might be a cockroach who crawled into this establishment? And how did these young activists keep their resolve not to strike back when confronted by cross burning, Confederate flag-waving young customers jeering them at a White Castle in the Bronx — ethnic whites, no doubt, who constantly fought among themselves but this day were bonded by blood against a common foe determined, they believed, to take away their racial privileges?

Many blacks *did* retaliate physically, their eye-for-an-eye anger inspired by the speeches of the black separatist, Nation of Islam leader Malcolm X, then by Stokely Carmichael's call for "Black Power" to meet white power head-on (King predictably disapproving of that phrase, fearing it was incendiary). All too often, racial violence and killing dogged each non-violent campaign of the Movement, in the South and the North, like a biblical curse. Fathers were pitted against their sons, brothers against brothers, as it had been during the Civil War. Cities burned during long, hot summers of racial unrest. The martyrs were many, among them four black girls bombed in the 16th Street Baptist Church Sunday school in Birmingham. Those in the Movement grew weary of funerals and mourning. Looking back, we cannot help but see the 1960s as the most tempestuous and transformative period in American history after World War II. But, as with the creation of anything new, something old had to be destroyed. Power and privilege, as King pointed out, were never relinquished willingly. And so it was a violent decade, riddled with political assassinations that seemed to arrive with dizzying rapidity — John and Robert Kennedy, Malcolm X, Martin Luther King Jr. and many, many others. Given the fragility of a nation so in flux, careening toward social chaos, the federal government began drawing up plans to address the real possibility of civil war.

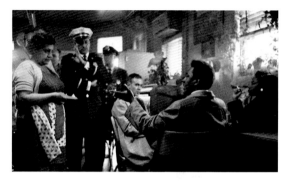

Bayard Rustin, Baltimore, Maryland.

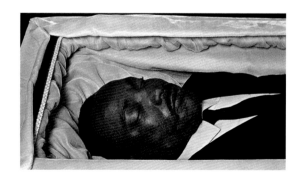

King funeral, Atlanta, Georgia.

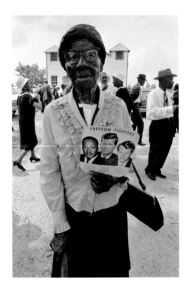

After church, Wilcox County, Alabama.

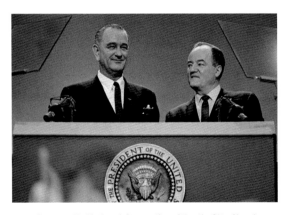

Democratic National Convention, Atlantic City, New Jersey.

King knew, and said often, that he was aware of the gamble the Movement was taking. It could only succeed in America, he said, because the sacred documents of this country's secular religion, containing principles dating back to the Magna Carta, would shame it into eventually providing justice and equality for all. Other nations — one thinks of Nazi Germany, Stalinist Russia or Cambodia in the 1970s — might well have responded to such large-scale civil disobedience by dotting the countryside with mass graves.

But the high-risk gamble paid off, resulting in the Civil Rights Act of 1964 and the Voting Rights Act of 1965, two monumental legislative achievements that gave new meaning to the American experiment in democracy.

In the end, the miracle of the Civil Rights Movement, and the special creativity of black Americans in general, proved to be a gift that just kept giving: a cornucopia of social progress. The Movement inspired freedom fighters around the world. It rallied anti-apartheid activists in South Africa, and when I was in Czechoslovakia in 1989, lecturing for the U.S. State Department, I saw a mile-long chain of student protesters threading through the winding streets of Prague as they sang "We Shall Overcome." In America in the 1970s, farmworkers, women and gays enthusiastically adopted the tactics and rhetorical tropes of the Movement to advance their own causes. The Movement changed forever American politics and culture. "There goes the South," President Lyndon Baines Johnson is reported to have said when he signed the Civil Rights Act, and he wasn't wrong. Newly empowered black voters overwhelmingly picked the Democrats as the party they trusted, which led to the flight of Dixiecrats — die-hard racists, states'-rights advocates and libertarian Democrats — to

the Republican Party, where they were embraced when President Richard Nixon implemented his "Southern strategy."

All people of color, including Asians and Hispanics, as well as the disabled and the elderly, were eased into positions of greater equality in American society by virtue of the new direction the Movement established. As for black Americans forty years after the Movement, a people oppressed for so long became, as writer Reginald McKnight once put it, "as polymorphous as the dance of Shiva." They have been CEOs at Time Warner, American Express and Merrill Lynch; they have served as secretaries of state and White House national security advisers; they have been mayors, police chiefs, best-selling novelists, MacArthur fellows, Nobel laureates, Ivy League professors, billionaires, scientists, stockbrokers, engineers, theoretical physicists, toymakers, inventors, astronauts, chess grandmasters, dot-com millionaires, talk-show hosts, actors and Hollywood film directors. At the dawn of the twenty-first century, the GDP of black America stood at $631 billion. Homeownership was close to 50 percent. The number of blacks living in poverty was approximately 25 percent, which is way too high, of course, but a vast improvement over indigence before the Movement began.

Today, and for the first time in modern history, black Americans are *visibly* entrenched in the rich fabric of America's lived experience as a complex and multi-faceted people that defy easy categorization.

Bob Adelman sees this — has seen it from before the beginning of the Movement. He shows us these people as they are, and as they were when they were in the streets, striving, dreaming. What drove the Movement was clear to him, and he makes it clear to us today. In his pictures, the triumph of the Movement — of all black Americans — is delivered with unforgettable power and beauty.

Demonstration, New York City.

Sheriff Thomas Gilmore, Eutaw, Alabama.

The Movement

Photographs and Comments

Bob Adelman

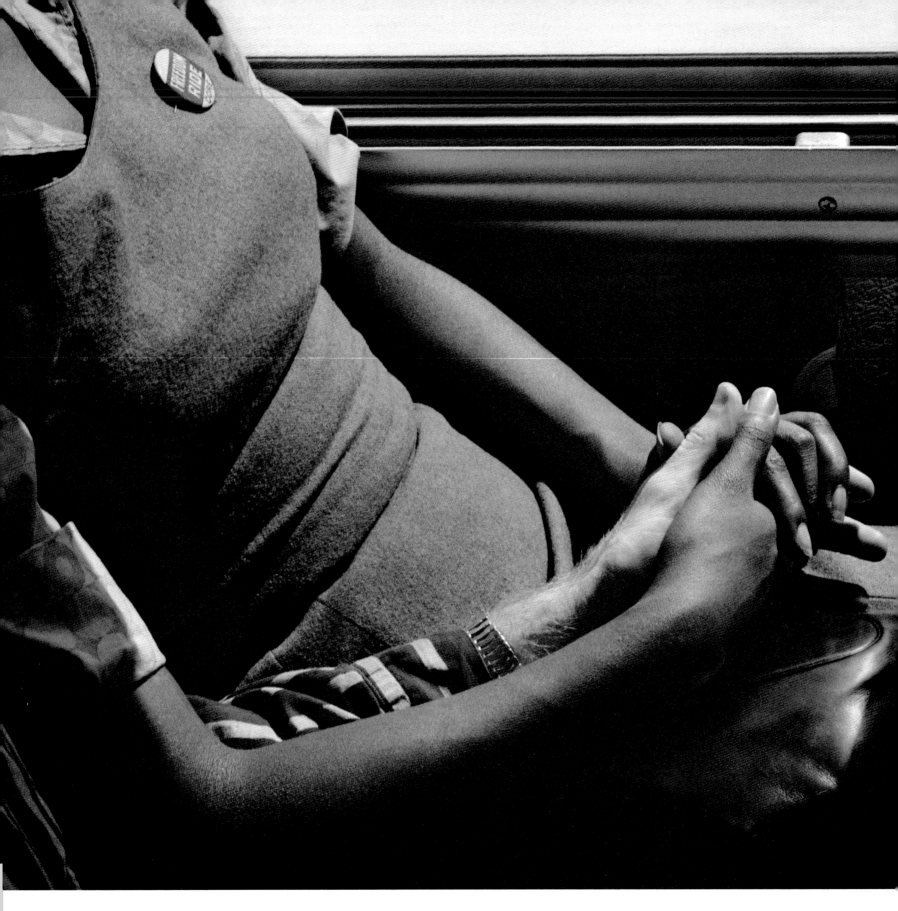

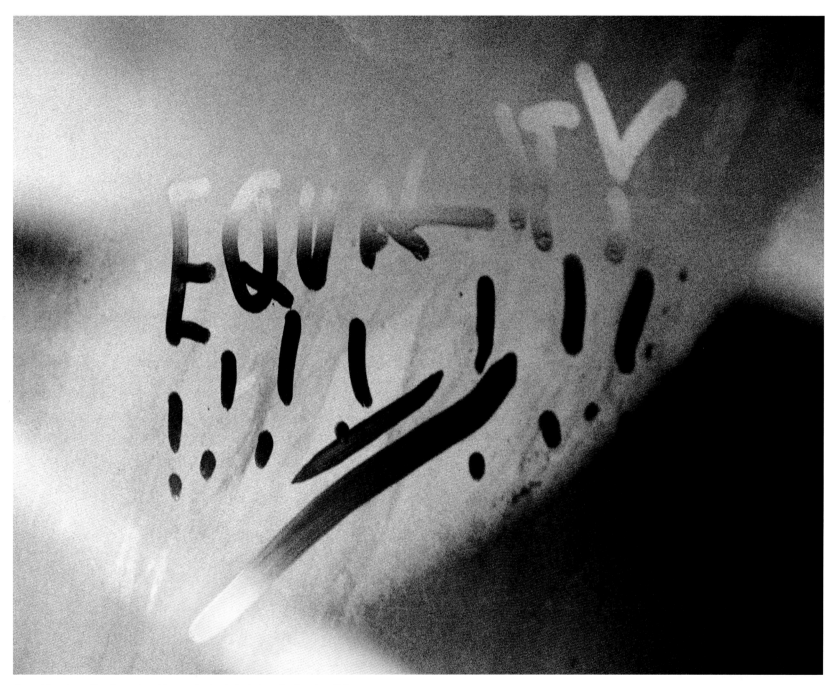

Sign of the times: The dream is written on the frosted window of a Freedom Riders bus, somewhere on the road between New York City and Washington, D.C.

"Gripped by terror, armed with only their ideals, the Freedom Riders were intent on smashing racial barriers yet terrified of the price they might have to pay."

Holding on: Freedom Riders on Route 40 between Baltimore and Washington, D.C.

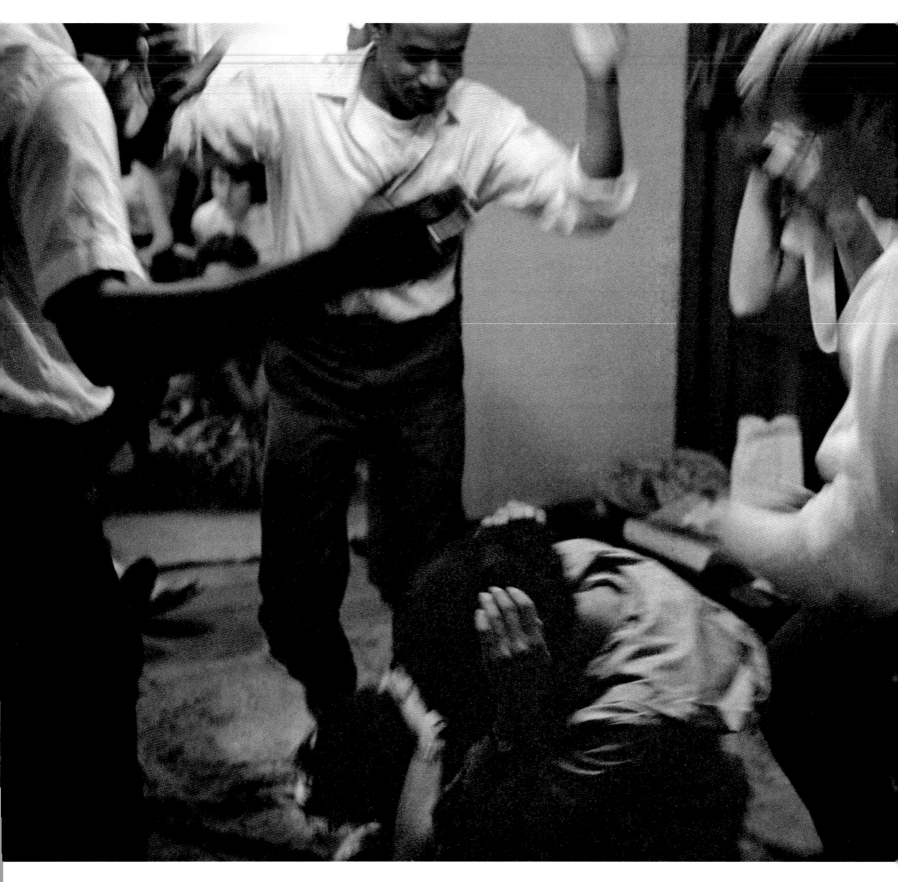

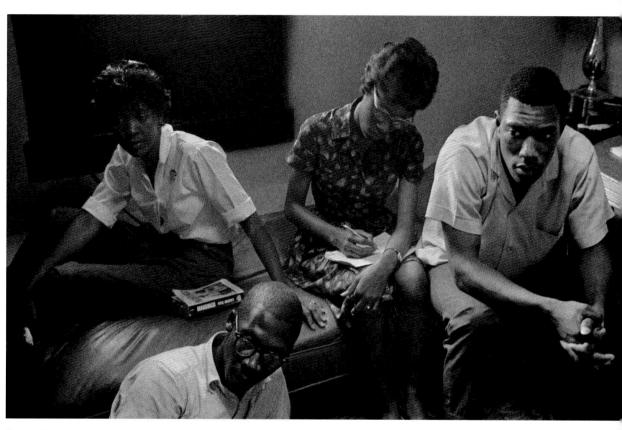

The art of war: Militant students learn Gandhi's approach to non-violent protest, Anniston, Alabama.

Damage control: Congress of Racial Equality volunteers, most of them students, are taught
to protect themselves if attacked during a peaceful protest, Columbus, Ohio.

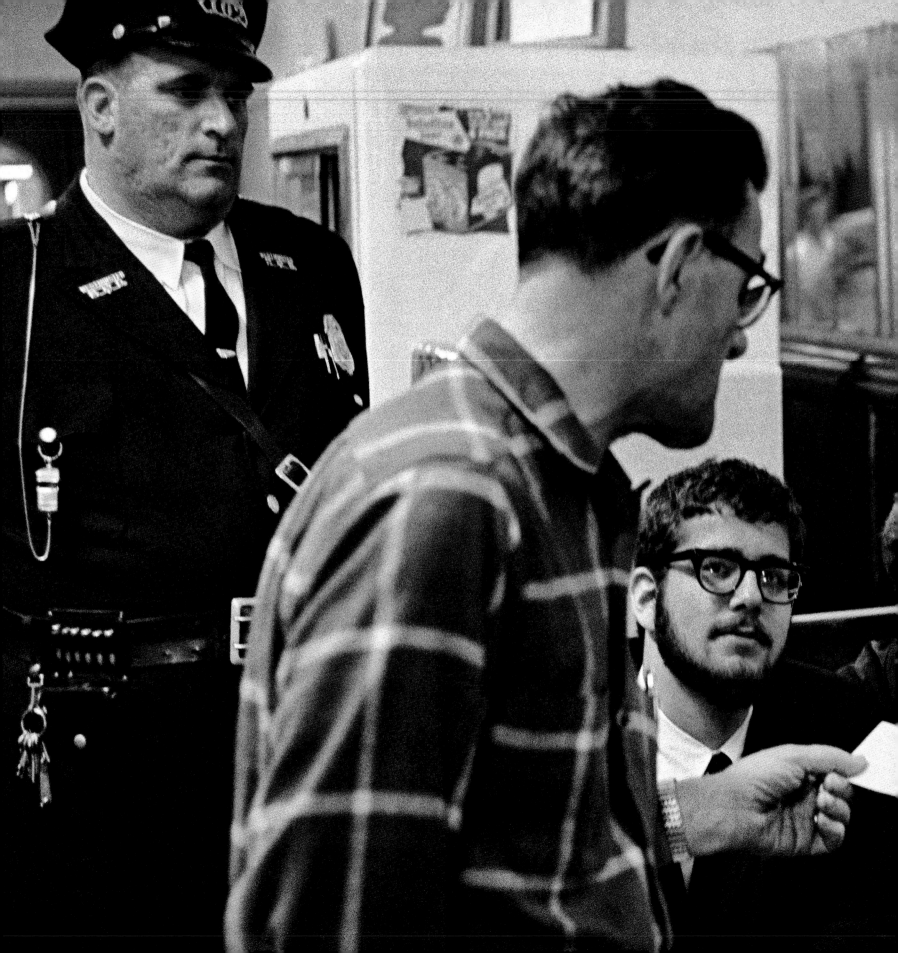

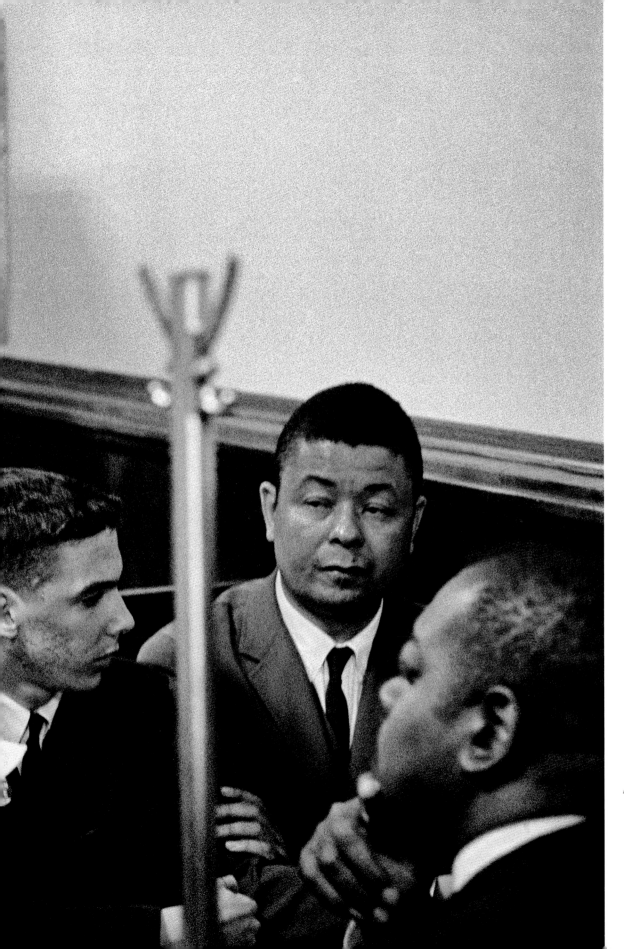

"The owner here has reserved his right to serve whomever he pleases. The presence of a policeman in a situation like this usually meant that instead of having food dumped on you and hot coffee in your lap, you'd be peacefully led to jail."

Sitting in, Cambridge, Maryland.

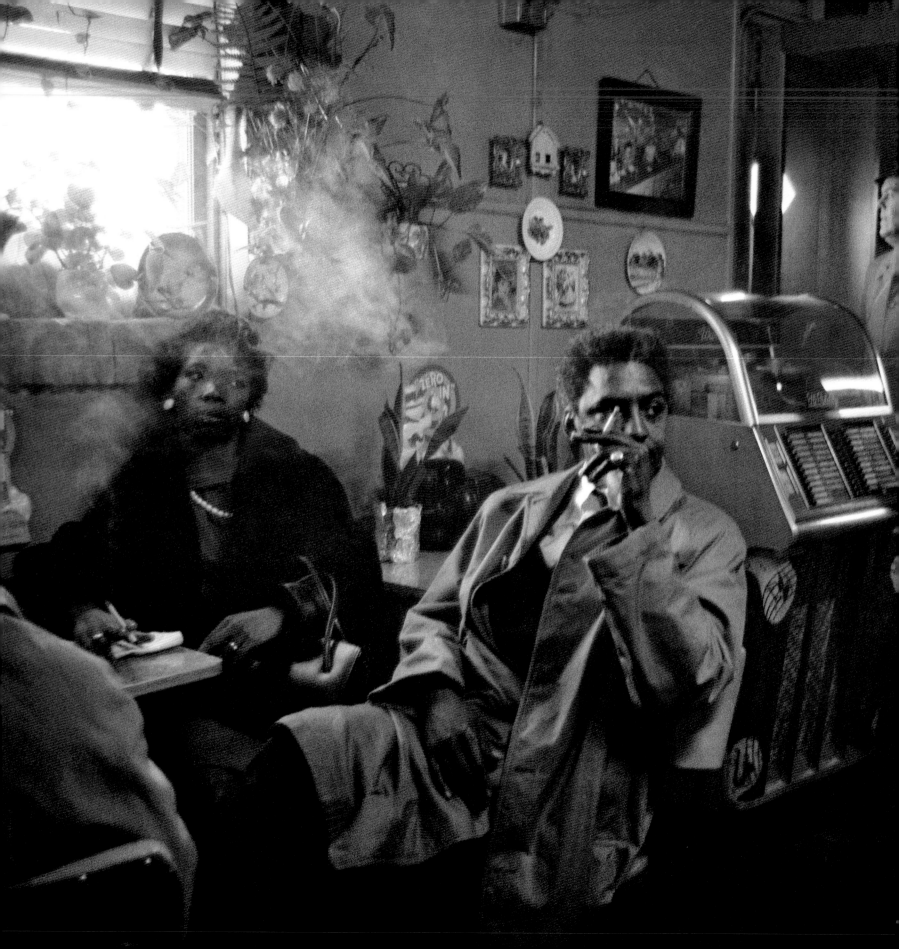

Demanding service: Bayard Rustin, the March
on Washington organizer, Baltimore, Maryland.

They sometimes served those who only sat and waited,
Route 40 between Baltimore and Washington, D.C.

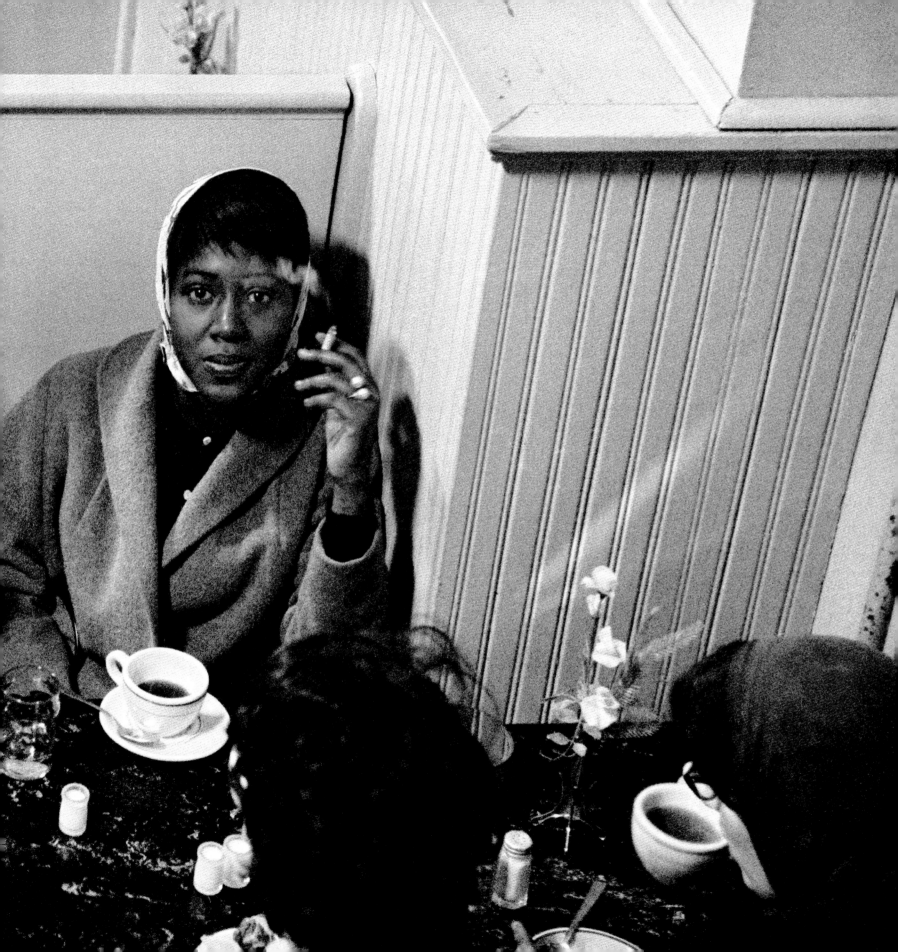

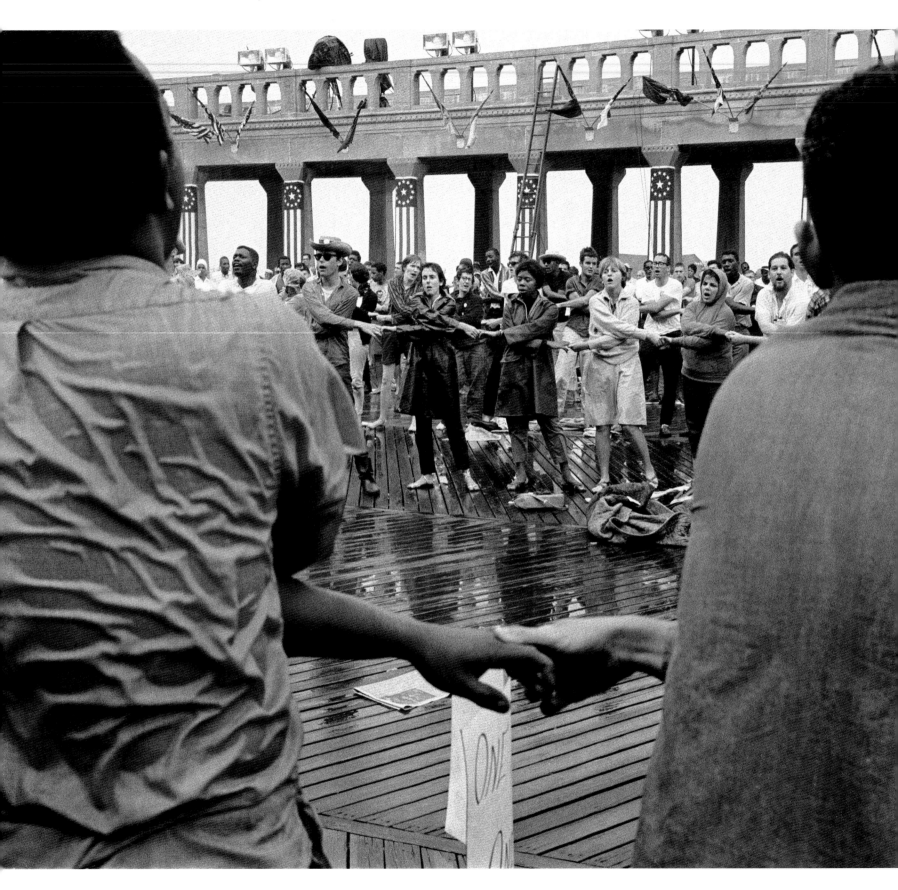

Chillin', Washington, D.C.

"The singing in Washington came at the end of a long day of demon-
strations. It was a way to unwind."

"Just back from the horrific and heroic Freedom Summer campaign of
1964, where they were attempting to register black voters in the Deep
South, students sang and protested outside the Democratic Party
National Convention in Atlantic City. They were asking for color-blind
voting laws for delegates and voters alike."

Singing in the rain, Atlantic City, New Jersey.

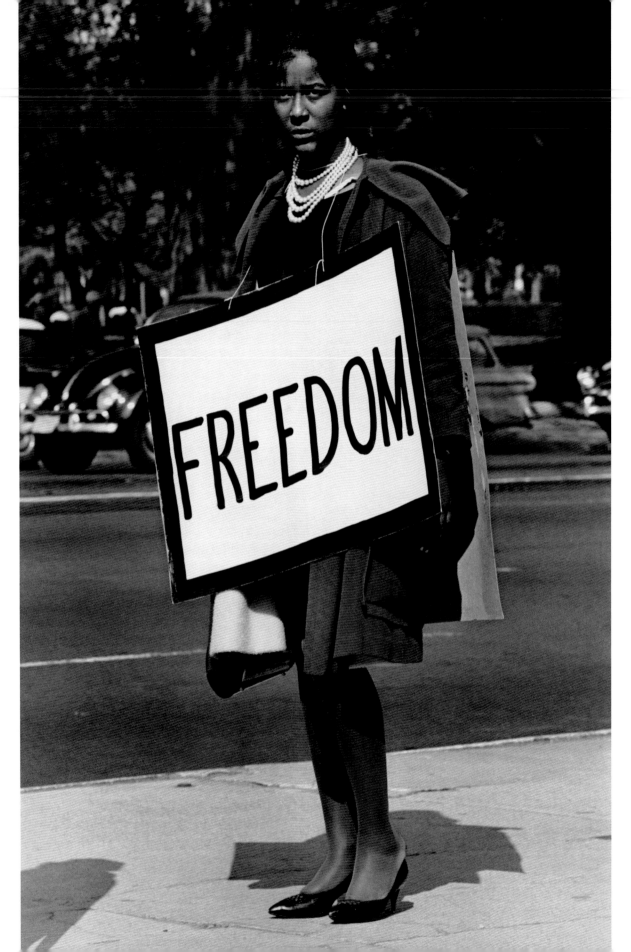

Signifying, the White
House, Washington, D.C.

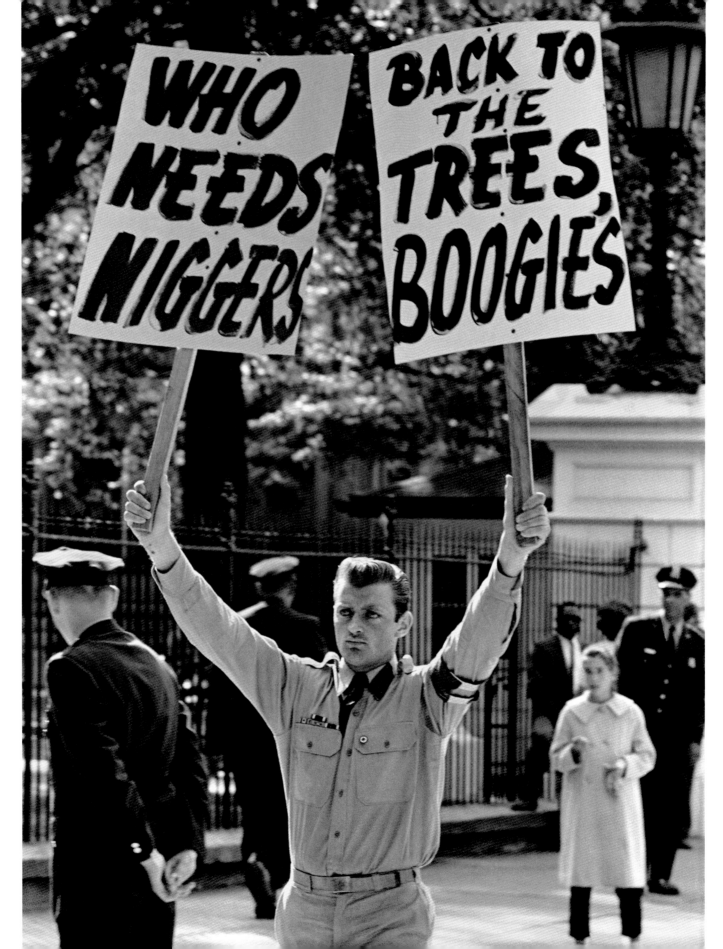

Hate speech, the White
House, Washington, D.C.

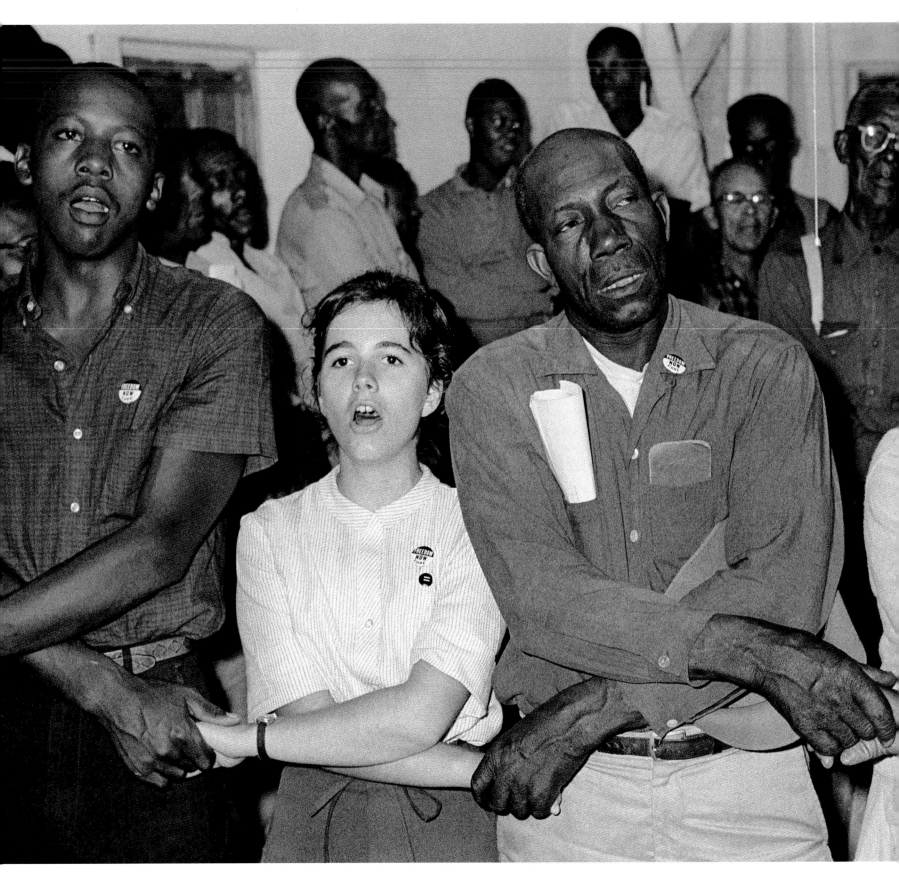

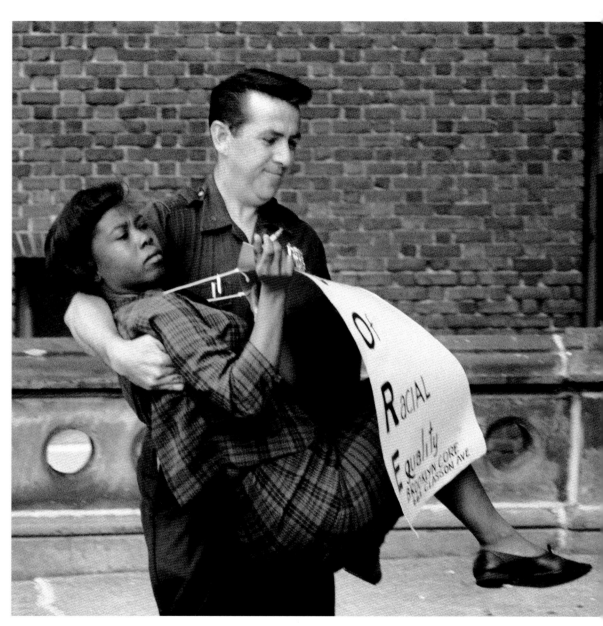

Passive resister, Brooklyn, New York City.

"In West Feliciana, an overwhelmingly black parish where no person of color had voted in the twentieth century, volunteer Mimi Feingold urged members of a church congregation to try to vote. She then joined hands with them to sing, 'This Little Light of Mine.'"

Joining the flock, West Feliciana Parish, Louisiana.

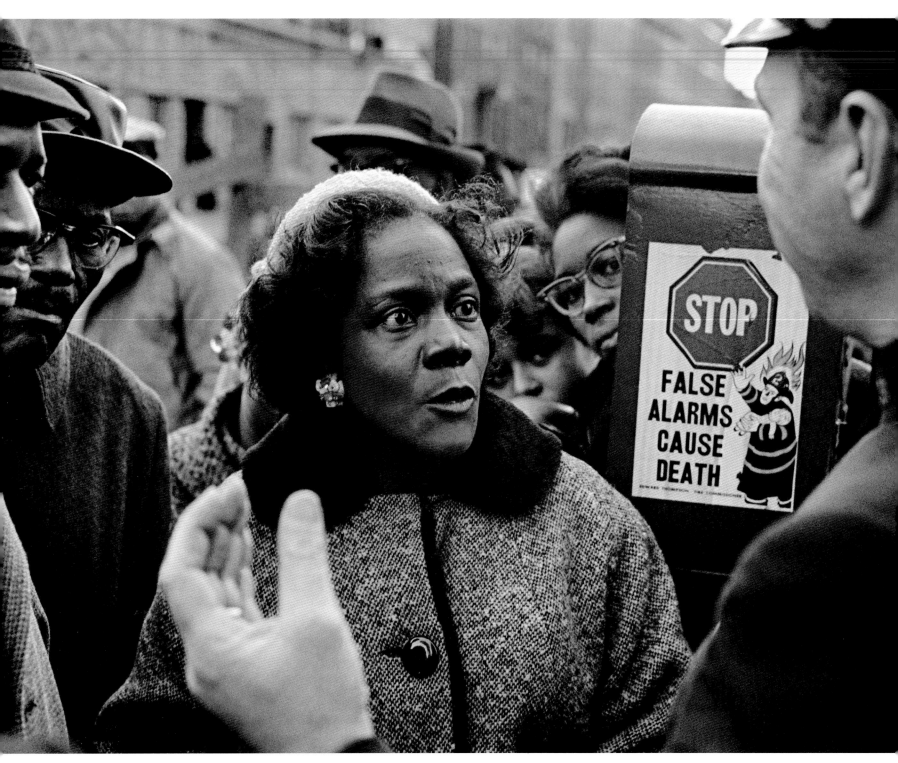

Safety first: Parents and children respond to a wave of accidents by blocking their street and demanding the installation of a traffic light, Brooklyn, New York City.

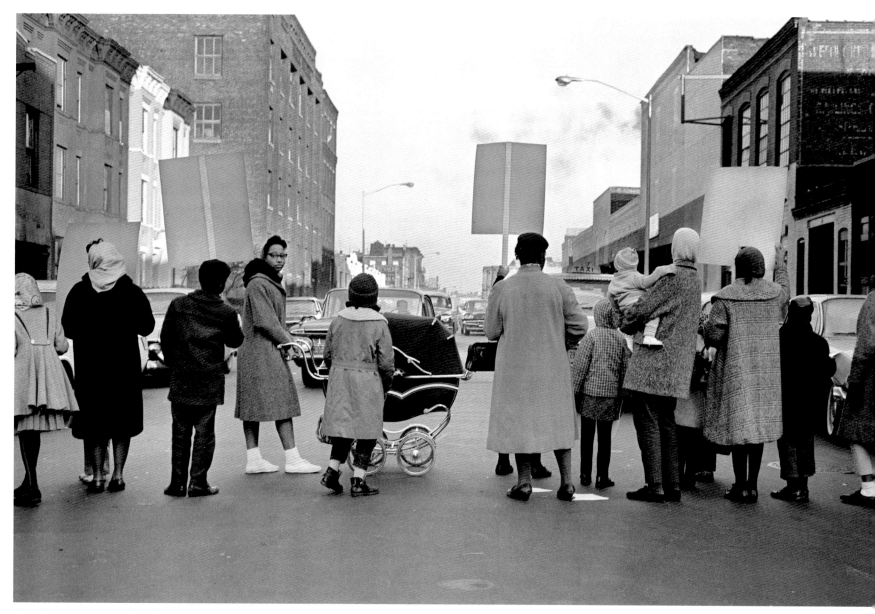

We shall not be moved, Brooklyn, New York City.

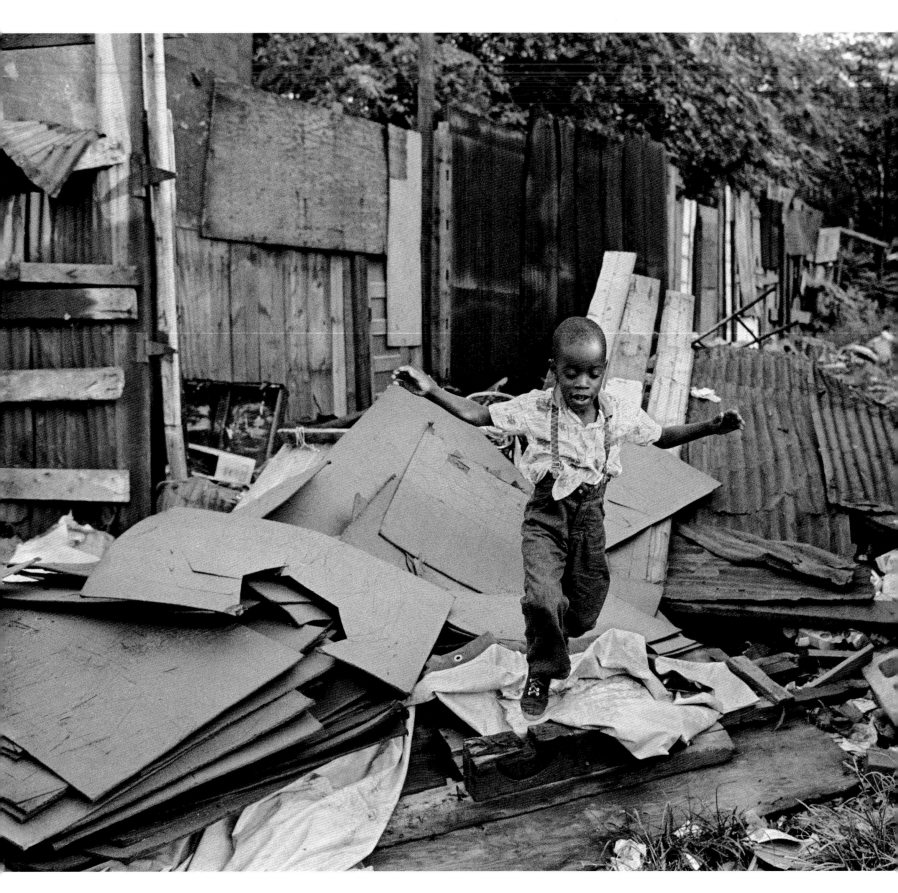

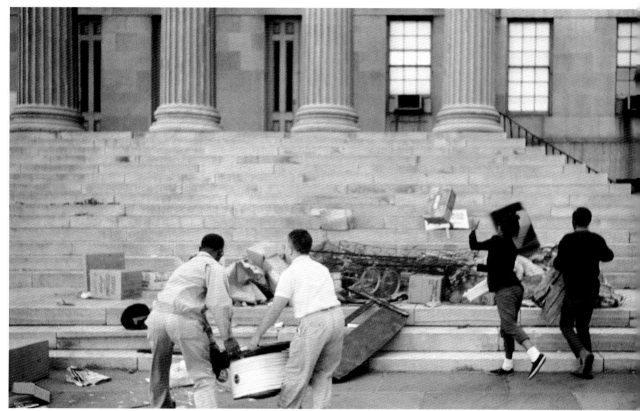

Payback: Dramatizing their rage at the city's neglect, residents of the Bedford Stuyvesant neighborhood dump their street refuse on the steps of Brooklyn Borough Hall, New York City.

Angel, Bedford Stuyvesant neighborhood, Brooklyn, New York City.

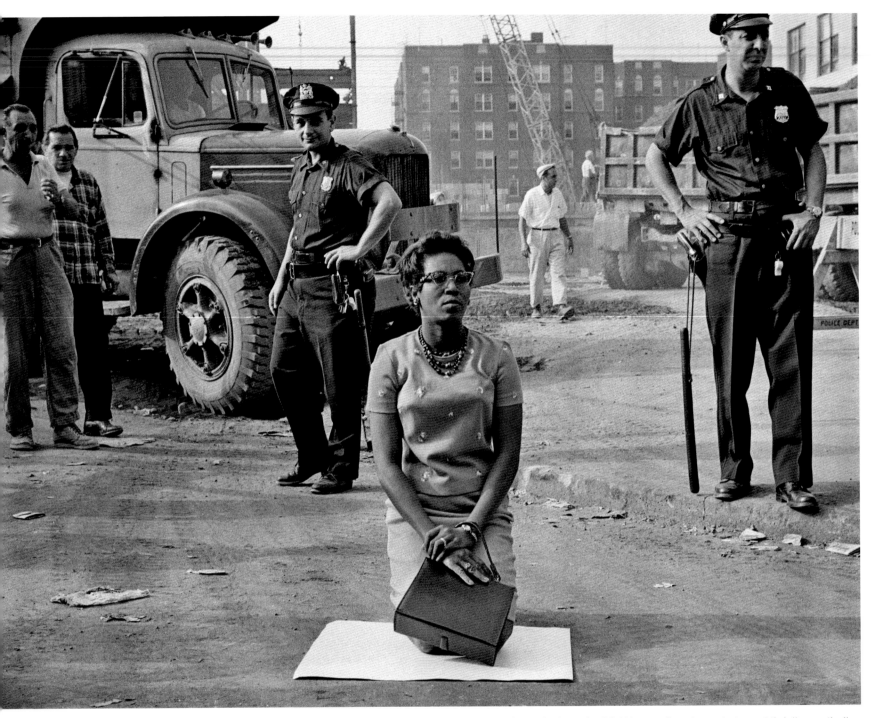

Stop action: Determined to end unfair hiring practices, two protestors put their lives on the line, closing down a construction site at the Downstate Medical Center, Brooklyn, New York City.

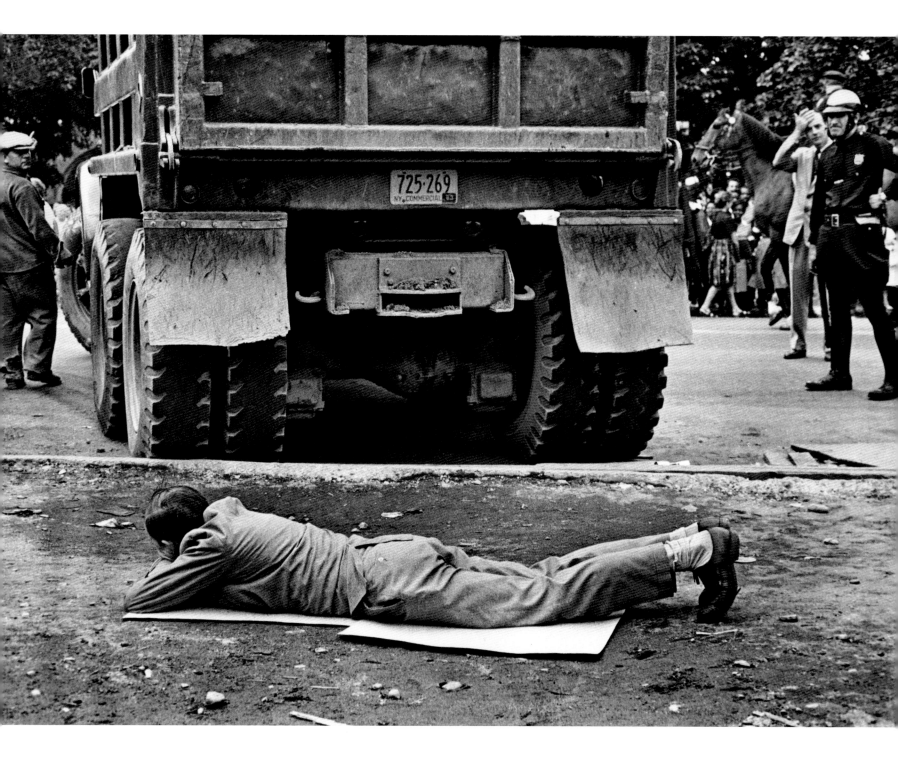

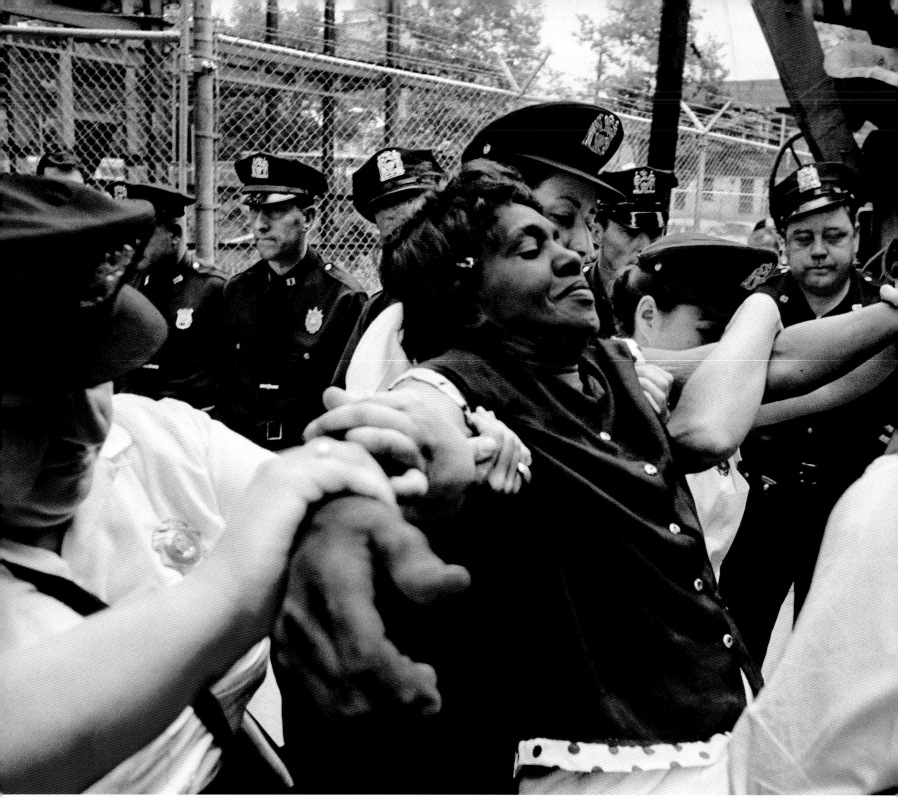

Pieta, the Downstate Medical Center, Brooklyn, New York City.

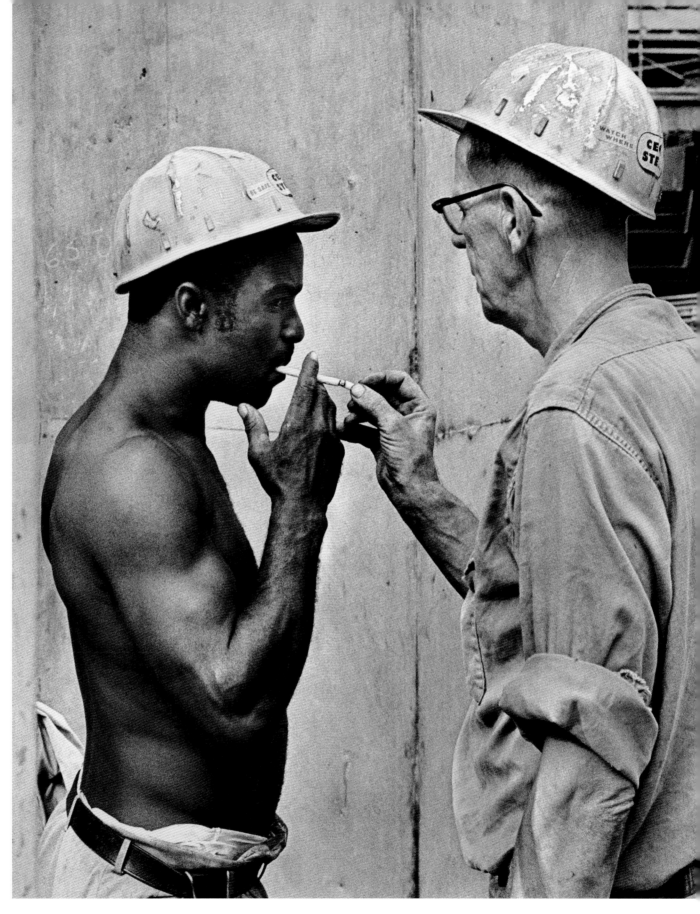

No matches, no matter:
a construction site,
New York City.

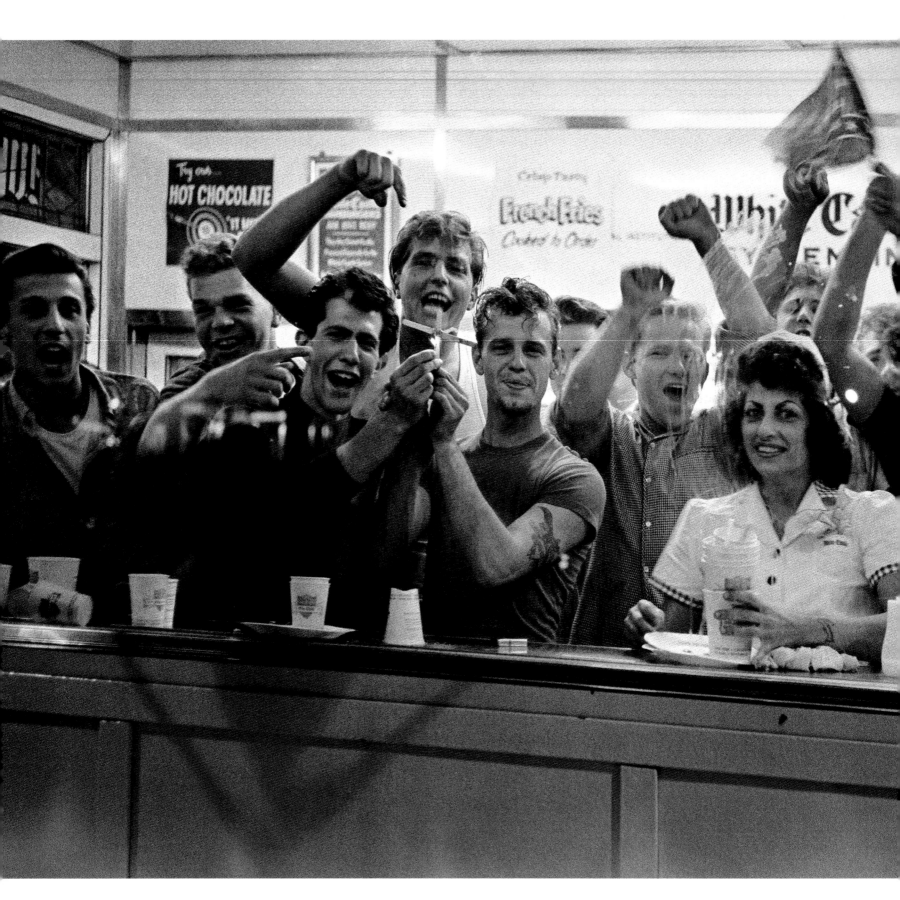

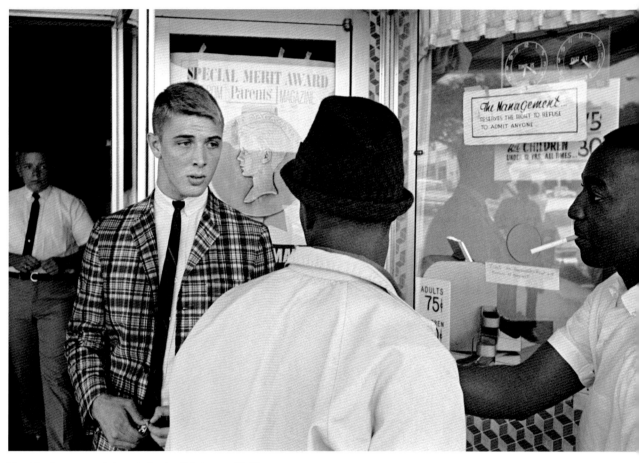

Stand back: a segregated movie theater, Tallahassee, Florida.

White Knights defend their White Castle as picketers outside
demand fair employment practices, Bronx, New York City.

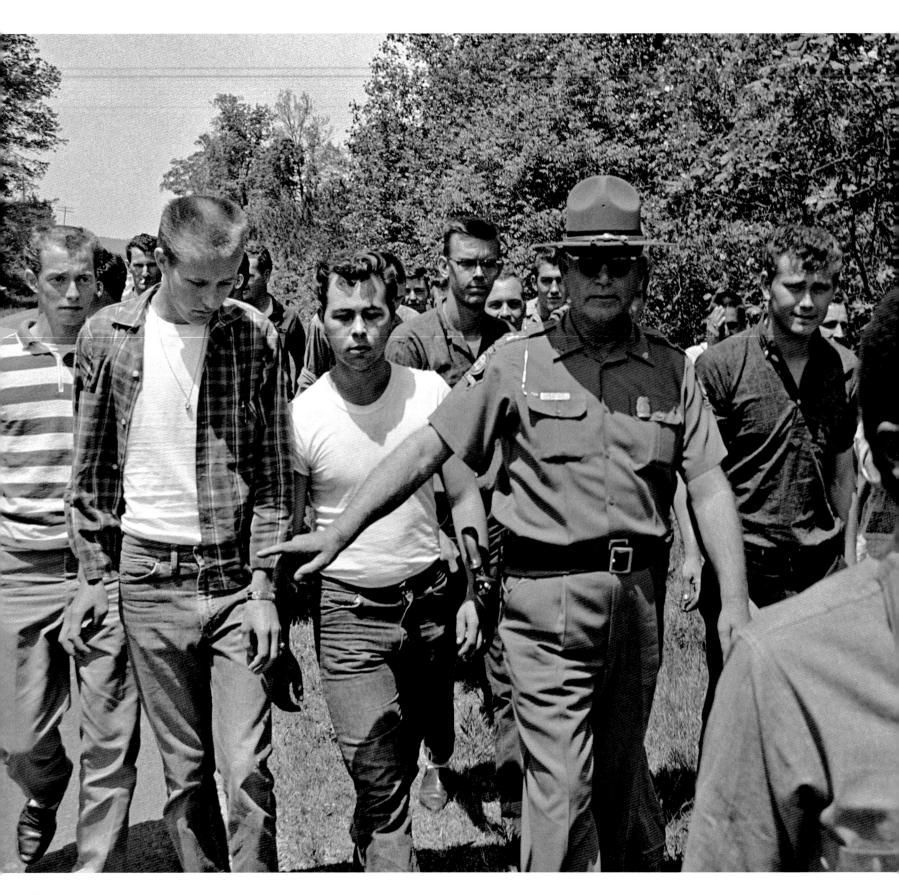

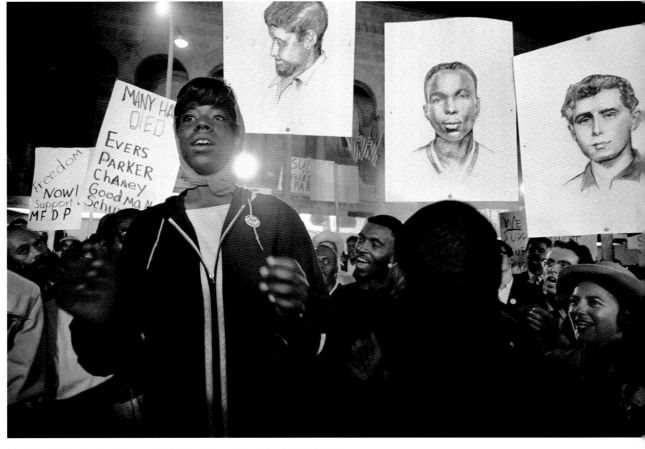

All-night vigil at the 1964 Democratic National Convention, Atlantic City, New Jersey.

"It's dues time. Activist Bob Gore is being trailed by a mob. The Freedom Walkers are about to be arrested at the Alabama state line simply for walking on the side of the road."

Freedom Walkers retrace the route of a slain black postman, Highway 11 near the Georgia-Alabama border.

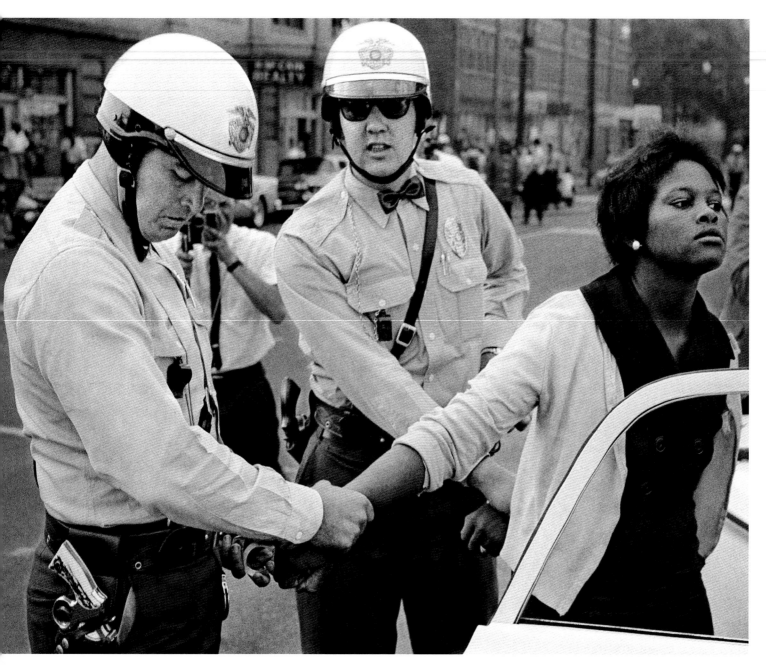

Innocent bystander arrested, Birmingham, Alabama.

"Birmingham was a turning point. It was the first time the Movement took on such a large city. King called it the most segregated city in America. The Klan's penchant for resolving racial conflicts with dynamite earned the city the nickname Bombingham."

Picketer under arrest behind Loveman's department store, where the protest concerned unfair hiring practices, Birmingham, Alabama.

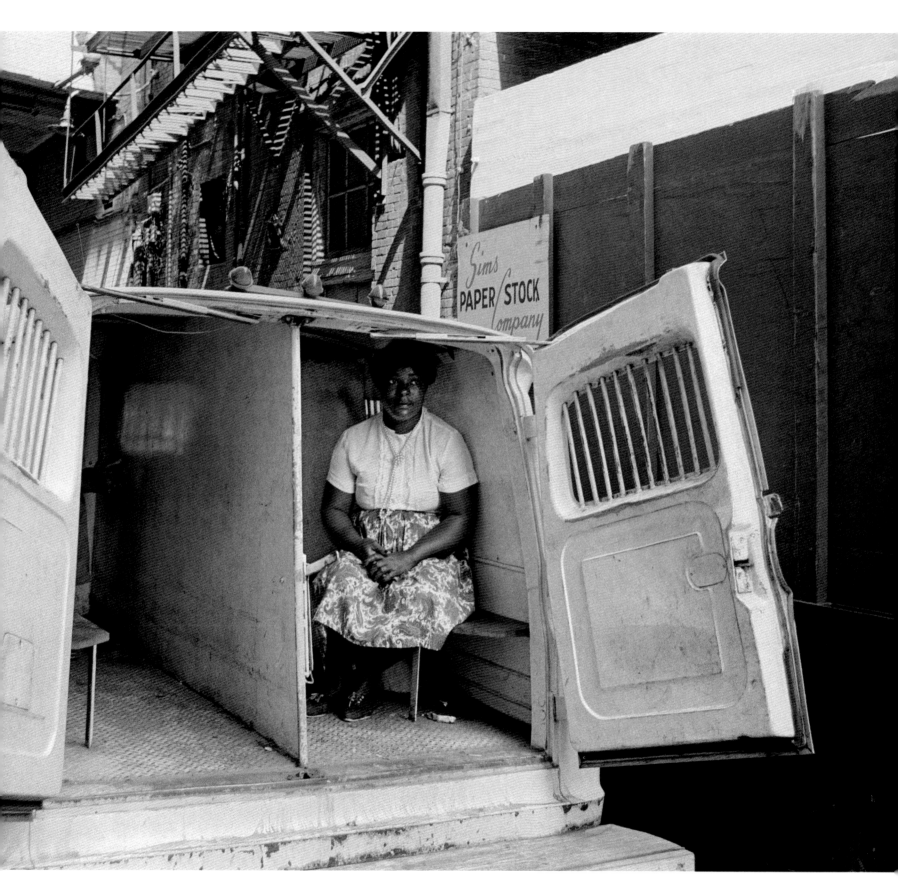

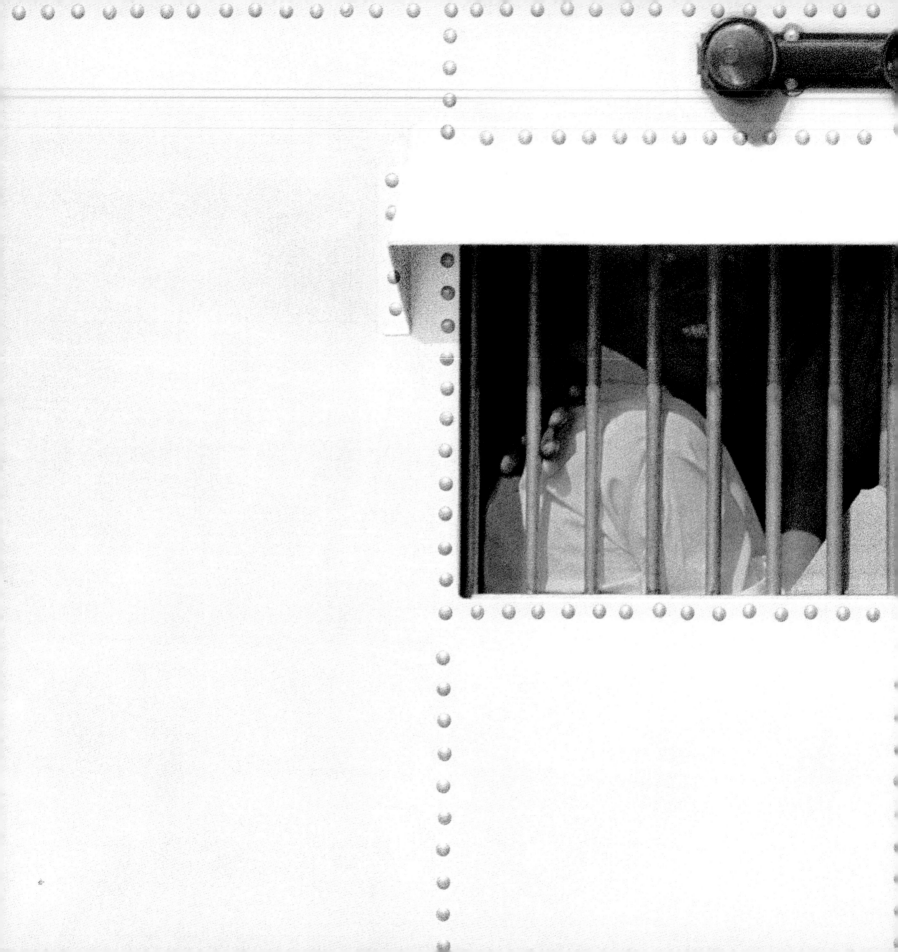

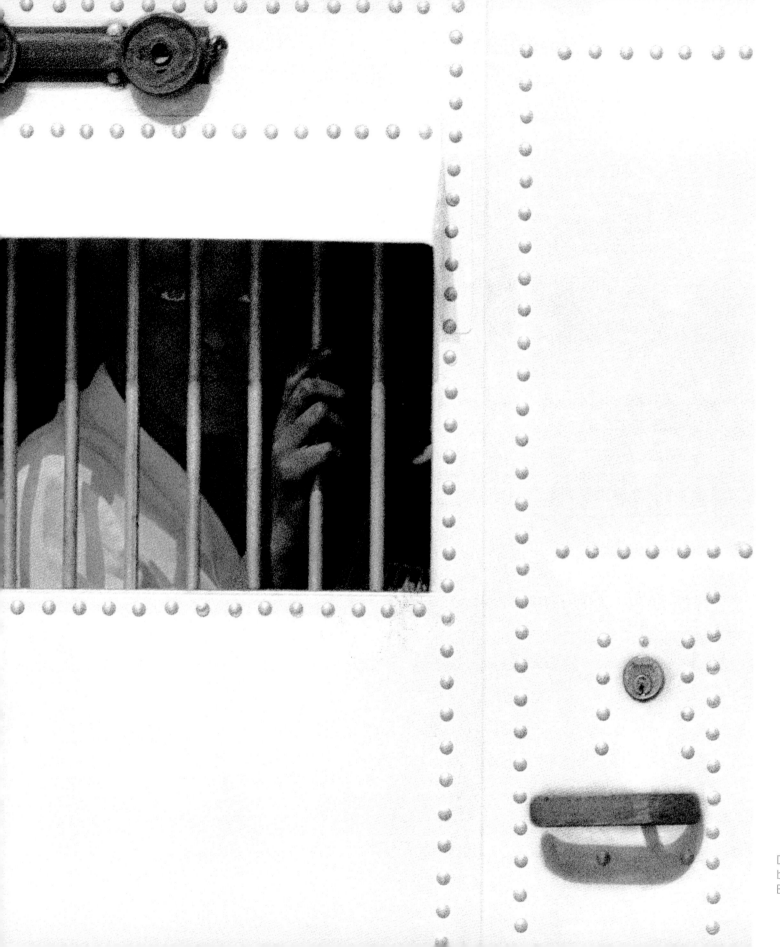

Demonstrators behind
bars in a paddy wagon,
Birmingham, Alabama.

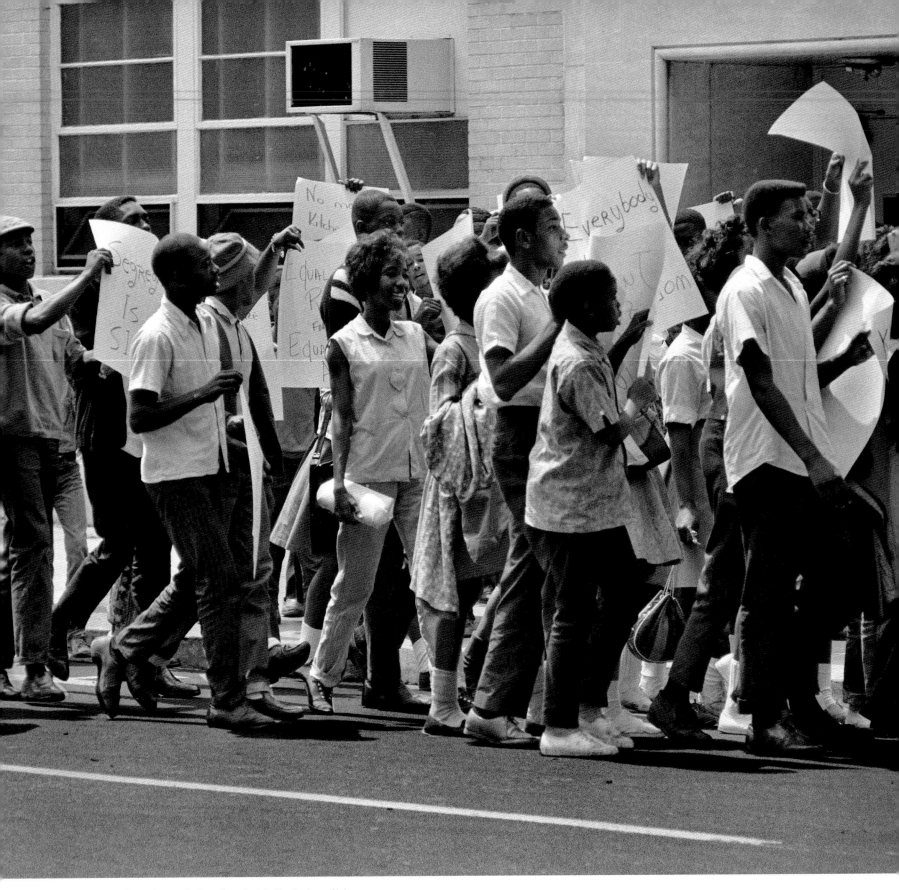

Fooling the Man: Protesting students gaily go to jail, Birmingham, Alabama.

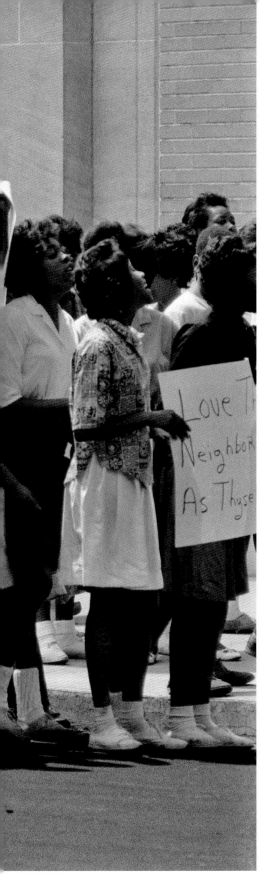

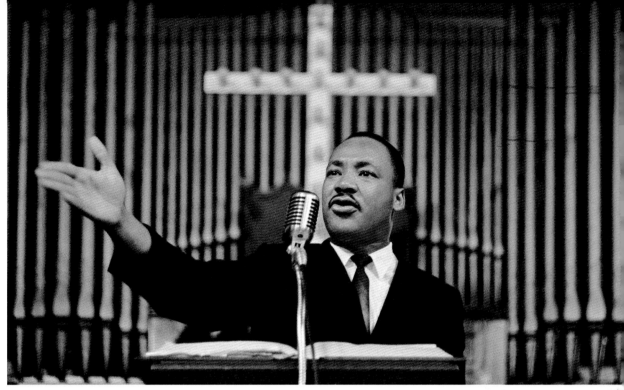

During a mass meeting at the 16th Street Baptist Church, King urges his supporters to join the demonstrations, Birmingham, Alabama.

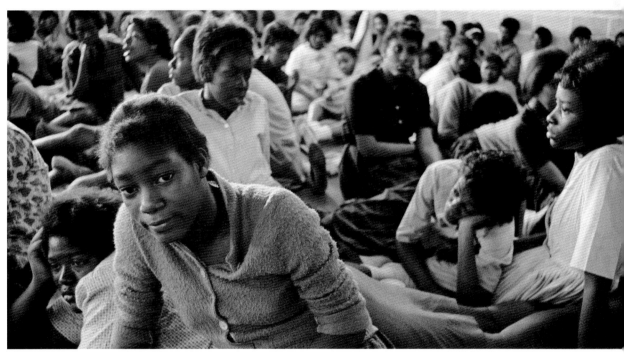

Improv prisons: High school student demonstrators are detained in a sports stadium, Birmingham, Alabama.

"The police had contained the demonstrations to the black part of town. But by filling the jails, the protestors immobilized the police—and the next wave of demonstrators could peacefully protest for the first time in downtown Birmingham. The jails were flooded, the city was paralyzed and the white leadership realized it had to come to the bargaining table."

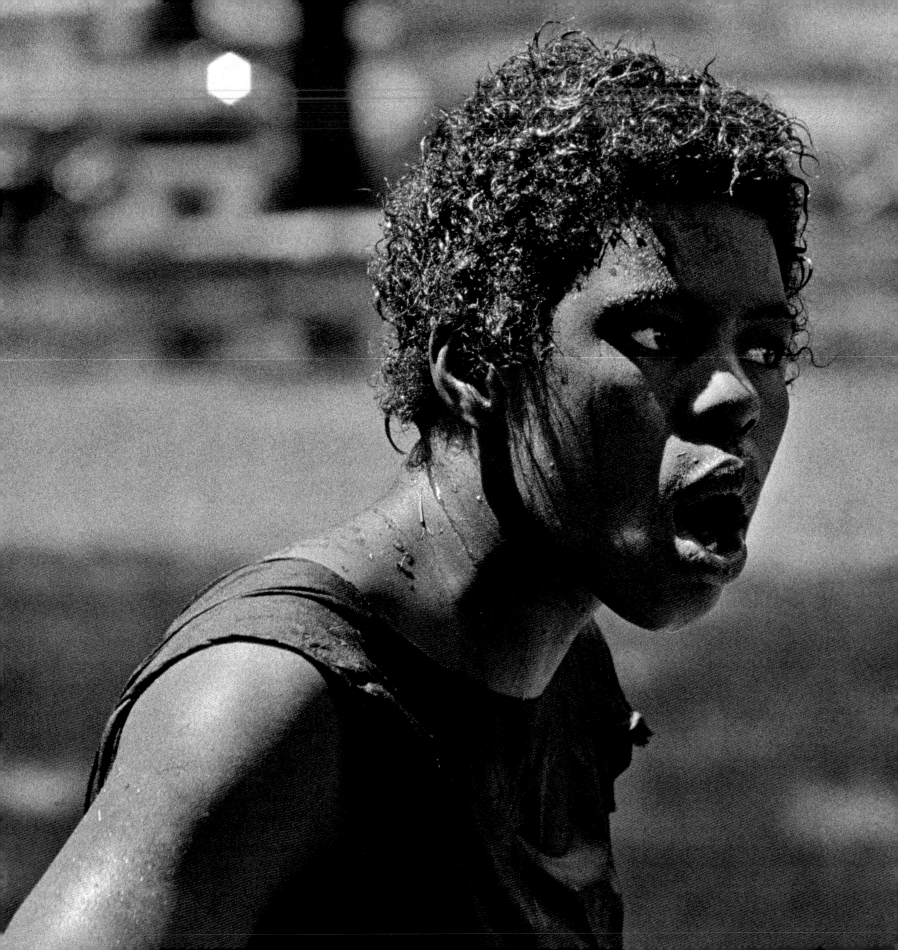

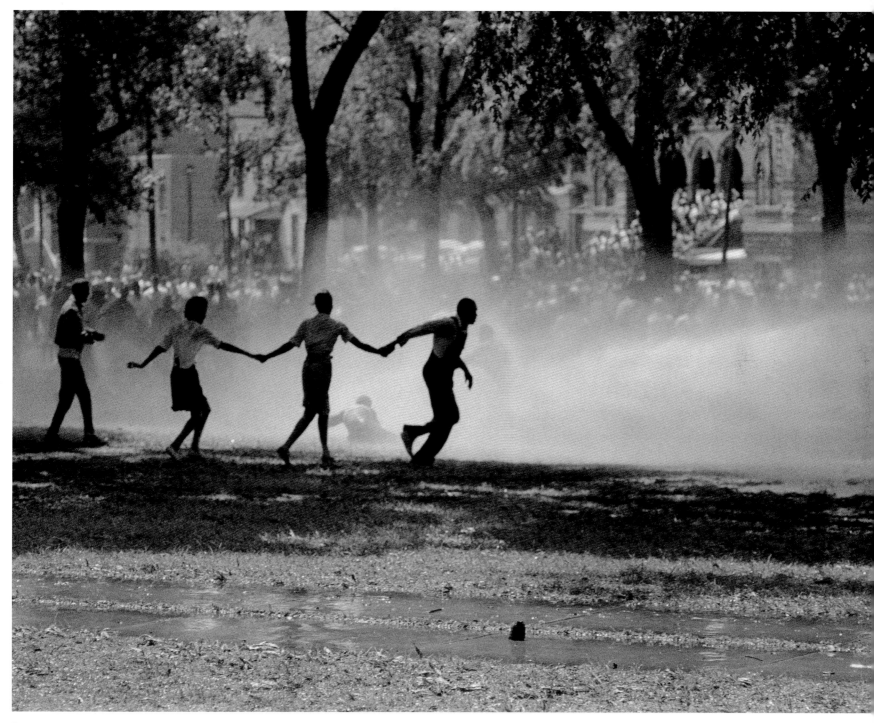

Demonstrators hold on to one another to face the spray, Kelly Ingram Park, Birmingham, Alabama.

"The force of the spray from the fire hose was so powerful that it peeled the bark off the trees. Protestors skidded along the grass, propelled by the torrent."

Hell, no!: A downed onlooker rises up enraged, Birmingham, Alabama.

"The police and firemen used a brute show of force to try to stop the ongoing demonstrations. It didn't work on this day. Rather than fleeing, the protestors hung on to each other and were able to stand up to the full fury of the water, though not without casualties. I have never witnessed such cruelty. There was almost as much moisture behind the lens as in front. I gave a print of this picture to Dr. King. He studied it and said, 'I am startled that out of so much pain some beauty came.'"

No man is an island, Kelly Ingram Park, Birmingham, Alabama.

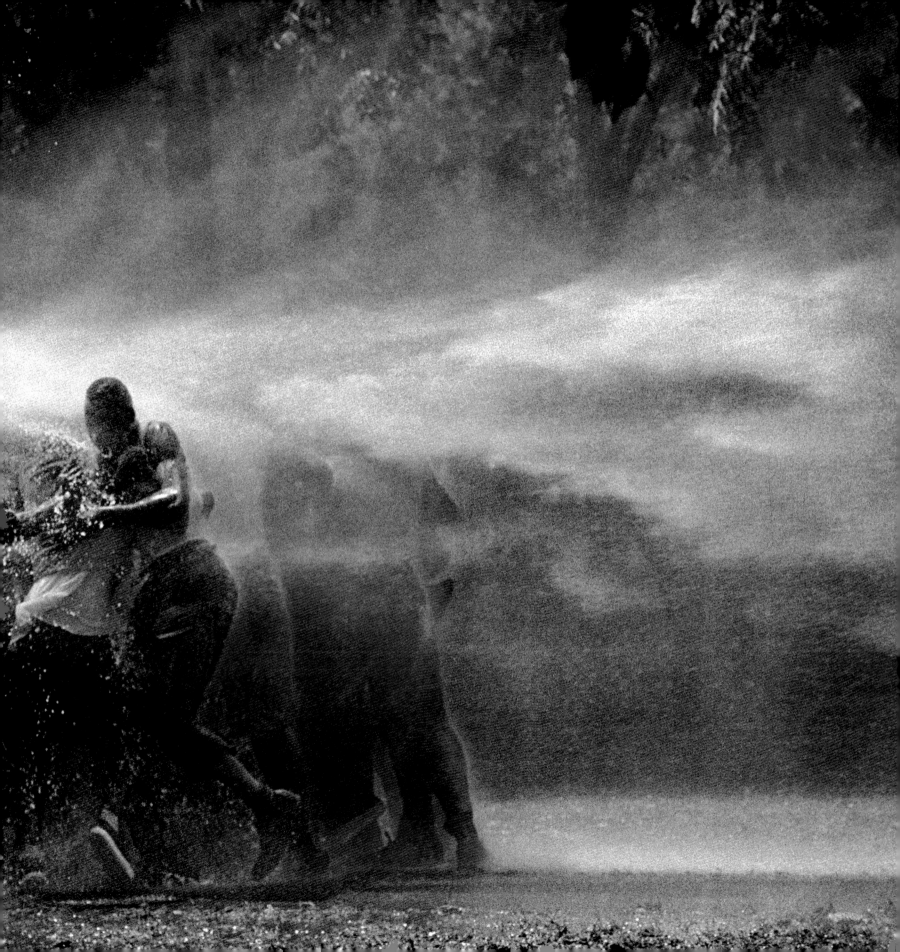

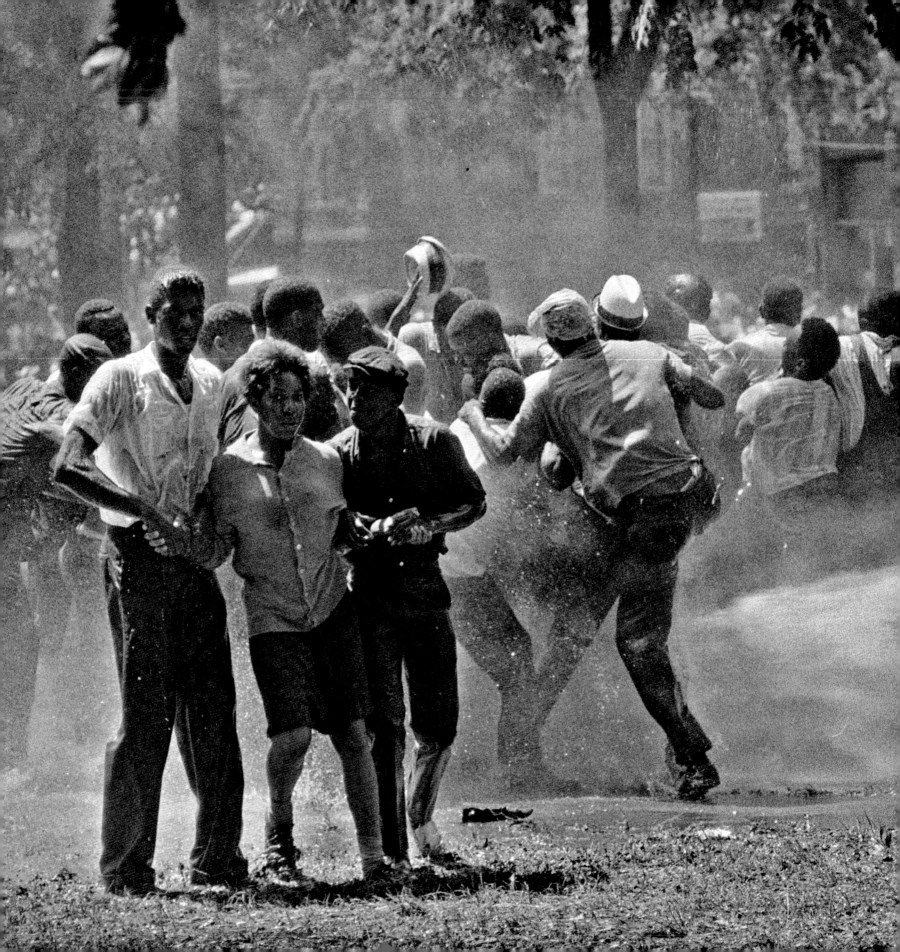

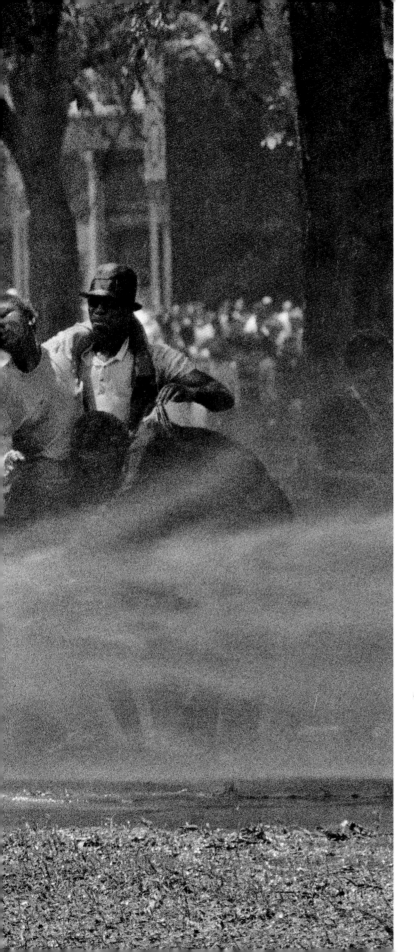

"'If you don't bear the cross, you can't wear the crown' was the loving spirit that animated the Movement. In Birmingham, the protestors clearly earned their crowns. The use of fire hoses and dogs backfired. City officials lost control of themselves, of the protests and of segregation. What happened in Birmingham provoked John Kennedy to denounce segregation — the first U.S. president to do so — and to urge its legal ban. The drama that unfolded in Birmingham proved to be a triumphant moment for the ideals of non-violent social change."

Beloved community, Kelly Ingram Park, Birmingham, Alabama.

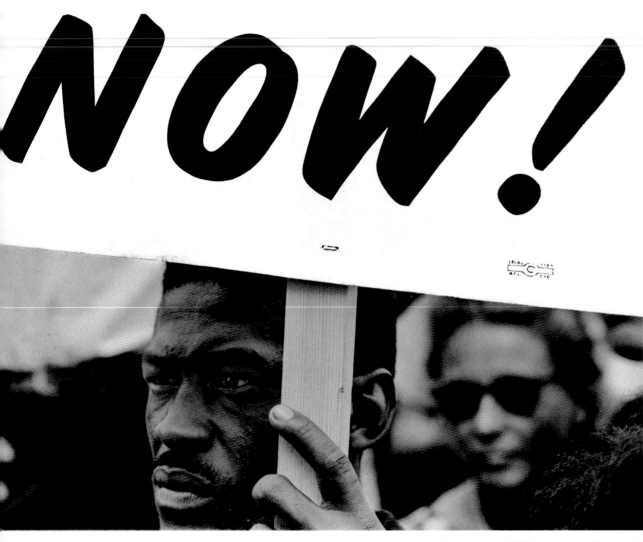

Redemption: participants in the 1963 March on Washington, D.C.

"It was a vast outpouring of support, with 250,000 protestors from all walks of life peacefully gathered in Washington to demand that the president and Congress enact into law the nation's long-deferred promises of full equality. Hopes were high, there was great exuberance, a deep sense of purpose and, after Birmingham, the feeling that victory was in the air."

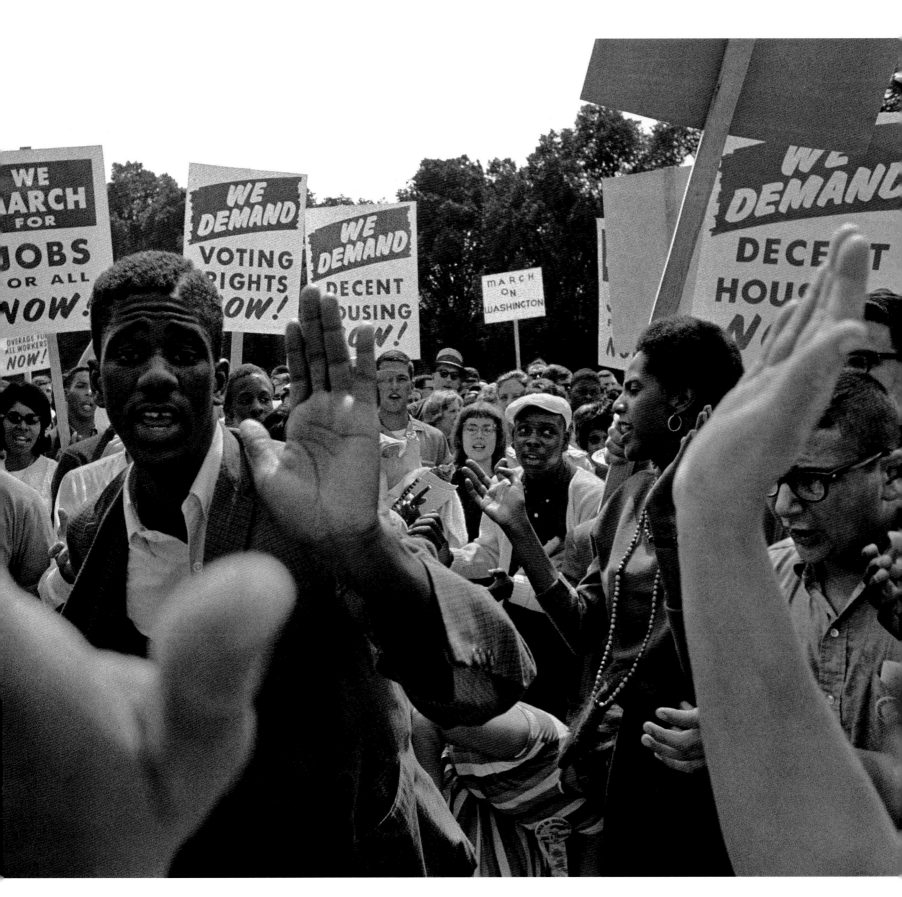

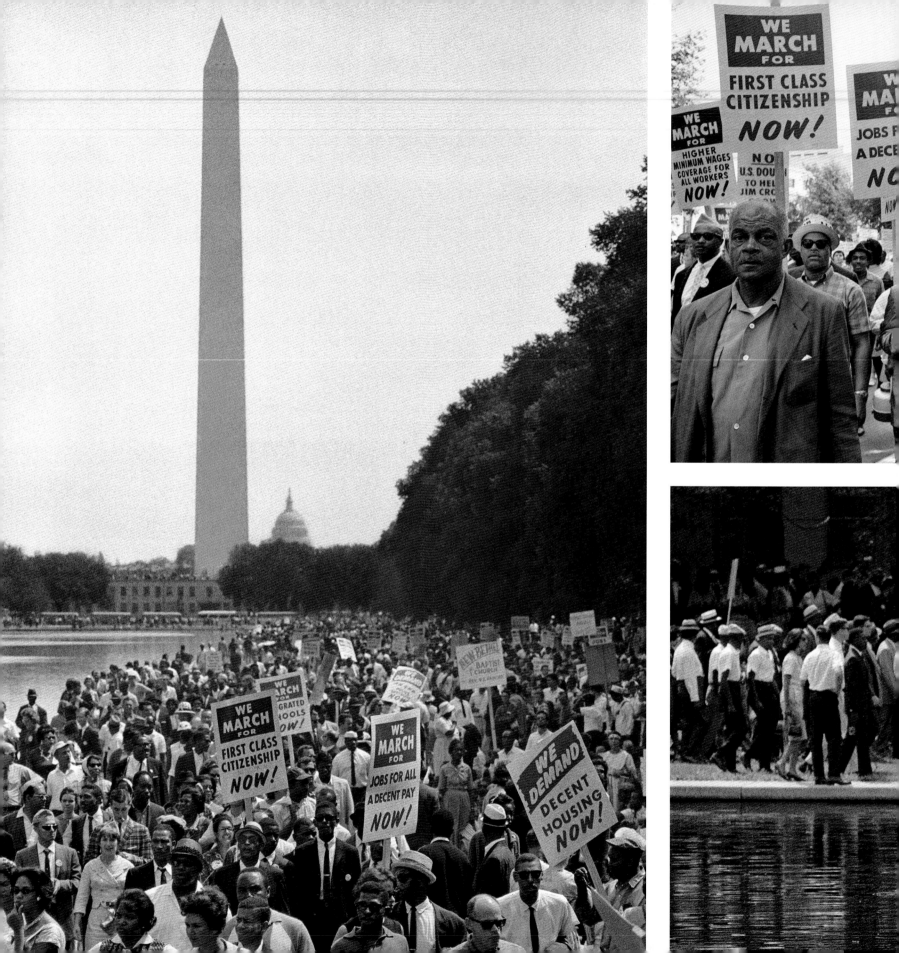

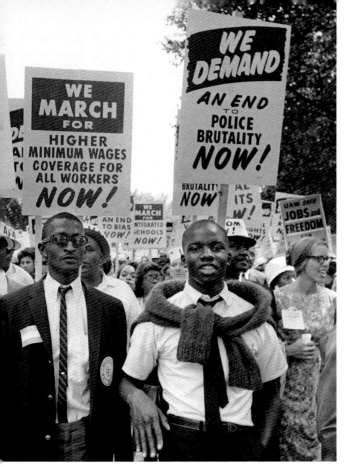

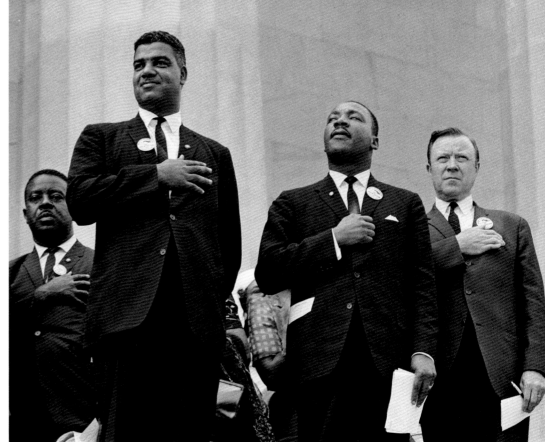

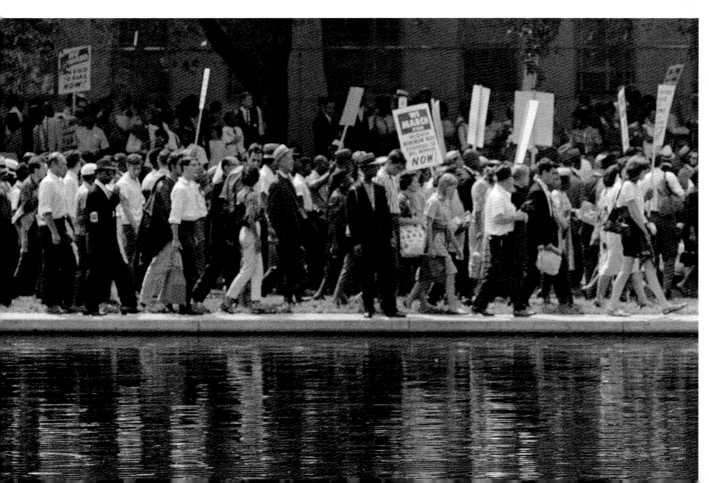

Above: Leaders including the Reverend Ralph Abernathy (far left) and National Urban League Director Whitney Young Jr. (left) join King to pledge allegiance at the beginning of the ceremony at the Lincoln Memorial, Washington, D.C.

"They came from all over the nation, assembled at the Washington Monument where they heard speeches and were entertained by the likes of Joan Baez. The actual march was from the Washington Monument to the Lincoln Memorial."

Left, top and bottom: Marchers en route to the Lincoln Memorial, Washington, D.C.

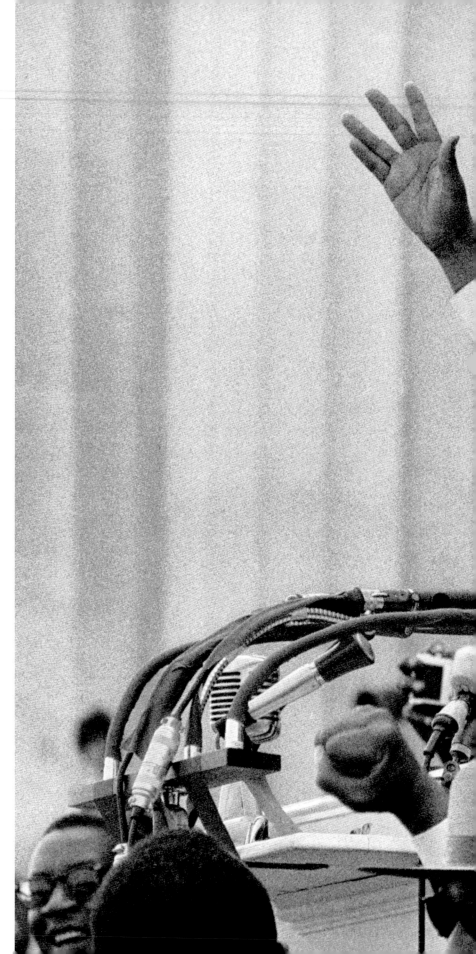

The Dreamer dreams: King ends his speech with the words of the old Negro spiritual, "Free at last! Free at last! Thank God Almighty, we are free at last!" Washington, D.C.

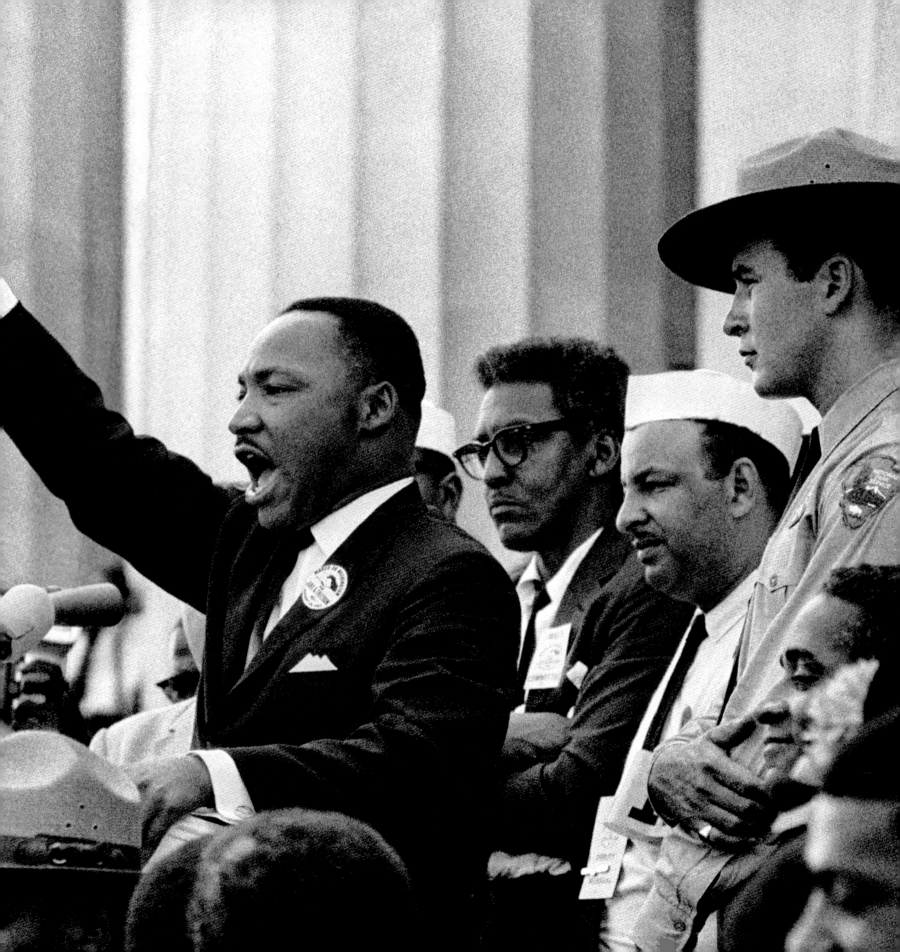

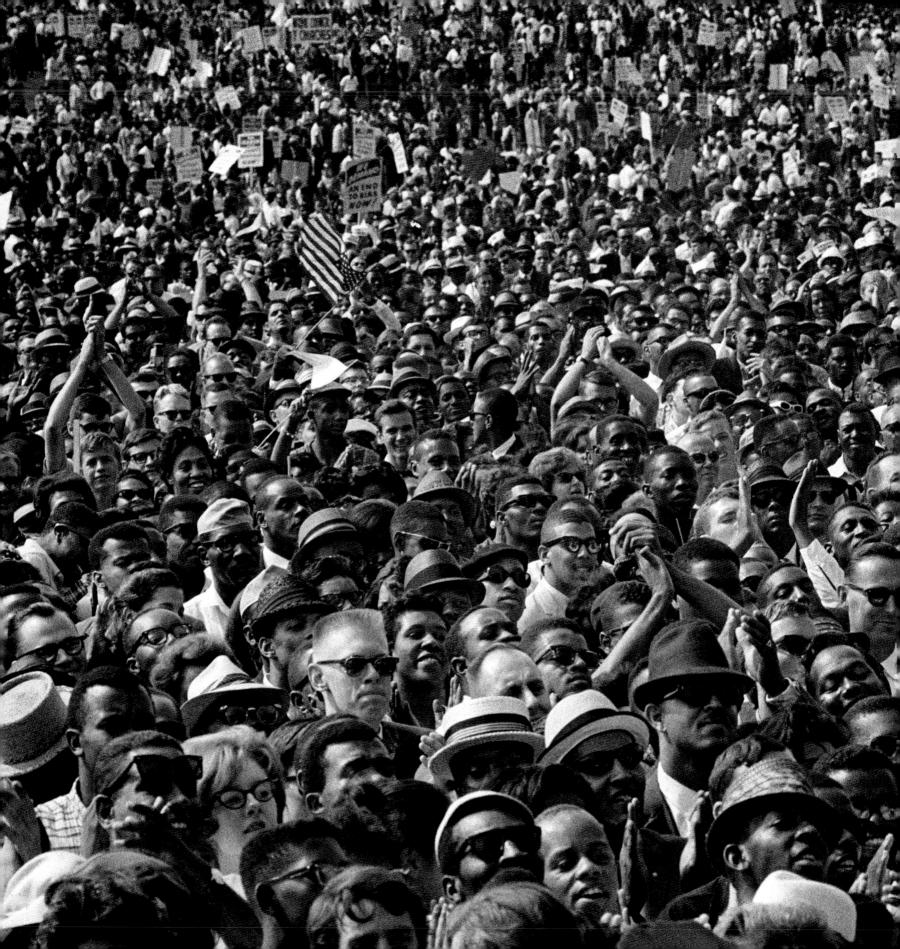

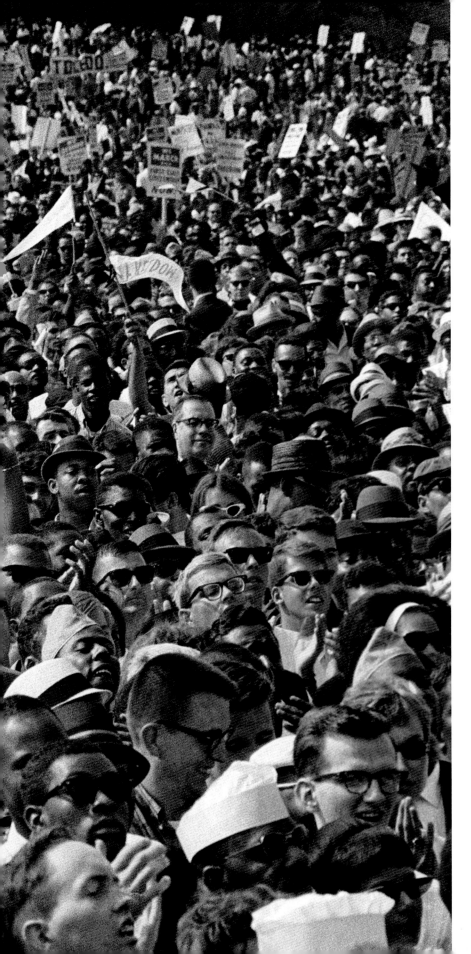

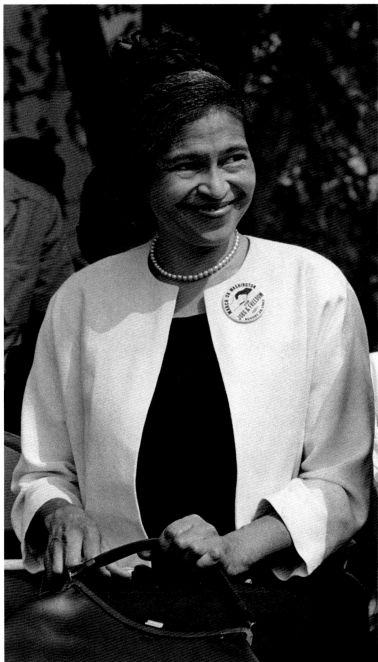

Rosa Parks, an honored guest at the march, Washington, D.C.

"As King made his urgent call to the nation for action, spontaneously chanting his never-to-be-forgotten dream, his plea was answered by a rising crescendo of roars, cheers and thunderous clapping. By the power and urgency of his appeal, the mass and unity of his supporters, you just knew 'His truth is marching on.'"

Amen, brother: enthusiastic march participants as King speaks, Washington, D.C.

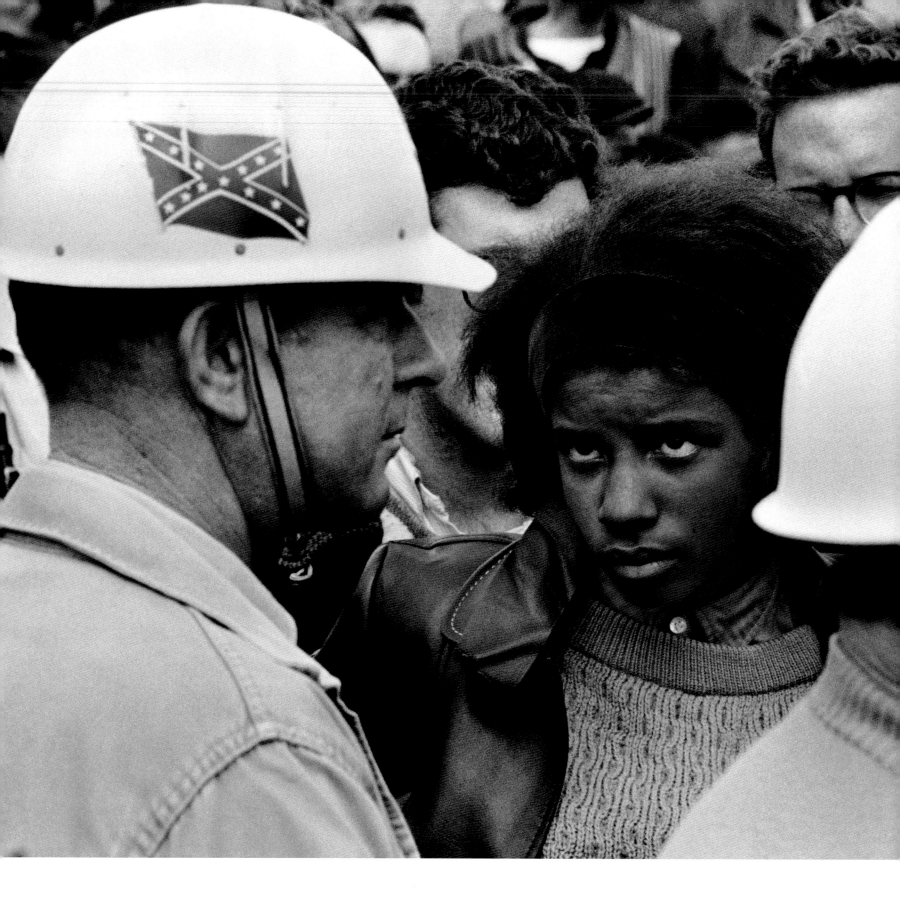

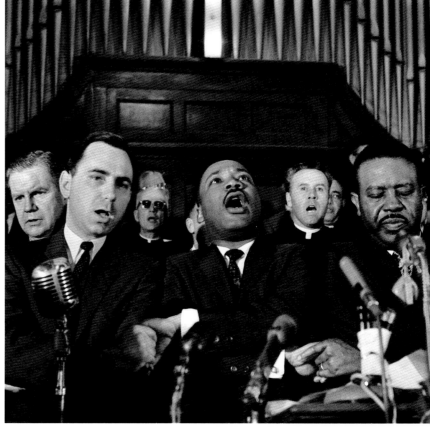

King leads the singing of "We Shall Overcome" after eulogizing a slain civil rights crusader, the Reverend James Reeb, Brown Chapel, Selma, Alabama.

"Shortly after accepting the Nobel Peace Prize, King left that high point in his life in Stockholm to return to the valley. On the streets of Selma, he planned to fight for laws that would guarantee equal voting rights throughout the South."

Hard stare: A young woman penned in by Sheriff Jim Clark's posse glares as her fellow demonstrators chant, "No more Jim Clark over me," Selma, Alabama.

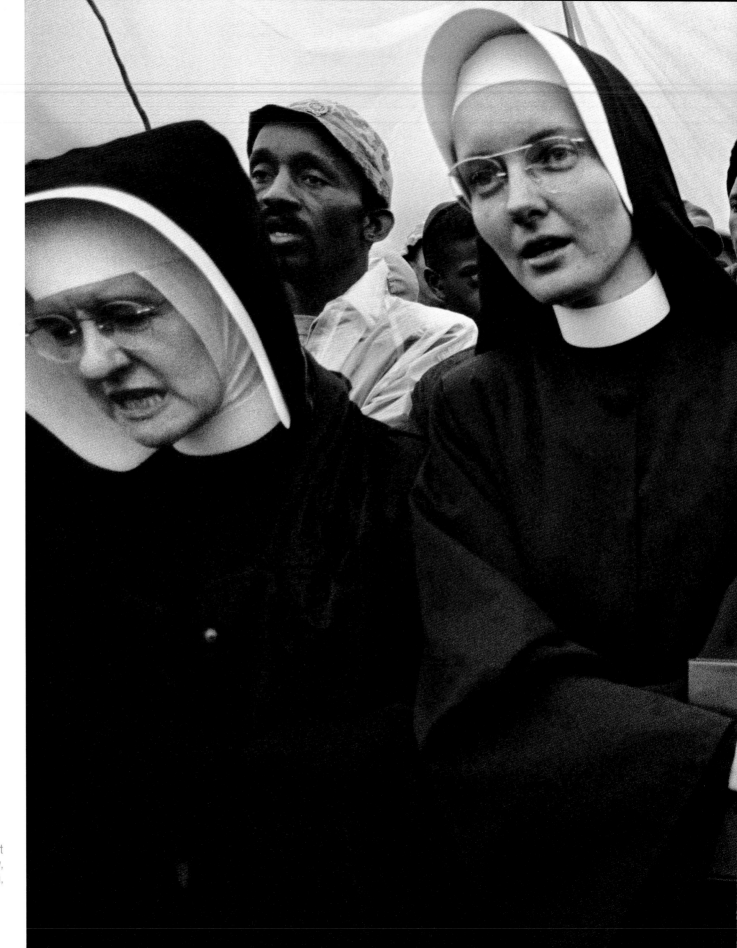

Answering King's call for support from the religious community, nuns join the protests, Selma, Alabama.

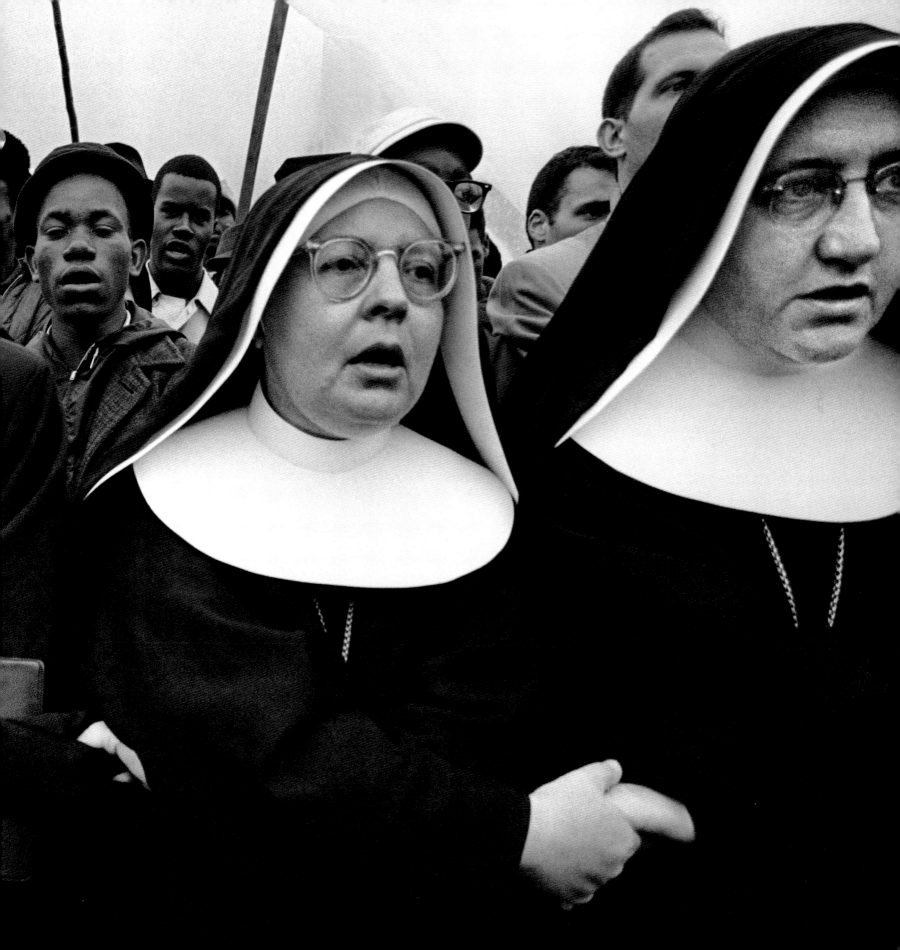

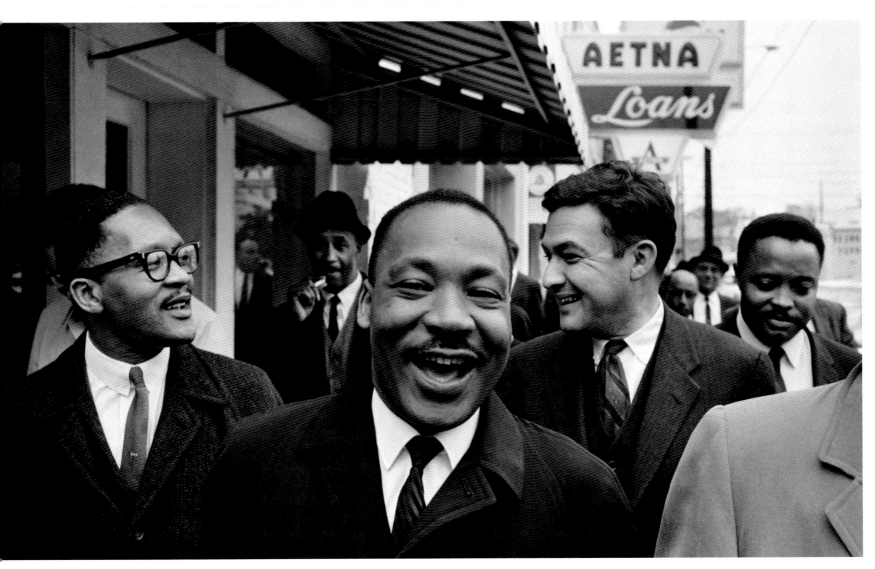

King is exultant after a federal judge, Frank Johnson, rules that the Selma-to-Montgomery march can proceed, Montgomery, Alabama.

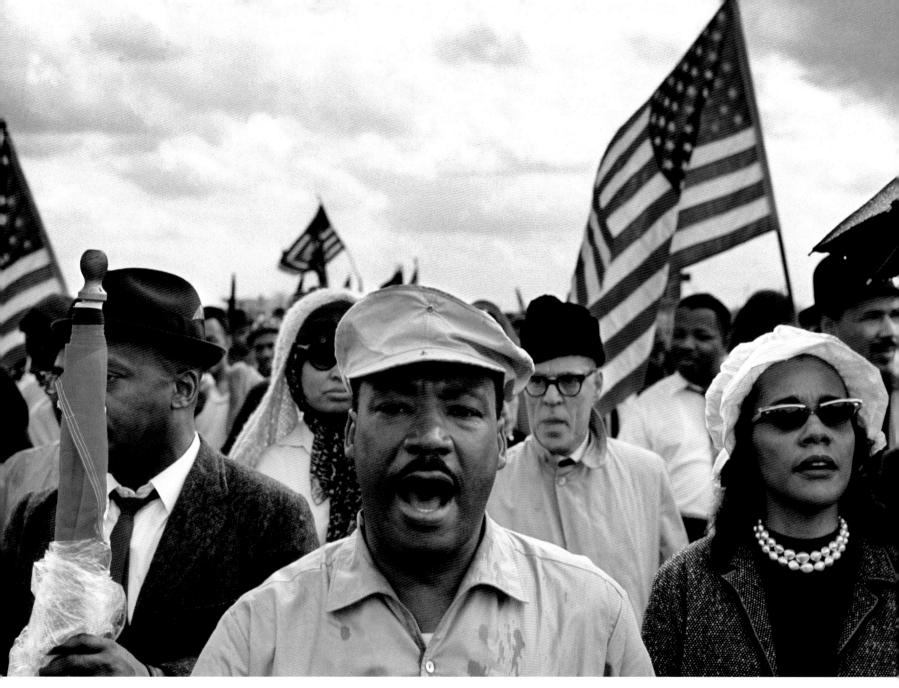

Glory bound: King and his wife, Coretta, lead the marchers on Jefferson Davis Highway en route to Montgomery, Alabama.

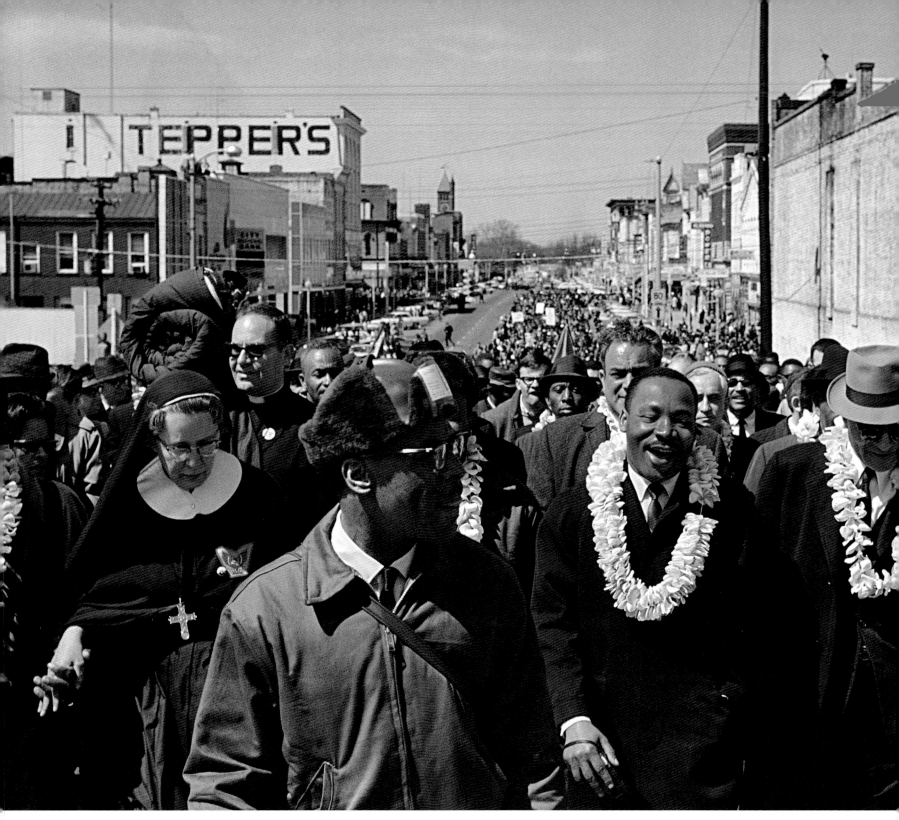

Crossing over: King leads the Montgomery-bound marchers over the Edmund Pettus Bridge, which was already famous for shocking scenes of police brutality, Selma, Alabama.

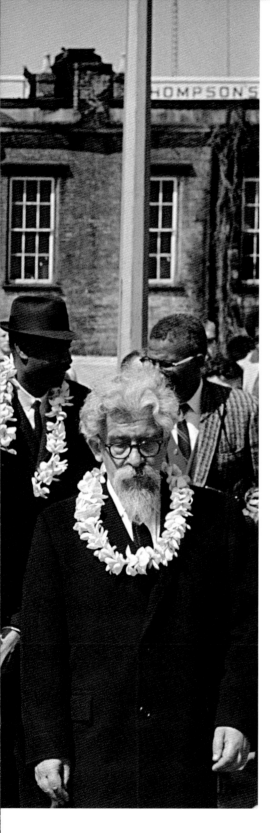

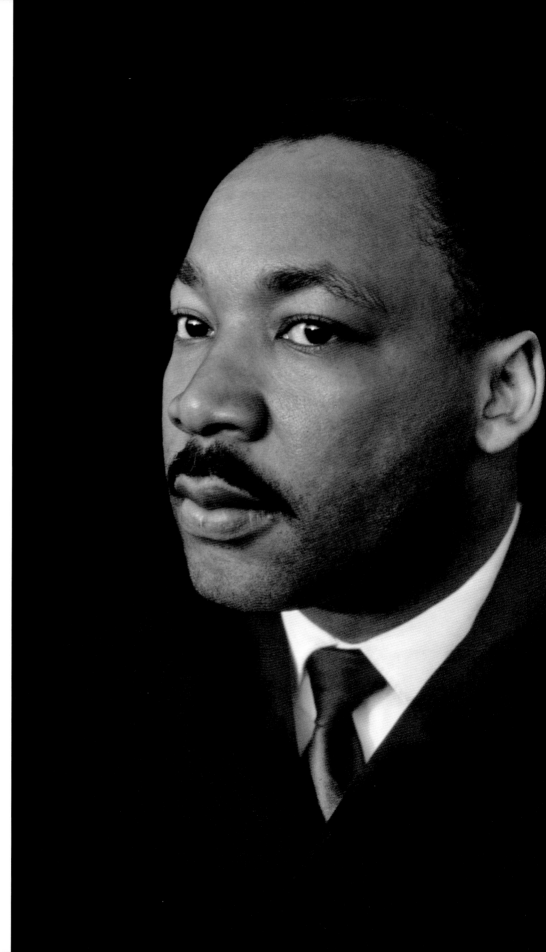

Eyes on the prize: King in a quiet moment during the march to Montgomery, Alabama.

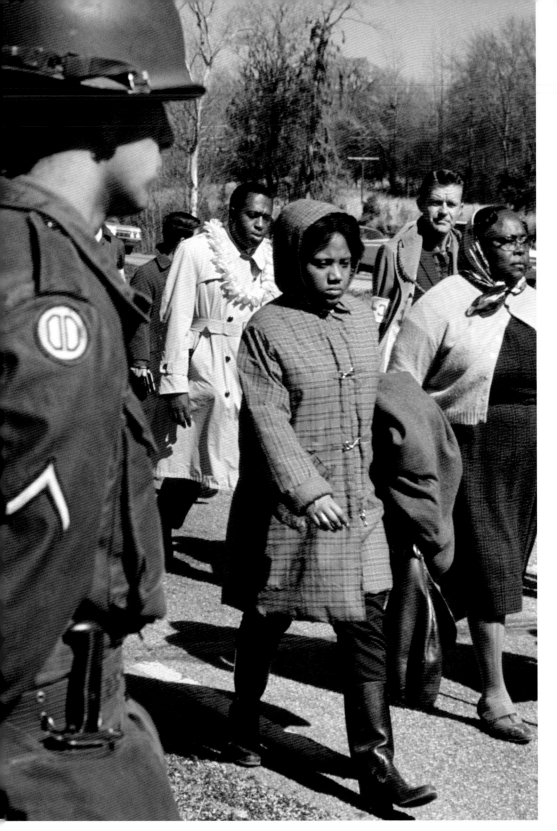
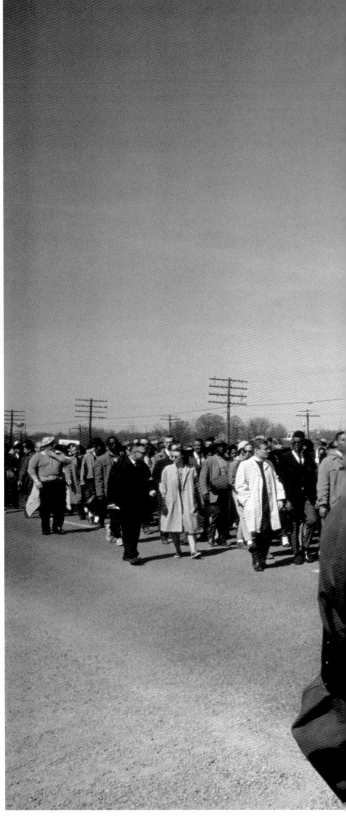

Marchers on the road to Montgomery, as their ranks swell to an eventual 25,000 strong.

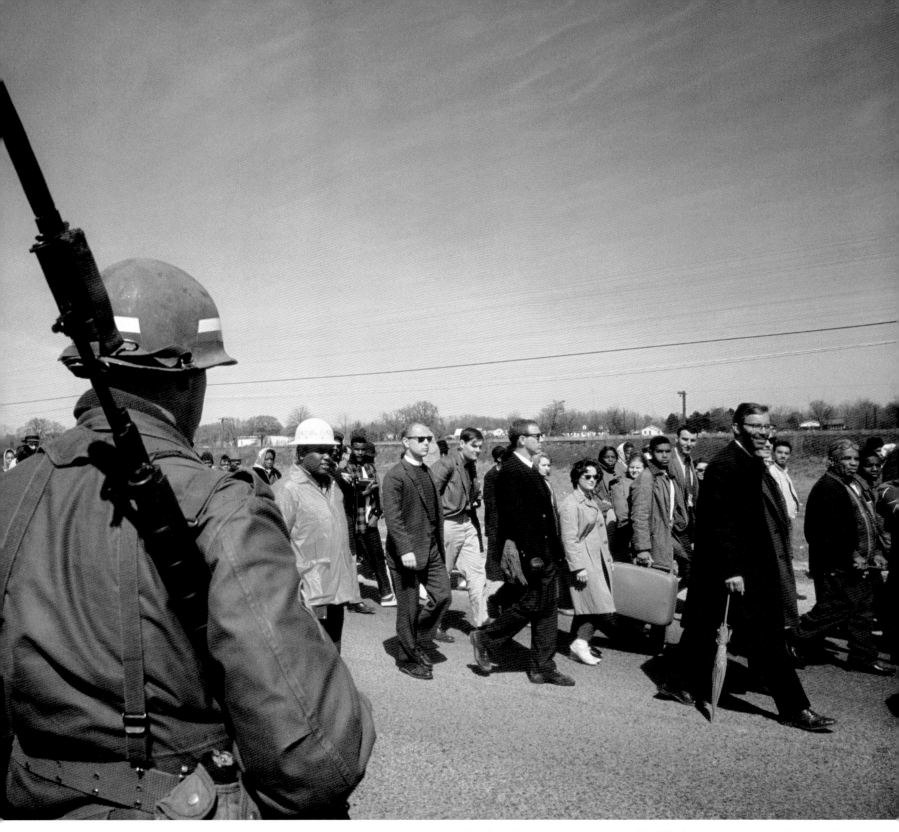

"With helicopters whirring above and the 54 miles of highway closely guarded by U.S. Army troops and the Alabama National Guard, the march into the Cradle of the Confederacy, Montgomery, was the greatest display of the power of the people's right to peacefully petition since Gandhi's Salt March to the sea. King's ultimate faith in American justice was rewarded by the military's protection, by President Johnson's vow that 'we shall overcome' and by Johnson's call for passage of a voting rights bill."

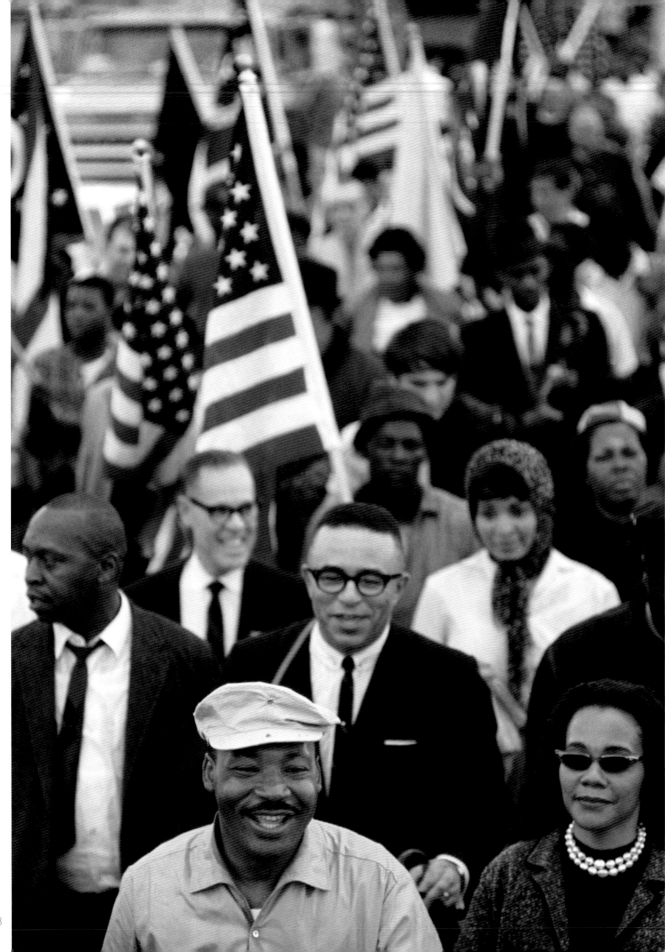

"King broke into a grin as he entered the city limits of Montgomery. Some of the obstacles he had overcome had to be on his mind."

Left: The marchers unfurl their flags, preparing to parade through the city, Montgomery, Alabama.

Opposite:
Top left: Sheriff Jim Clark flashes his famous "Never" button, Selma, Alabama.

Top right: Hecklers along the road, Selma Highway, Alabama.

Bottom: A car drives by on the Selma Highway while marchers take a break on the side of the road.

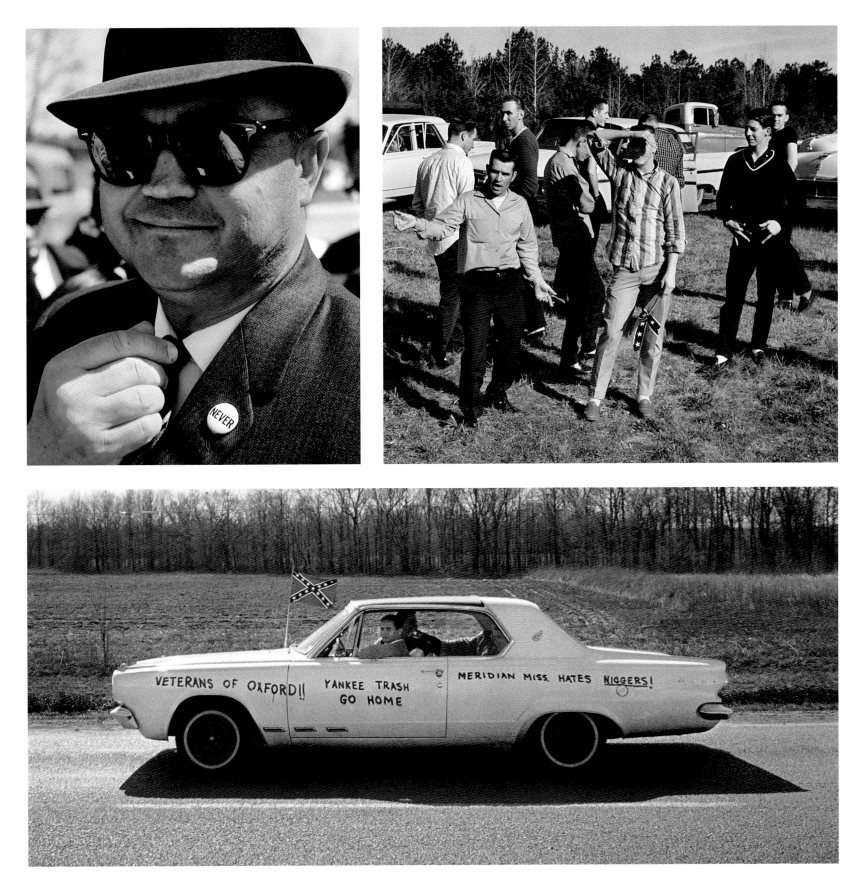

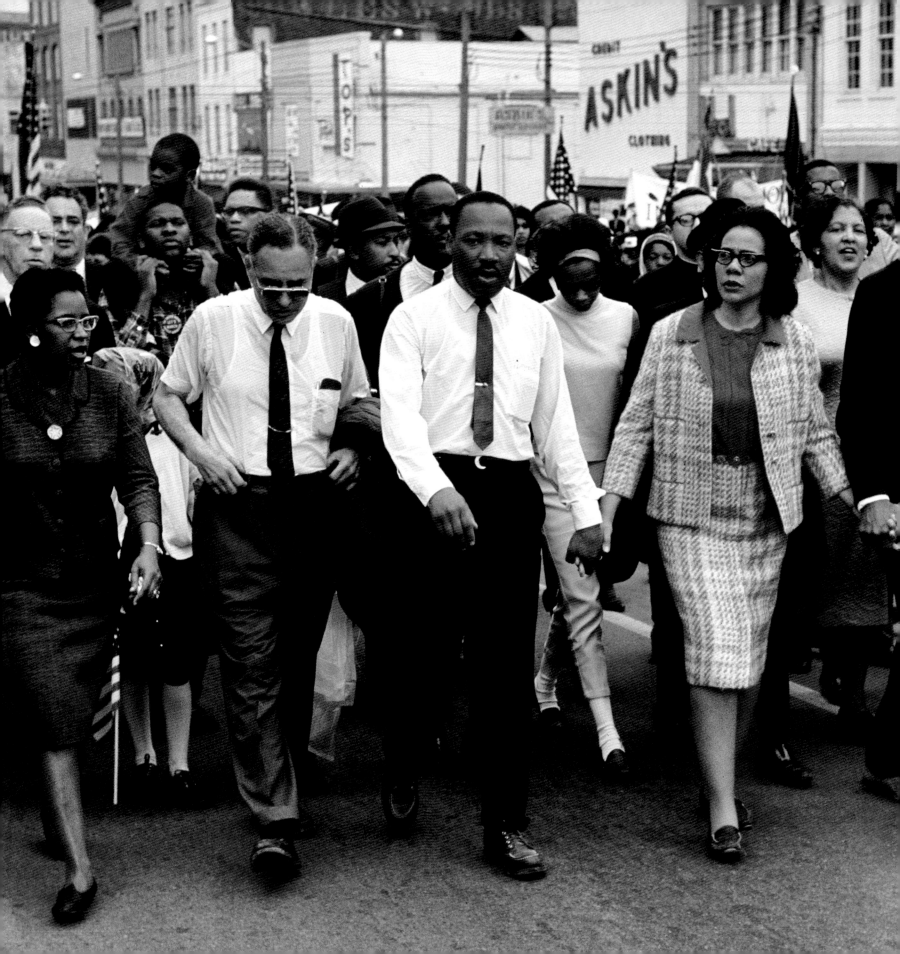

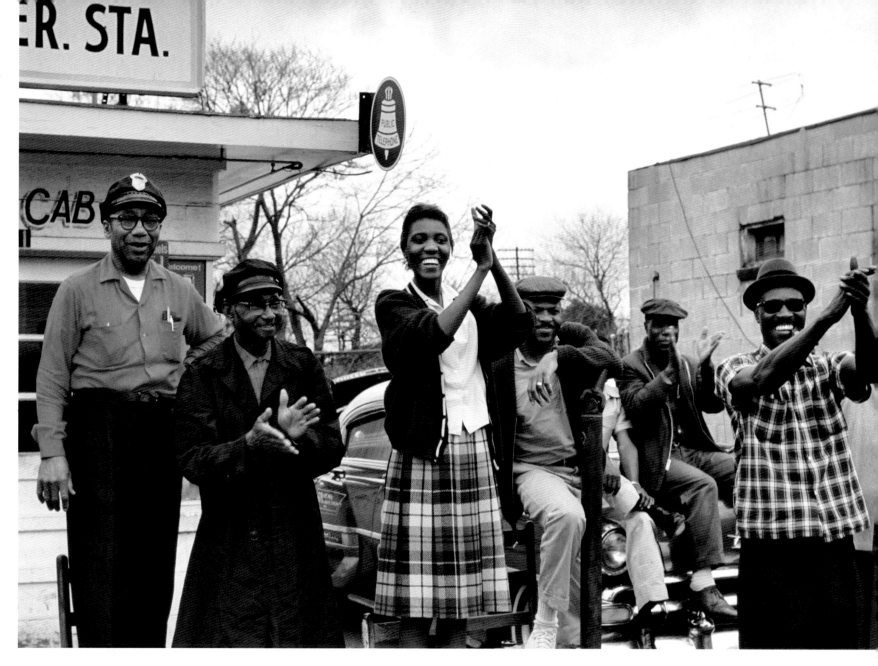

Opposite: Leading a throng of 25,000 marchers, King enters the downtown, Montgomery, Alabama.

Above: The marchers are cheered by workers at a cab stand that was one of the bulwarks of the Montgomery bus boycott ten years earlier, Montgomery, Alabama.

Left: Not everyone favors the march, Montgomery, Alabama.

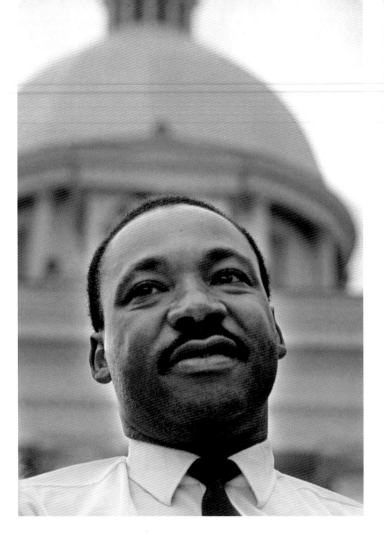

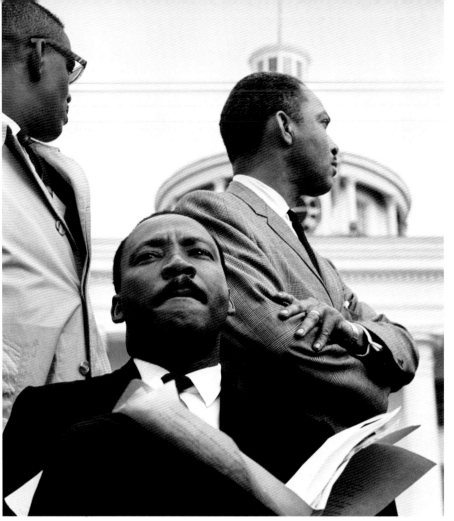

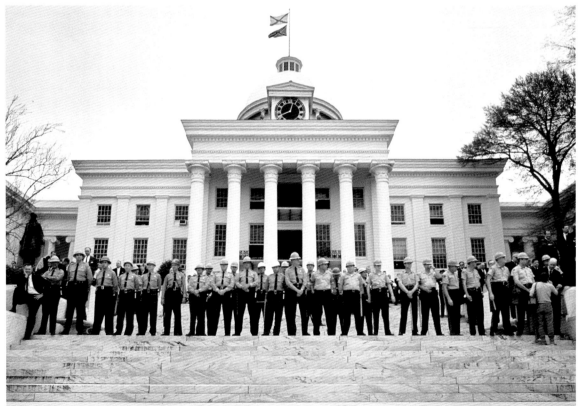

"In the heart of the heart of Dixie, with Alabama Governor George Wallace reportedly watching from behind curtains in the capitol building, King told the crowd 'Let us march on ballot boxes until race baiters disappear from the political arena.'"

Above, left and right: King gazes out at the crowd then prepares his speech, Montgomery, Alabama.

Left: Officers guard the entrance of the state capitol, on whose steps Jefferson Davis took the oath of office as president of the Confederacy, Montgomery, Alabama.

Opposite: King speaks to the crowd, Montgomery, Alabama.

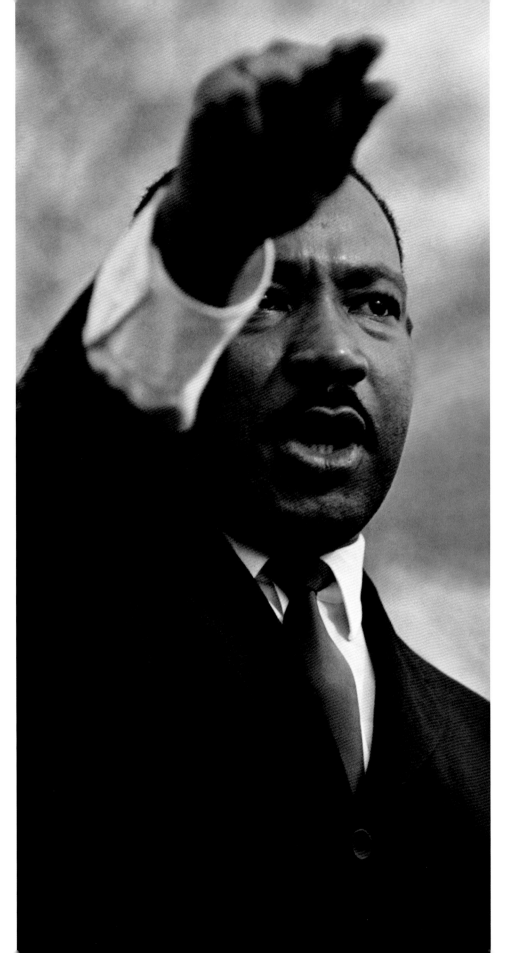
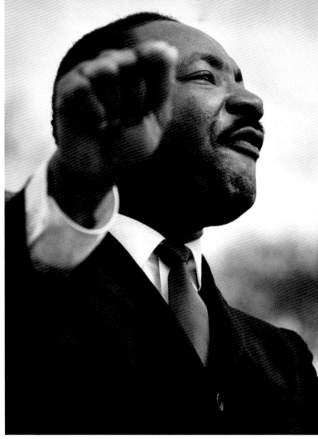
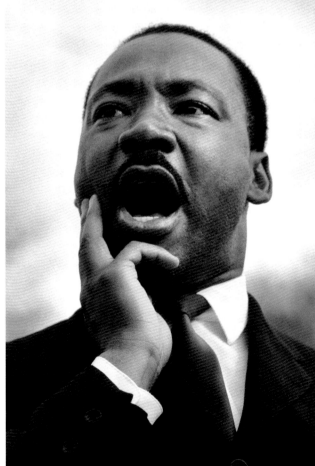

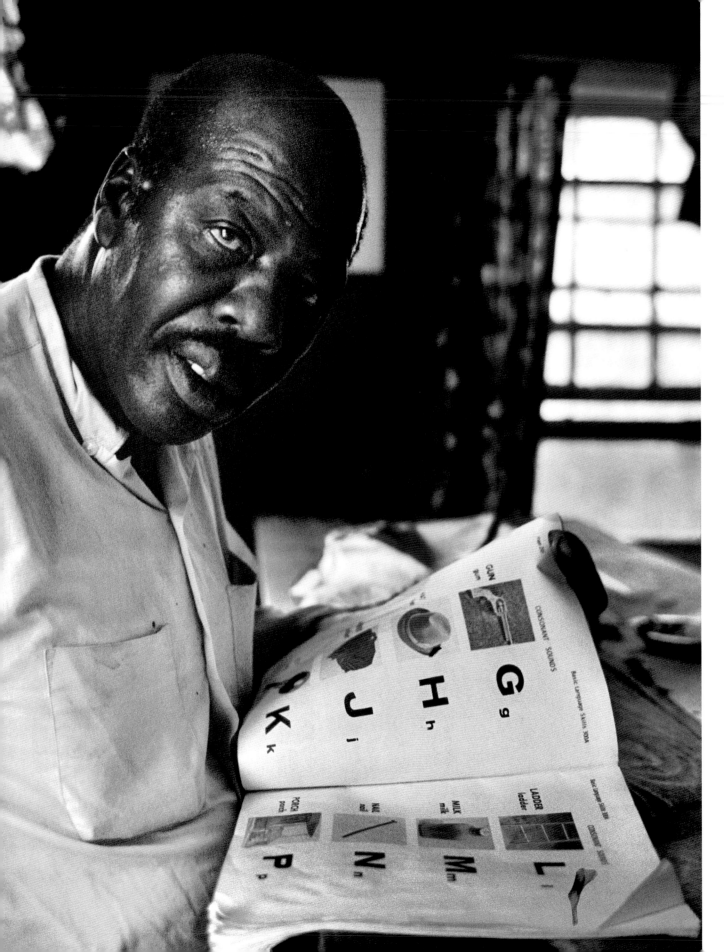

Getting the word: Ollie Robinson, an unemployed farmworker, learns to read, the Mississippi Delta, Mississippi.

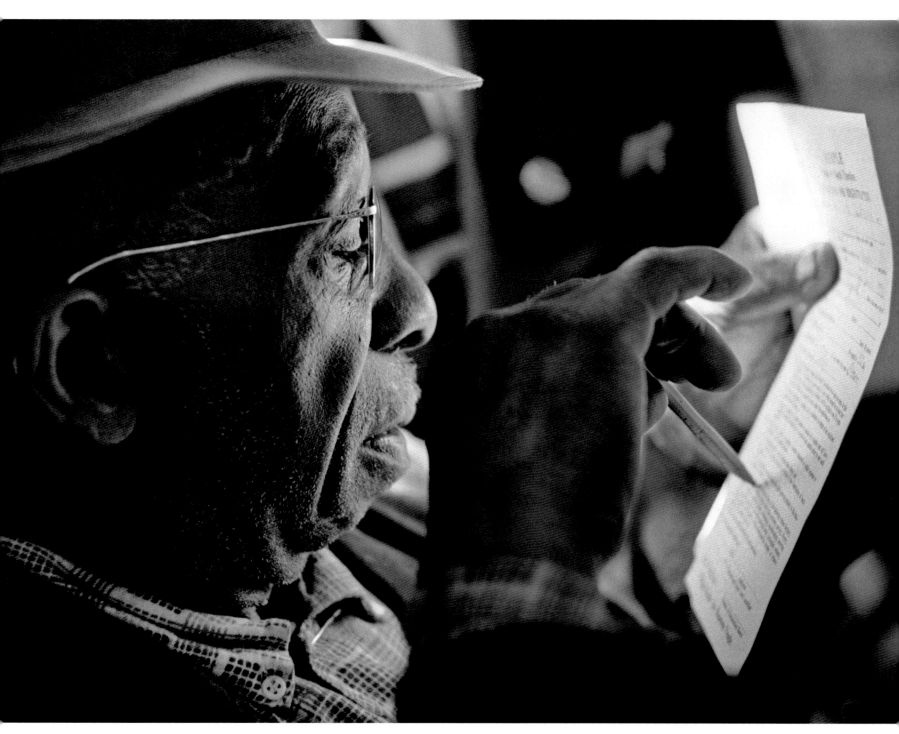

A precious right: A candidate studies the practice form for a voter registration test — which he will pass, Sumter, South Carolina.

"Starting with Reconstruction after the Civil War, whites gained and maintained political control in the South by systematically denying blacks the vote. One of the most pernicious deterrents after the poll tax was abolished was the use of literacy tests."

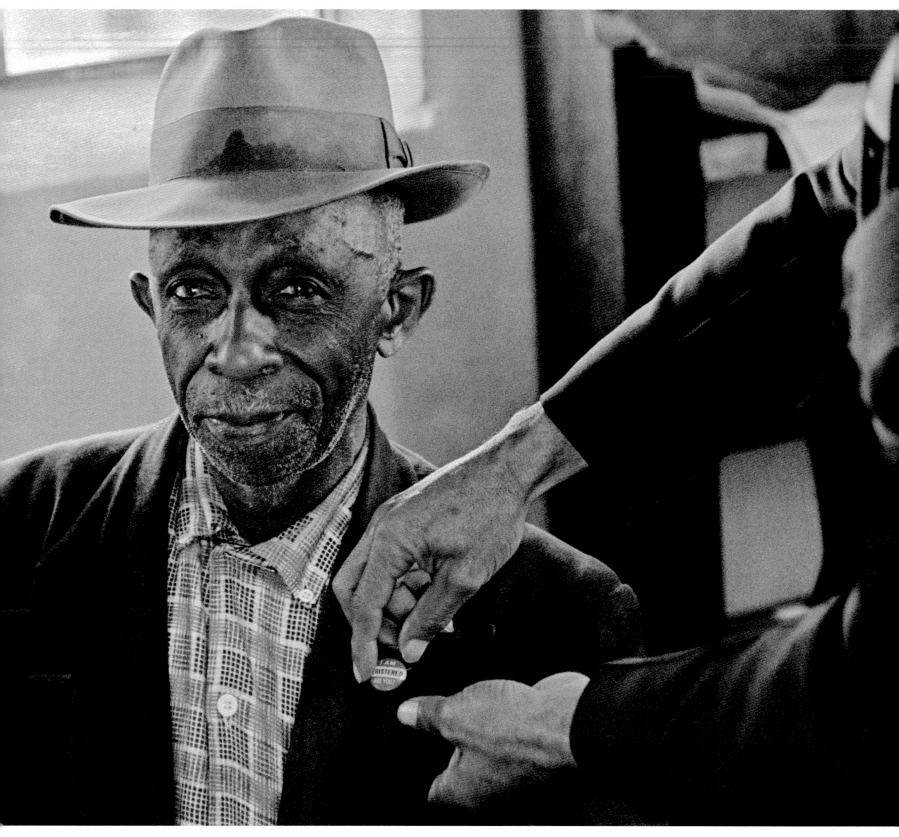

A successfully registered voter is awarded his button, Sumter, South Carolina.

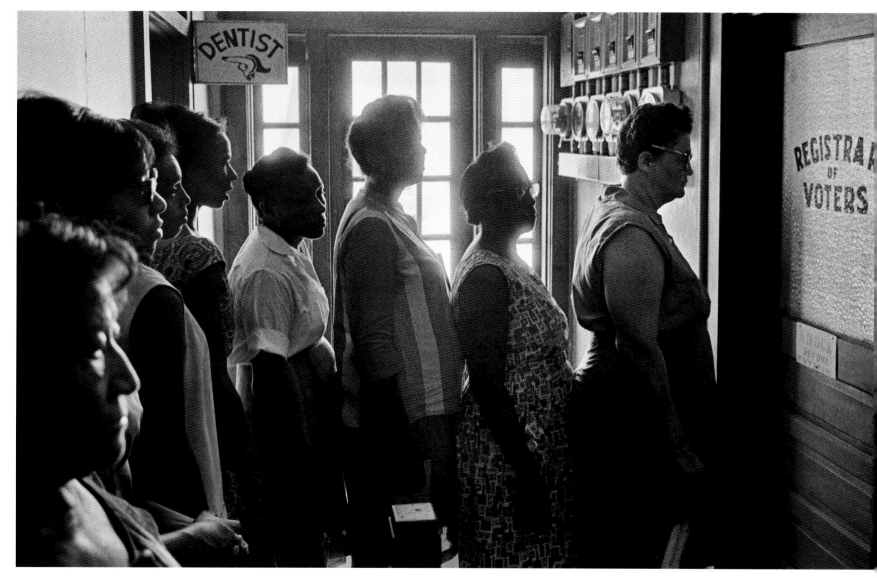

A study in impatient patience, voter applicants line up then wait — and wait and wait — to register, Clinton, Louisiana.

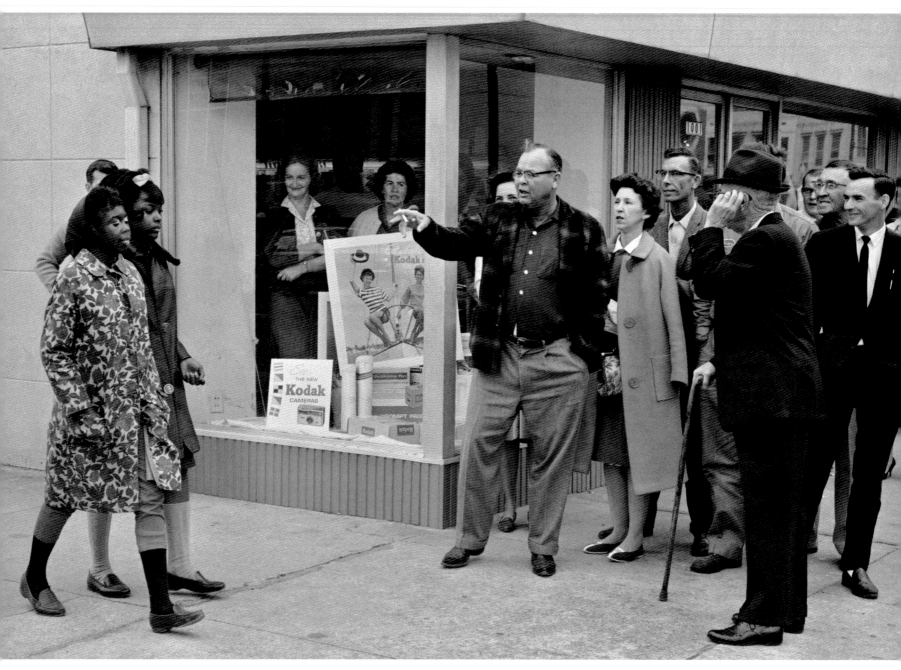

Words can wound, and the hecklers know it as they insult two black women who are part of a voting rights drive, Selma, Alabama.

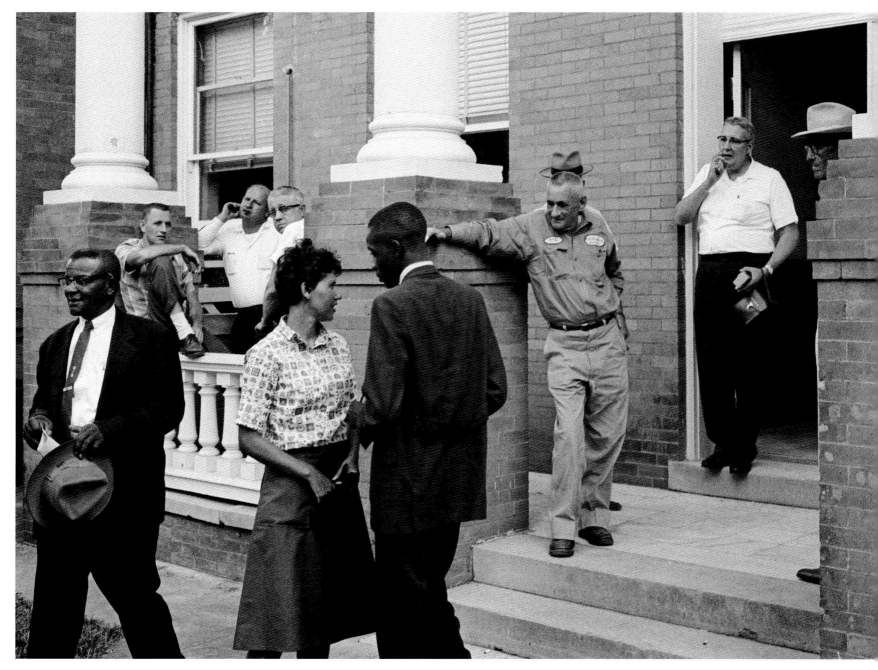

After eight years of trying, the Reverend Joe Carter succeeds in registering to vote then is jeered as he walks down the courthouse steps, St. Francisville, Louisiana.

"Joe Carter was the first African American in his parish to register to vote in the twentieth century—this despite the fact that two out of three residents of the parish were black. Once he succeeded in his quest, danger was in the air. I remember someone at the courthouse shouting at me, 'Take his picture, it may be the last one he takes.'"

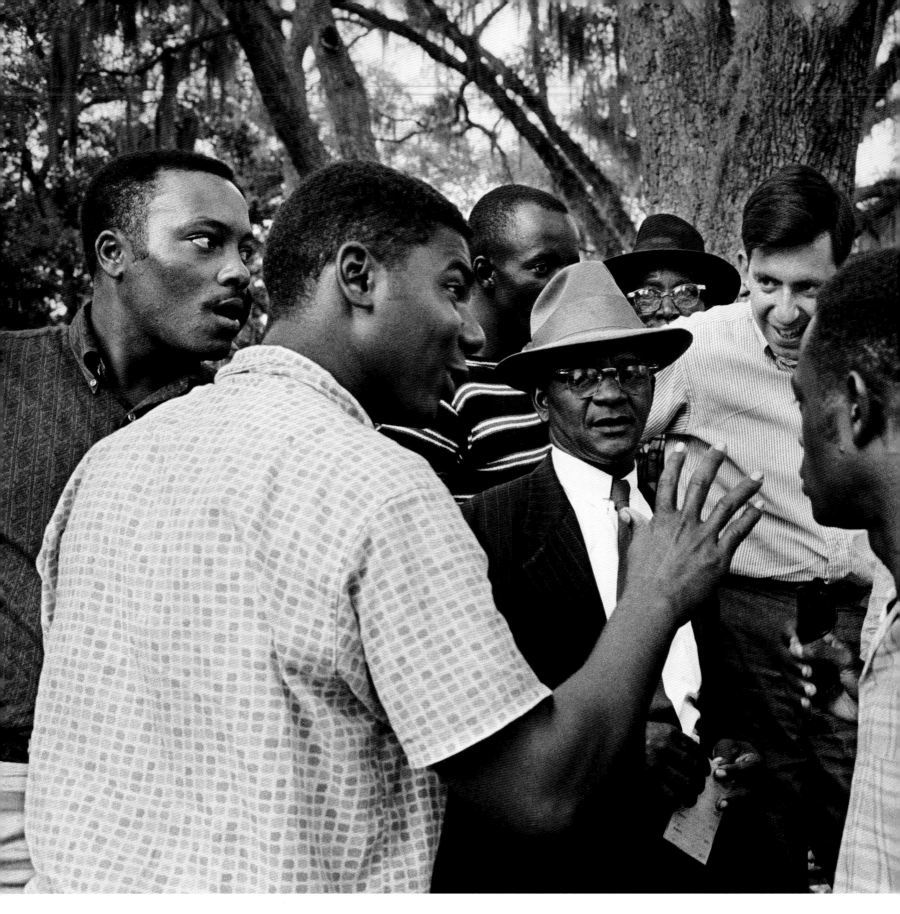

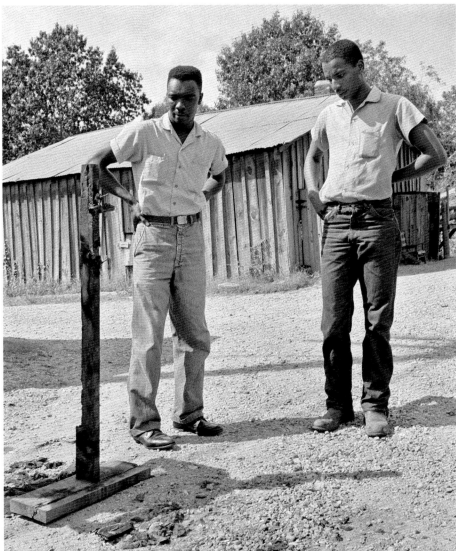

Burned cross: In response to the Reverend Joe Carter's efforts to register and vote, Klansmen attempt to intimidate local blacks, West Feliciana Parish, Louisiana.

Neighbors and civil rights workers gather to congratulate Carter and hear about his historic breakthrough, West Feliciana Parish, Louisiana.

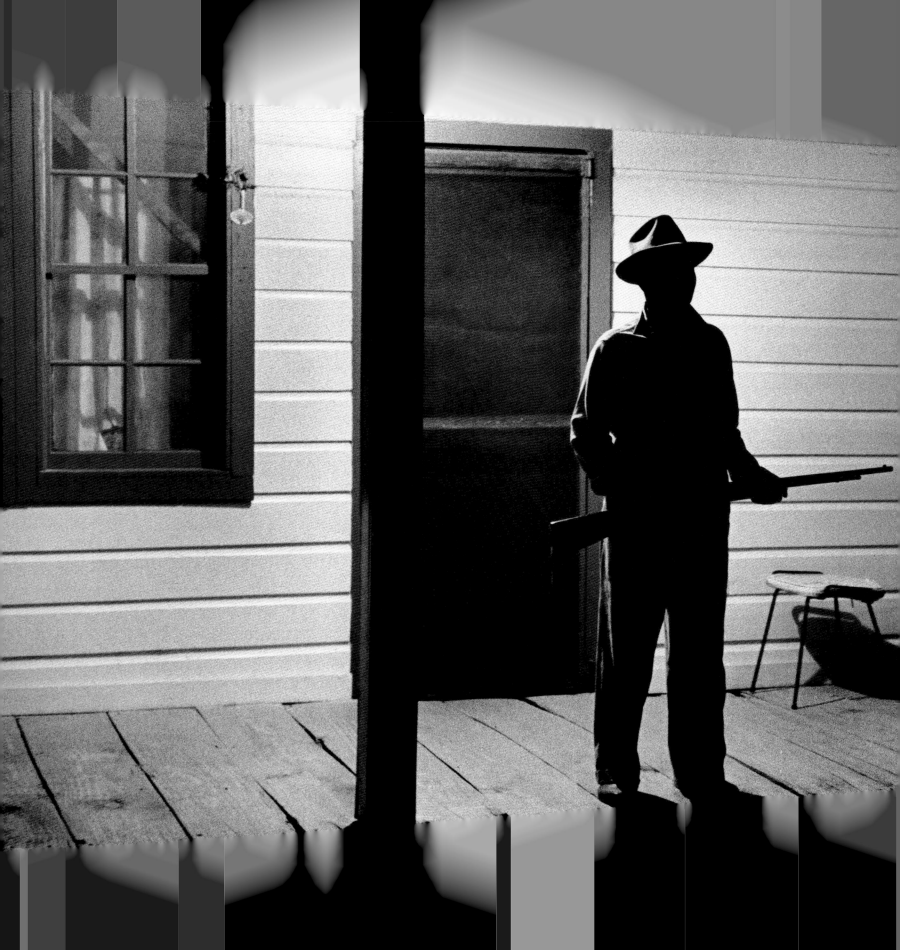

"After Reverend Carter had registered to vote, that night vigilant neighbors scattered in the woods near his farmhouse, which was at the end of a long dirt road, to help him if trouble arrived. 'If they want a fight, we'll fight,' Joe Carter told me. 'If I have to die, I'd rather die for right.'

"He told me, 'I value my life more since I became a registered voter. A man is not a first-class citizen, a number one citizen, unless he is a voter.' After Election Day came and went, Reverend Carter added, 'I thanked the Lord that he let me live long enough to vote.'"

Carter, expecting a visit from the Klan after he has dared to register to vote, stands guard on his front porch, West Feliciana Parish, Louisiana.

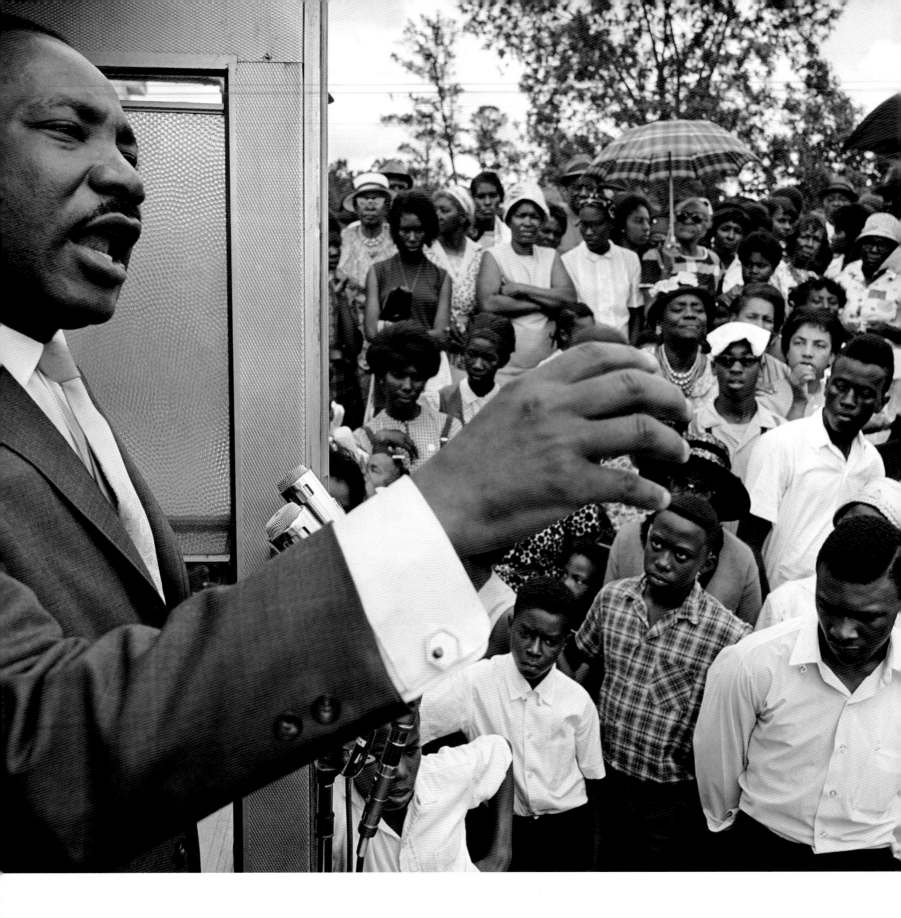

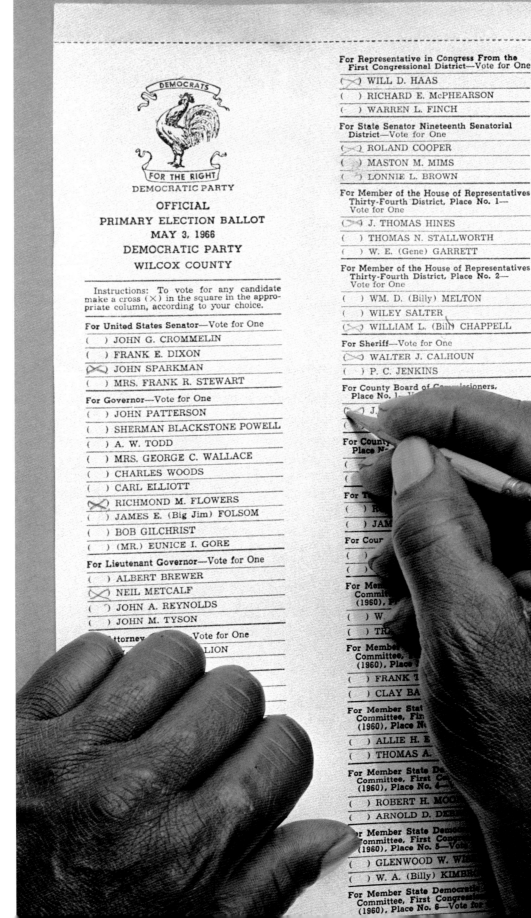

"'Give us the ballot!' King had demanded in his maiden speech to the nation while standing in Lincoln's shadow at the Prayer Pilgrimage in Washington, D.C., in 1957. Now that demand had been met, and King implored his followers to overcome their fears and walk through the opened door."

Opposite: Getting out the vote, King travels throughout the South urging his brethren to take advantage of the newly enacted Voting Rights Act.

Right: Making his mark, one of the first African Americans to cast a vote under the new law exercises his franchise, Camden, Alabama.

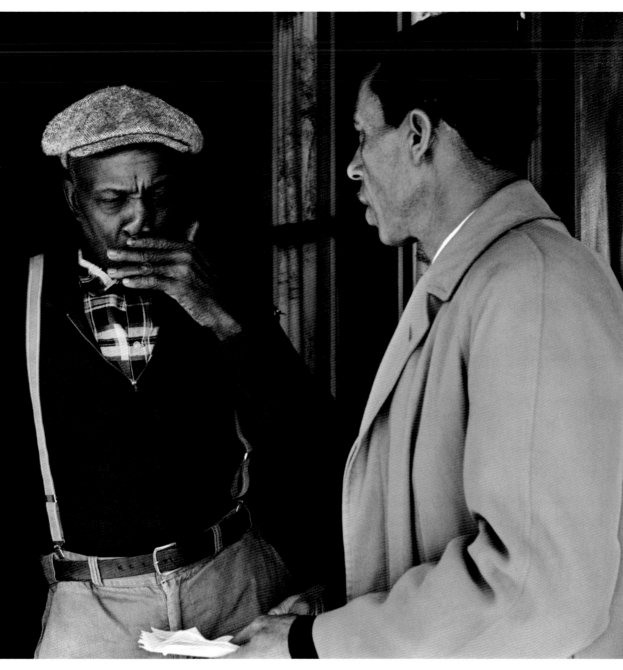

A candidate ponders what he's hearing as voter-registration organizer Frank Robinson offers assistance, Sumter, South Carolina.

"During the debate on the Voting Rights Act of 1965, Dr. King argued strenuously that illiterate blacks should have the right to cast their ballots orally. He justified his position by pointing out the poor quality of education offered in separate-but-equal schools."

Having his say: An illiterate first-time voter casts his ballot orally under the provisions of the Voting Rights Act as an FBI agent looks on, Camden, Alabama.

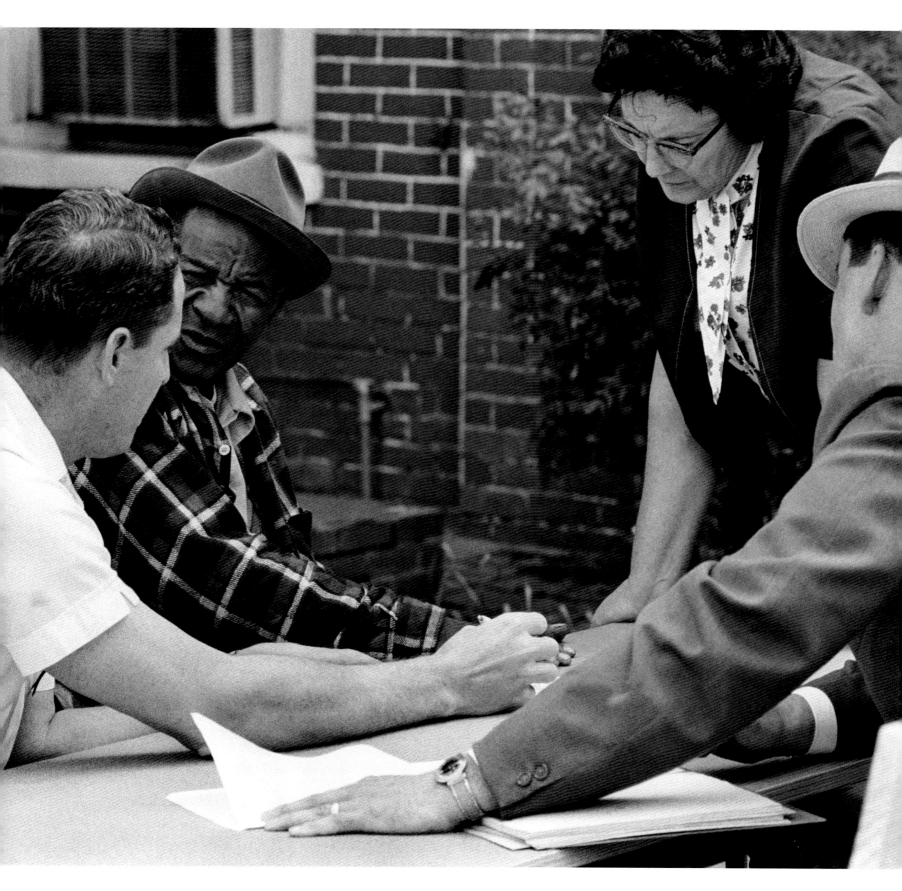

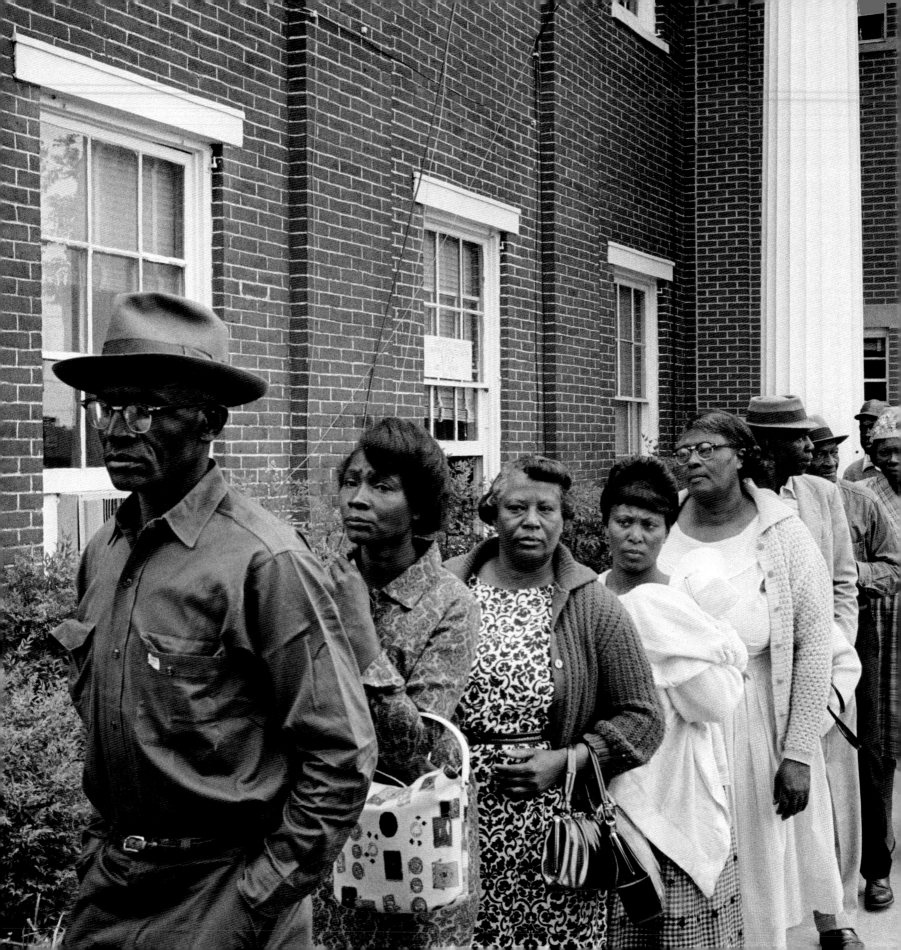

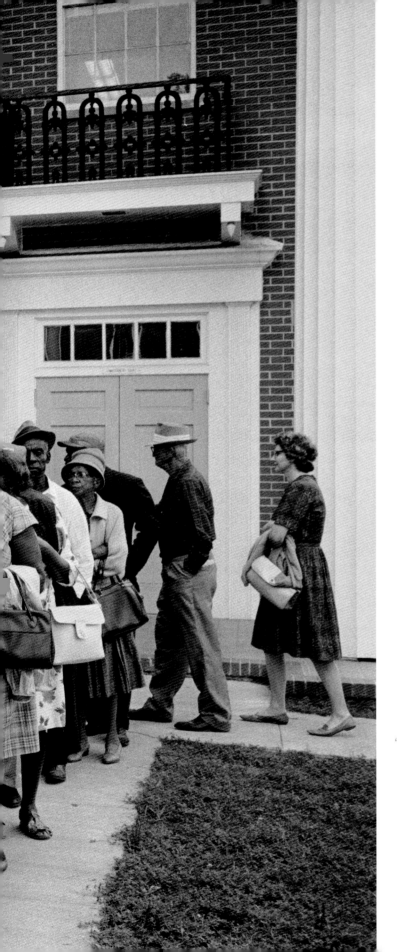

"The Voting Rights Act of 1965 changed everything, outlawing literacy tests and other barriers. It made it possible for thousands of black officials to eventually be elected in the South, and it certainly helped in the election of two white southerners to the presidency. It was a large factor in the gradual decrease of racial tension throughout the South. In a rare show of unity, more than forty years after the Voting Rights Act was passed, Congress renewed the measure unanimously."

A new day dawns: Voters, most of them about to fill out their first-ever ballots, line up at the courthouse, Camden, Alabama.

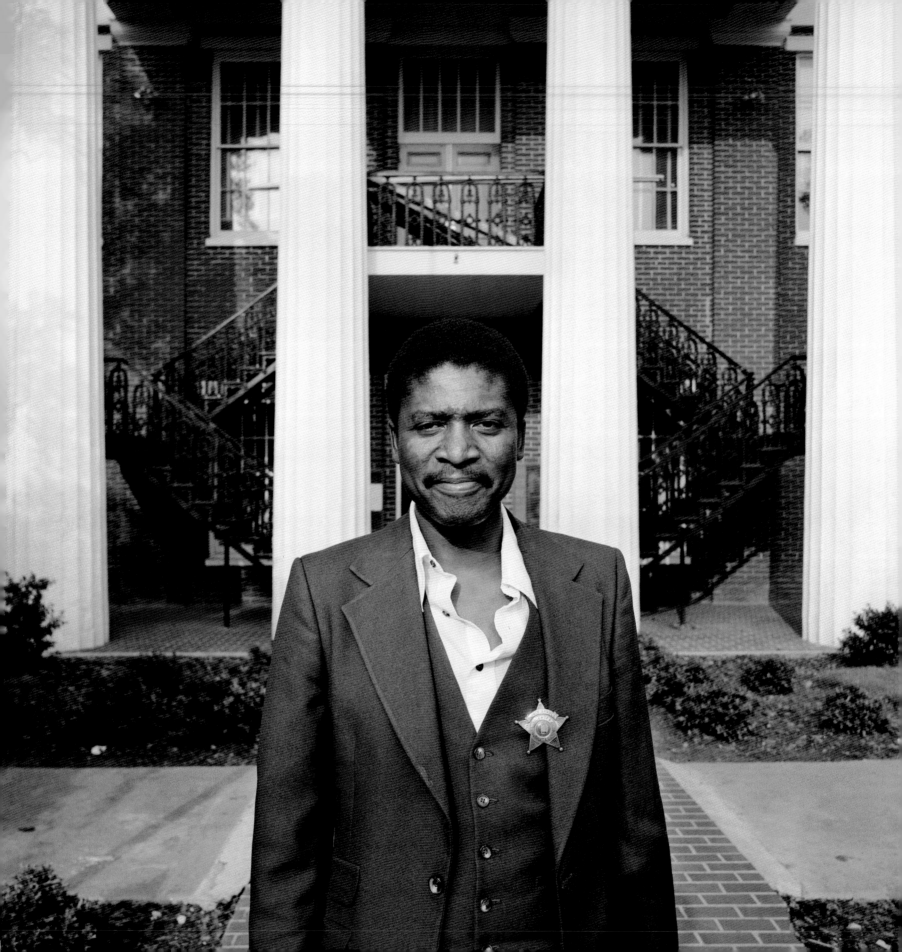

The New South: In the old county courthouse, U.S. Senator Richard Shelby greets the sheriff, Camden, Alabama.

The Man: Prince Arnold stands in front of the courthouse. He is the first black sheriff elected under the Voting Rights Act in Wilcox County, Alabama.

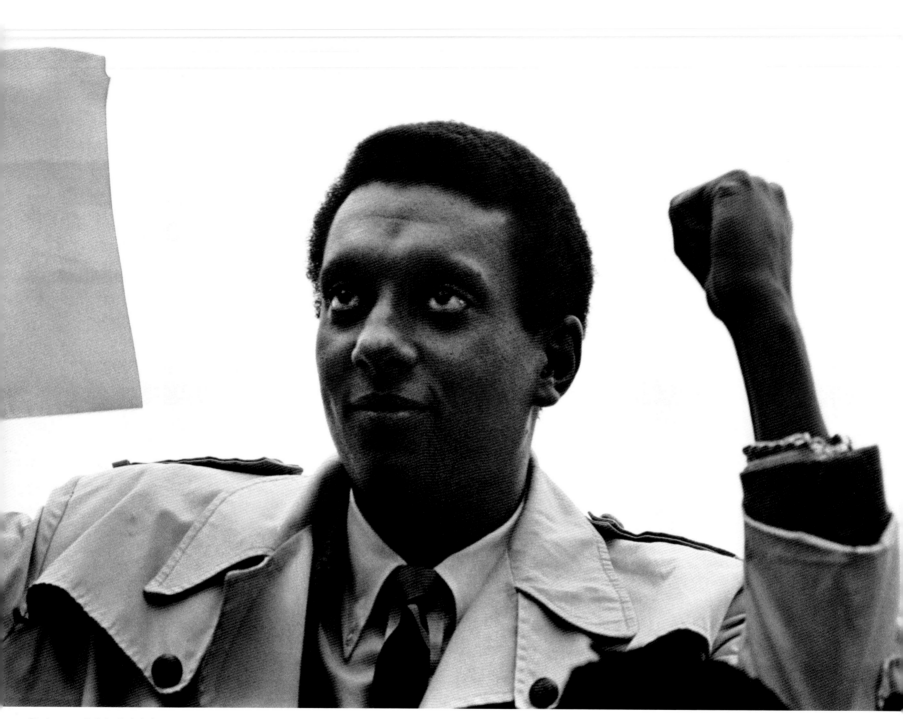

Black power: Activist Stokely Carmichael salutes a peace rally at the United Nations, New York City.

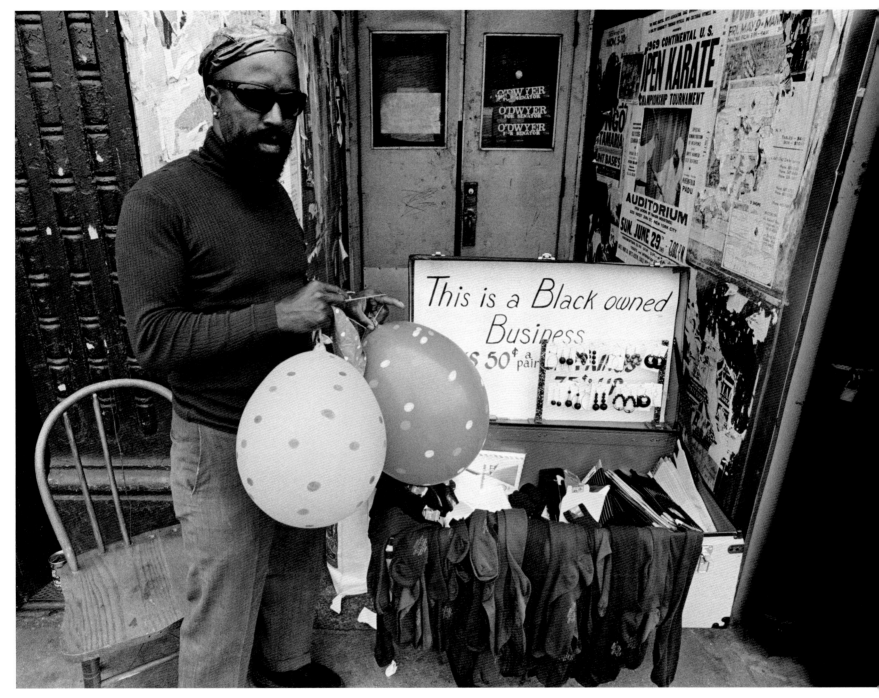

Black enterprise: A peddler displays his wares in a doorway on 125th Street, Harlem, New York City.

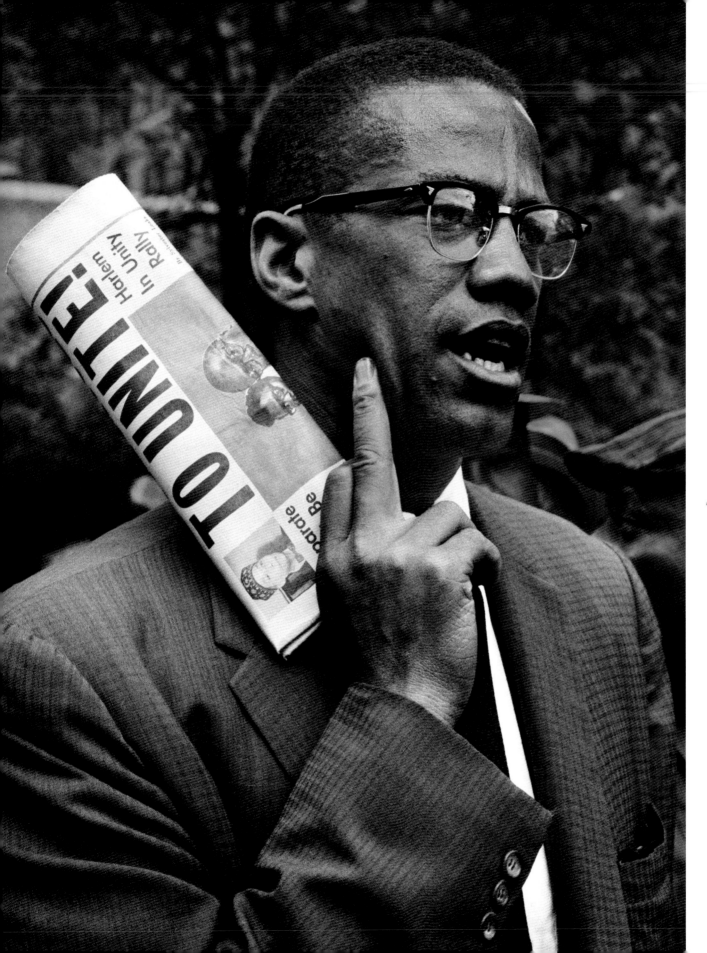

"He was a fiery orator. No one could give tongue to the grievous wrongs suffered by African Americans in white America more trenchantly than Malcolm. To get his message out to the assembled press, he showed up at civil rights demonstrations as the photographer for *The Messenger*. We sometimes discussed cameras and f-stops. I was surprised when he asked me how I thought the Black Muslim faith compared to Islam. Emphasizing my limited knowledge, I very hesitantly favored Islam — it welcomed all races and was older and wiser. Some time later he converted to Islam, which was a great revelation for him but, tragically, led to his assassination."

Malcolm X at a civil rights demonstration, Brooklyn, New York City.

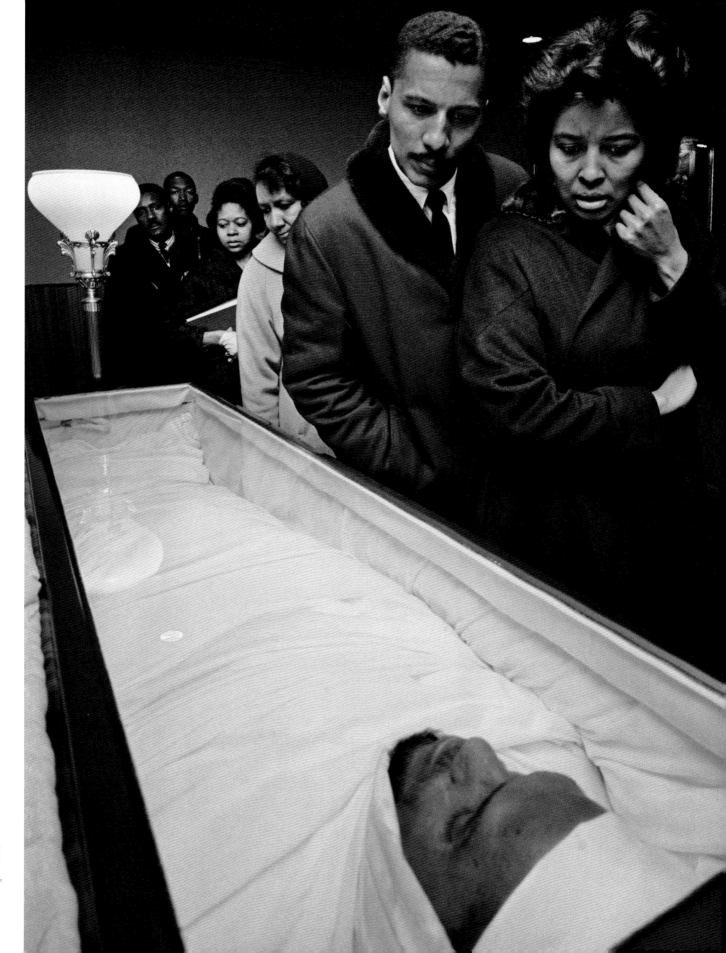

With Allah: Sheathed in accordance with Islamic tradition, the slain martyr is viewed by thousands, Harlem, New York City.

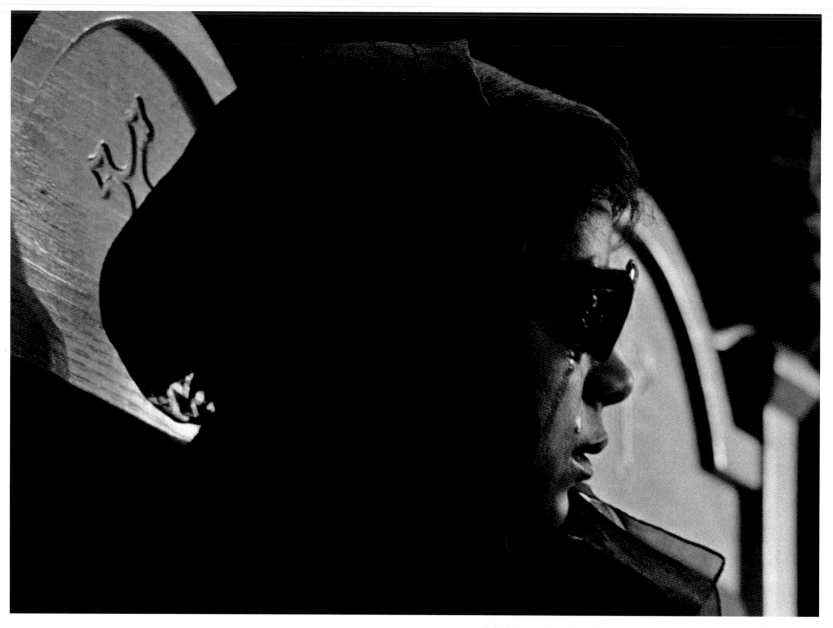

Malcolm X's widow, Betty Shabazz, grieves at his funeral, Harlem, New York City.

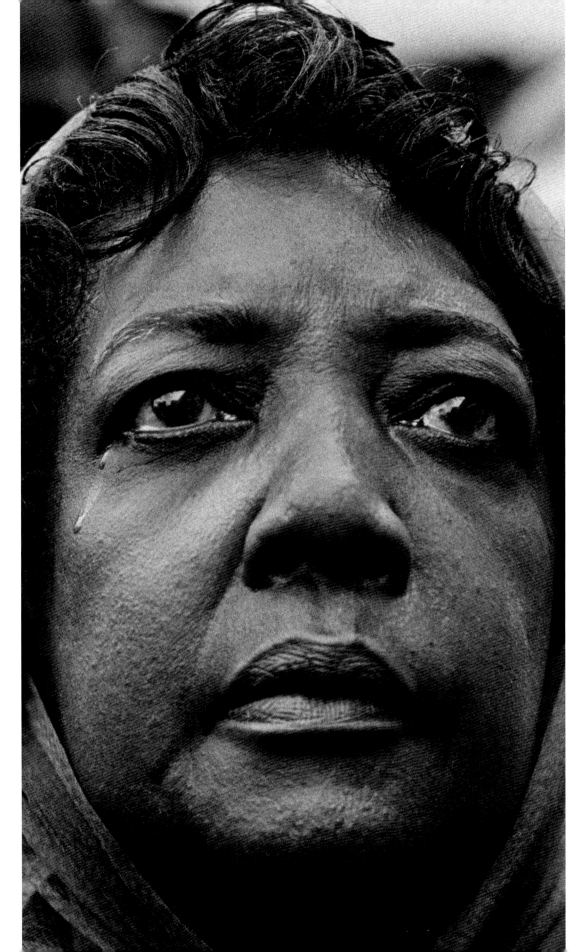

A woman mourns at a public memorial service for slain civil rights leader Martin Luther King Jr., Memphis, Tennessee.

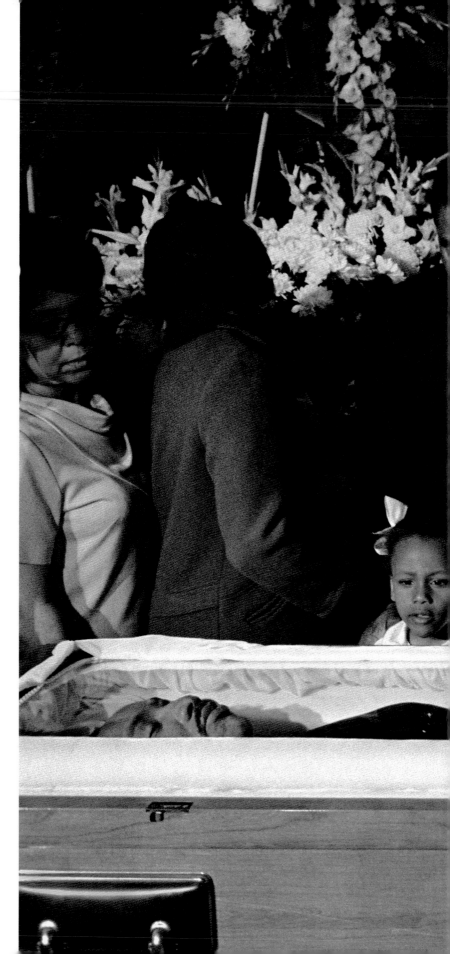

"The King family had had to share him with the world all his life, and now he was finally home. He once voiced how he wished to be remembered and those words resonated at his funeral. 'I'd like someone to mention that I tried to be right on the war question ... that I did try to feed the hungry ... that I did try, in my life, to clothe those who were naked ... that I did try, in my life, to visit those who were in prison ... that I tried to love and serve humanity.'"

Members of King's family, including his wife and children, view his body as it lies in state, Atlanta, Georgia.

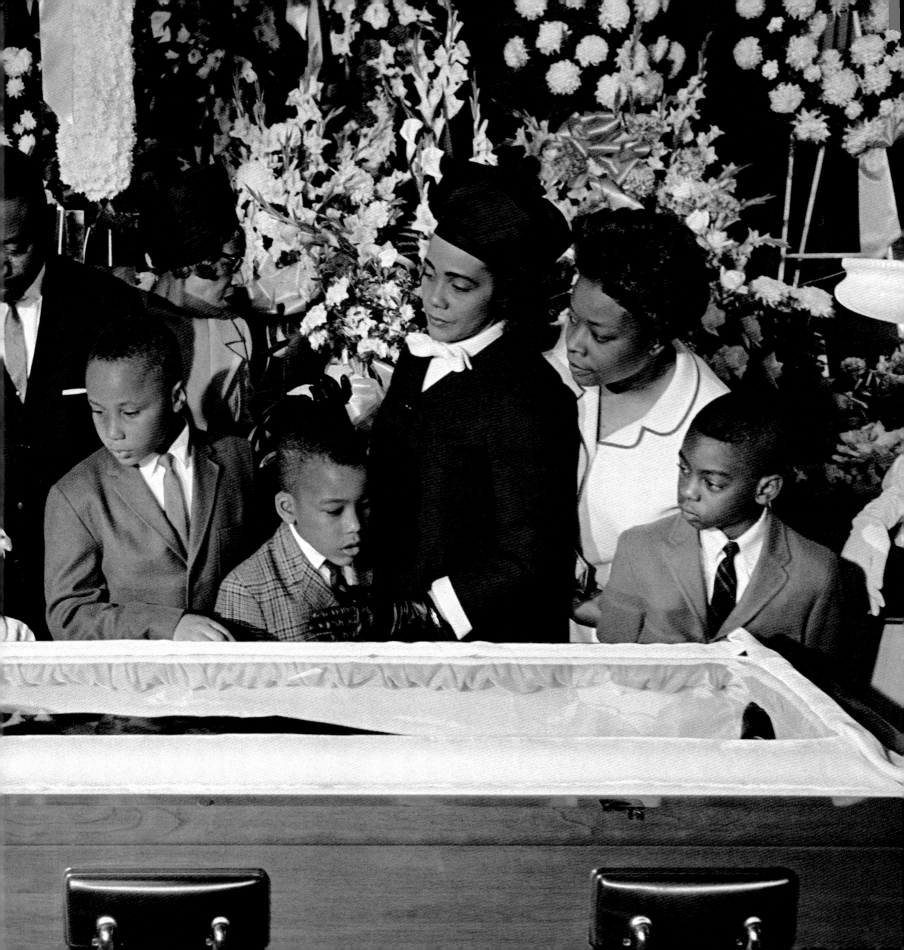

Riot control: Police patrol the streets after King's assassination
touched off rioting in more than 100 cities, Newark, New Jersey.

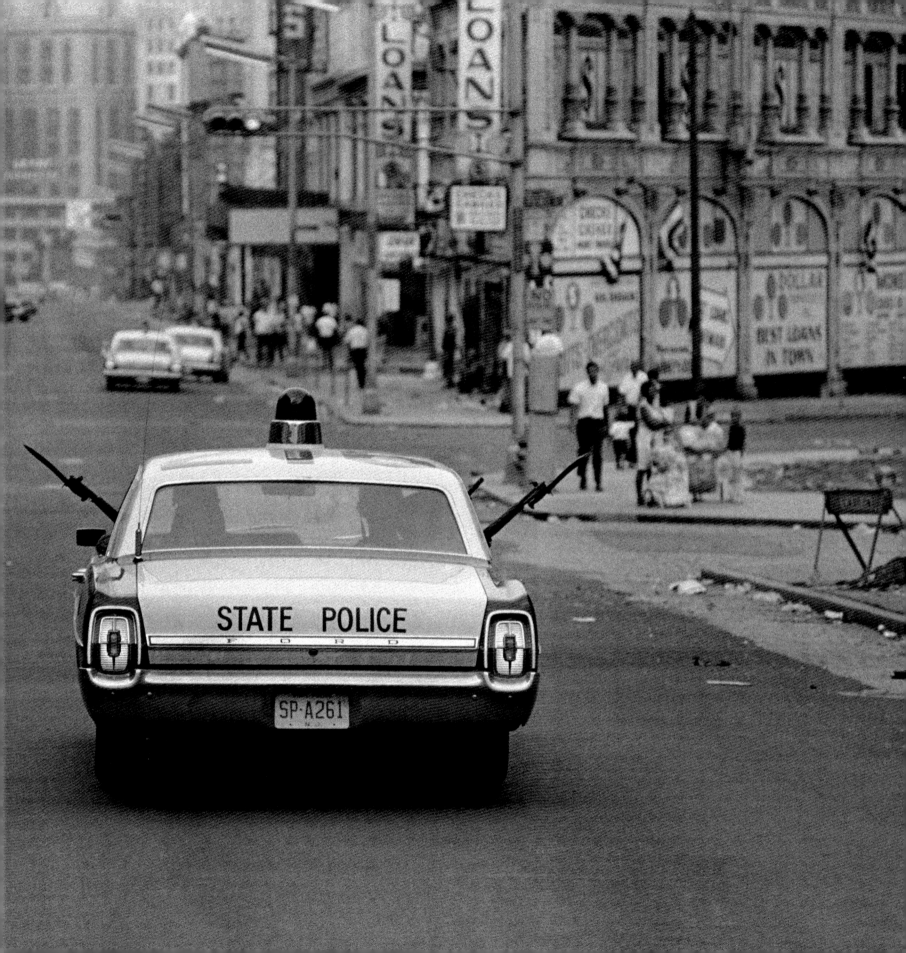

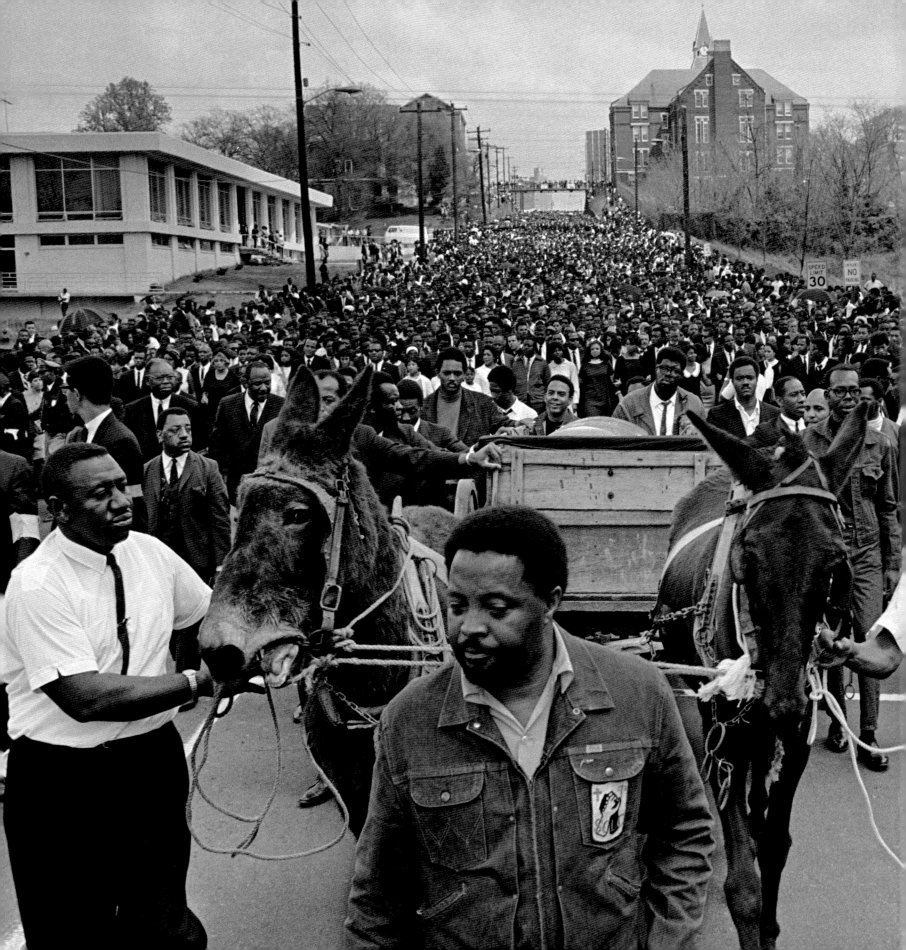

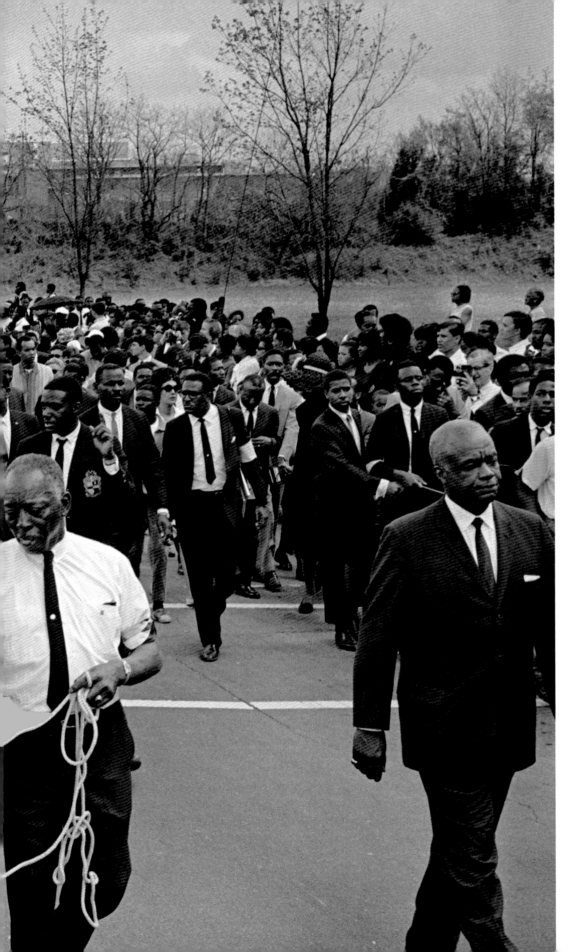

"With more than 50,000 mourners from all over the world following, King's earthly remains were borne on a simple country wagon pulled by two mules. It was fitting: A wooden wagon was basic transport for the disadvantaged and disinherited, the people he served in his very public ministry. King's life was dedicated to service. He studied, strategized, exhorted, prayed, marched, pleaded, protested, negotiated and spoke, all to remedy long-standing injustices.

"In his Gehenna he suffered vilification, numerous jailings, 'round-the-clock telephone threats, stonings, several bombings, a stabbing, repeated beatings, cross burnings, nervous exhaustion and, finally, an assassin's bullet. King died serving the dispossessed, and they understood this and adored him for it. Country people would and did drop to their knees as he passed, bawling out, 'de Lawd!'"

Free at last: King goes to his rest, Atlanta, Georgia.

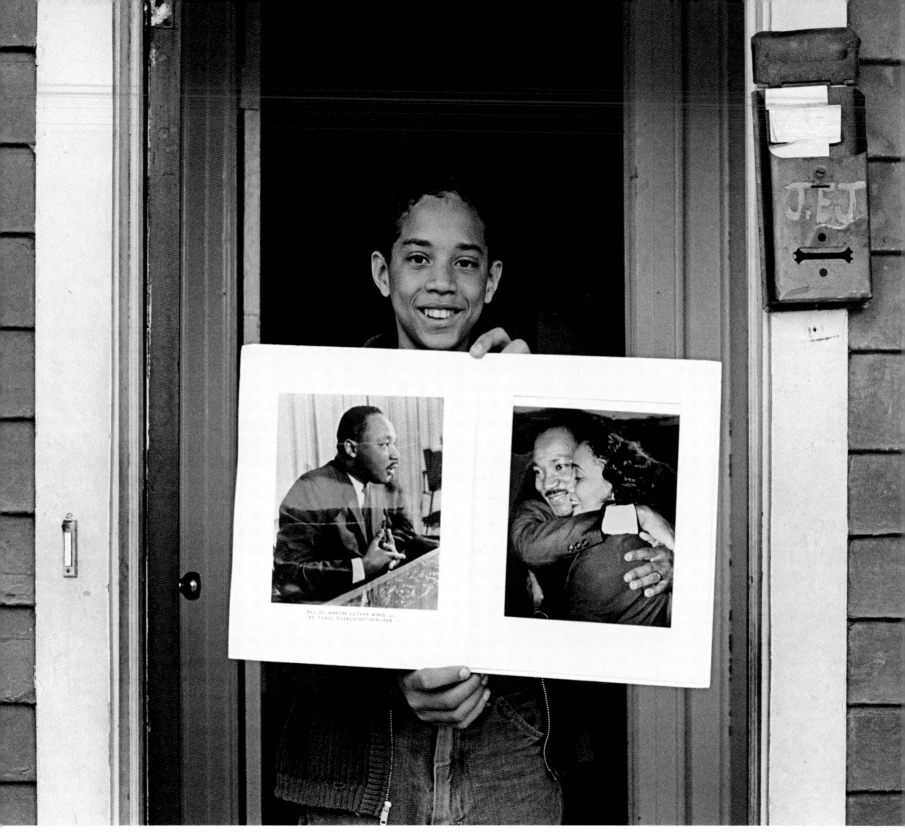

His hero, Queens, New York City.

"I was in Queens talking with his father when I asked this young fellow who his hero was. I expected the name of a sport's star. He didn't answer but, instead, went to the family mantle and proudly did 'his show-and-tell.'"

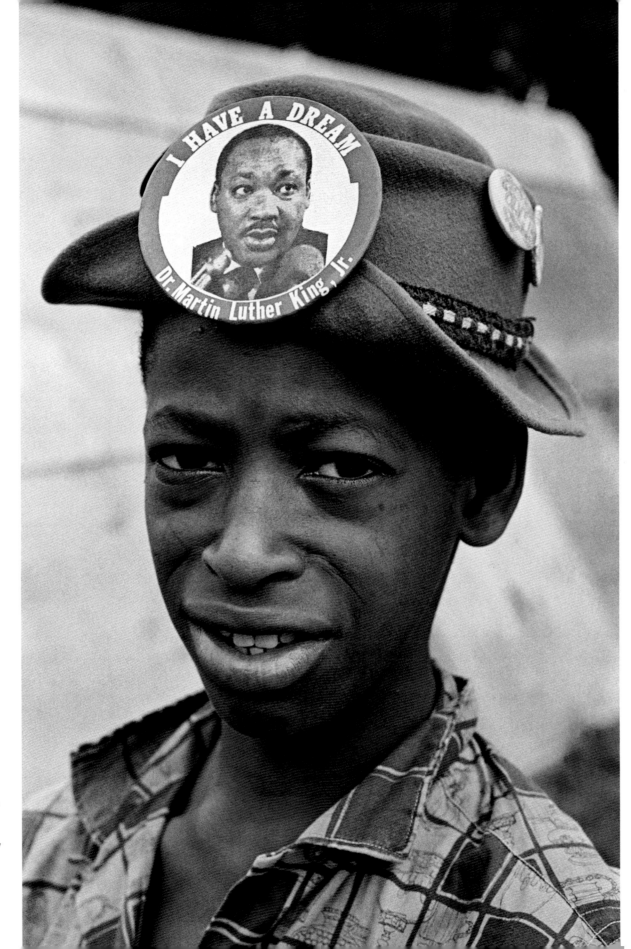

"King's last great crusade was the Poor People's March. He never made it to the march. Trying to help the poor in Memphis, he was cut down. And the poor are still with us. As King said in a sermon, 'One of the great agonies of life is that we are constantly trying to finish that which is unfinishable.'"

Young demonstrator at the Poor People's March, Washington, D.C.

INDEX

Page numbers in italics refer to photos